FASHIONABLE ART

FASHIONABLE ART

Adam Geczy and Jacqueline Millner

Bloomsbury Academic
An imprint of Bloomsbury Publishing Plc

B L O O M S B U R Y
LONDON · NEW DELHI · NEW YORK · SYDNEY

Bloomsbury Academic
An imprint of Bloomsbury Publishing Plc

50 Bedford Square	1385 Broadway
London	New York
WC1B 3DP	NY 10018
UK	USA

www.bloomsbury.com

Bloomsbury is a registered trade mark of Bloomsbury Publishing Plc

First published 2015

British Library Cataloguing-in-Publication Data
A catalogue record for this book is available from the British Library.

ISBN: HB: 978-0-85785-181-9
PB: 978-0-85785-182-6
ePDF: 978-0-85785-225-0
ePub: 978-0-85785-183-3

Library of Congress Cataloging-in-Publication Data
Geczy, Adam.
Fashionable art/Adam Geczy and Jacqueline Millner.
pages cm
Includes bibliographical references and index.
ISBN 978-0-85785-181-9 (hardback) – ISBN 978-0-85785-182-6 (paperback) –
ISBN 978-0-85785-183-3 (ebook) 1. Art and society. 2. Aesthetics. 3. Social values.
I. Millner, Jacqueline. II. Title.
N72.S6G43 2015
701'.03–dc23
2014036562

Typeset by Integra Software Services Pvt. Ltd.
Printed and bound in Great Britain

To David H. and JPC who have been there for us and
who are our fashion icons

CONTENTS

LIST OF ILLUSTRATIONS

ACKNOWLEDGEMENTS

Adam would like to thank Sydney College of the Arts, the University of Sydney, his friend and collaborator Vicki Karaminas, his parents Andrew and Carolyn and his sons Marcel and Julian.

Jacqueline would like to thank Professor Colin Rhodes, Dean of Sydney College of the Arts, University of Sydney, for his support in granting her time to pursue this research. She is most grateful to those who hosted her during some of the intense periods of writing, including Jane Polkinghorne and the Bammy Residency, Mariluz Marmentini and Philip Millner. To the artists who have granted us permission to publish their images here: thank you so much. And finally, thanks to John Paul, Zac, Jaspar and Bella, for loving support and inspiration, always.

Thanks from both of us to Bloomsbury Publishing for their interest, support and attention, to Hannah Crump for her diligence and to Anna Wright, our editor, for her unfailing sympathy.

INTRODUCTION

And now the art world has become so big and stars seem to come and go as swiftly as reality television characters in Hollywood…

—MICHAEL KIMMELMAN[1]

'Contemporary art' has to be one of the more vapid and frustratingly tautologous of labels. At least modernism had a sense of dramatic panache: Futurism, Orphism, De Stijl (*the* Style), the 'return to order'. If postmodernism caused consternation amongst the uninitiated (or the intransigent), then the name contemporary art adds insult to injury, hiding in the sheep's clothing of semantic simplicity. For all art produced at its time is contemporary. It is a truism that could only be made to qualify the term, as in now, for otherwise it is too obvious to bother about. Postmodernism, finding itself uncomfortable with an epigone named post-postmodernism – that would after all emphasize a linear progression which is a postmodern no-no – nervously had to find a contender and the only name at its disposal was contemporary. 'Contemporary' agreed to fill in for a while, but there were no viable applicants and so contemporary art got the job. Yet, if one is to look at it from a slightly different angle, there is also something telling about the term. Both postmodernity and 'The Contemporary' are terms involving time. One is a rethinking of the past, the other confers primacy to the present. Whereas art continued the flows of history, it is now in a very different vehicle and following a different logic. What this book explores is the extent to which that logic is the logic of fashion.

A headline in 2012 in *Blouin Artinfo* reads, 'Former YBA Patron Frank Cohen on Why British Modern Art Is Back in Fashion'.[2] What is observable since at least the beginning of the new millennium is an increased marriage of the words 'fashion' and 'art', sometimes derogatorily, but on other occasions as if the old enmity between

[1]Michael Kimmelman in an article on Leo Castelli in *The New York Review of Books*, September 2011, 24.
[2]http://www.artinfo.com/news/story/757855/former-yba-patron-frank-cohen-on-why-british-modern-art-is-back-in-fashion

fashion and art, between the transient and the frivolous and the reflective and serious, were not there. Both Dada and Pop challenged the dichotomies of high and low, and both in different ways sought to shatter the boundaries between art and life. The example of Warhol is signal here, insofar as he, more than any artist in modern times, made next to no distinction between the world of fashion and that of art. His presence as an artist had as much a social function as it did a subjective one to the extent that he became the leader of a brand whose production house was categorically called The Factory. His portraits and screenshots can be read on several levels, and one of them is play of surface and the art of making social contact. Like his contemporaries the conceptual artists, one does not contemplate a Warhol as one would a Goya, but unlike the same contemporaries, Warhol thrust the viewer into the web of commodity fetishism, desire and its limit, death. Probably because he did not have the alliance of art and fashion uppermost on his mind, Warhol was able to isolate one of the essential elements of fashion and the movement of capital in late capitalism: evanescence.

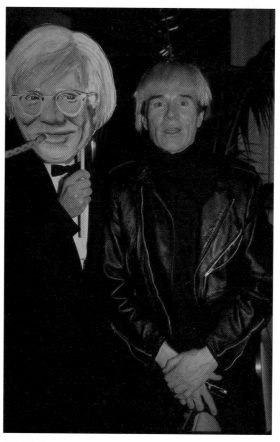

FIGURE 1 Andy Warhol. Photo by the LIFE Picture Collection/Getty Images.

It was not until very recently that the revisionist theories of art history embraced fashion within the evolution of modernism. Depending on when one sees the advent of the modern age – the French Revolution or the Republican revolutions across Europe in 1848 or the Haussmannization of Paris shortly after that – it is more than a coincidence that artistic modernism is coterminous with the rise of fashion as a system, that is, as a regulatory idea within the marketplace. It is also significant that Marx published his first serious work, *Contribution to the Critique of Political Economy*, in 1859. These events occurred at precisely the same time as the rise of the first haute couturier Charles Frederick Worth: the dressmaker to Empress Eugénie, Worth had a stranglehold over Paris fashion in the late 1850s and 1860s. With the freest license, his dresses lifted from an eminent roll-call of masters, from van Dyck to Gainsborough. Worth set himself above his predecessors (who had been primarily women) and called himself an artist and his work creations.[3] Only a few years before Worth's rise to fame, Gustave Courbet, the lion of the artistic Realist movement, had completed *The Stone Breakers* (1849–50) and penned 'The Realist Manifesto'. Thus began two poles of creative activity, one concerned with beauty and profit, the other with truth and morality. It is a dichotomy that would narrow with time, until we reach the present when designers like Alexander McQueen and Rei Kawakubo are fêted for having successfully bridged the gap between garments and sculpture. The quantity of contemporary artists who call themselves 'cultural producers' is also telling, given the etymological root of fashion is *façon* and *façonner* derived from the Latin *factio* and *facere*, 'to make'.

While other studies successfully examine the crossover between fashion and art from fashion's point of view, this book does so from the point of view of art. But just as it is instructive to read the history of modernism in parallel with the development of fashion, it is equally illuminating to view its evolution in terms of fashion. This is quite an audacious claim, although it is less so when viewed from the perspective of recent decades: from the hyperinflated art market of the 1980s; to the manufacturing of the young British artists (yBa) phenomenon by an advertising magnate; to the establishment of what are now known as brand dealers and brand artists, people who embody the symbolic cachet of art itself, based on consensus, financial ratification, market demand – and luck.

The layperson's lament at postmodernism was that it followed no discernible pattern and had no legitimate leader, which was a sure symptom of its decline. With globalization, the sheer multifariousness and mass of art makes judgement, and social diagnosis, considerably more vexed. The decline of the critic since his (pointedly, Greenberg/Rosenberg) heyday in the 1950s is another sign of uncertainty about what is good art and why it ought to be deemed as such. This means that the public is in the hands of curators and private collectors. Both make choices and purchase art in the name of public or private property. What are their criteria? Curators seldom go off a whim since they are accountable to

[3]See Adam Geczy, 'Modernity', in Adam Geczy and Vicki Karaminas (eds), *Fashion and Art*, London and New York: Berg, 2012.

public or benefactor's funds. They are also frequently bound to the sponsorship of multinational corporations. The private collector is more inclined towards personal preference, but will also safeguard his/her corpus with works that are a sure-fire bet, and that means ones with a provenance, in major public collections and distributed by galleries that host artists of the same ilk.

We should remind the reader that this book is not a jeremiad against the rudderlessness of postmodernism or the vertiginous inconsistencies of contemporary art. Rather, it attempts to offer a way of understanding the art of recent decades through the idea of fashionable enclaves. These may be driven by investors in search of social approbation or of a safe place to park money. Or by a curator working by principles determined more by the need to increase audience numbers than by philosophical comment. There is always good art within these enclaves. It is not our task to explore alternatives to this system, to vouch for art's 're-enchantment', since we have faith that good art is out there. Rather, our concern is that art is collected and exhibited according to commercial and ideological principles whose thin veneer of moral probity masks potentially venal agendas. For example, even when Australian Aborigines continue to languish in degradation in remote areas, they are given royal treatment in artistic circles. Would Basquiat have been as popular were he not black? Has 'feminist art' been reduced to a husk of good intentions? Is multiculturalism in art a decoy for an attitude that transcends fascination and tolerance? Why is, or was, Chinese art so successful?

In the frustration over Contemporary art – capitalized to give it dignity beyond an empty adjective – it is enough to recognize that the vagueness of the term derives from the scope of the global: global markets, global economies and so-called global art. Contemporary art is a 'condition' in which there are so many points of view, so many different conditions, that its diversity cannot be trapped in a single definition. *And yet*, it is also the condition of globalization to find or impose points of commonality, to look for patterns and shared characteristics. These can range from the benign, like online 'communities', to the more sinister effects of mass-market branding and corporatization, from Starbucks to Nike. To ask, then, 'what is Contemporary art?' is perhaps a misplaced question or one that cannot be answered with any degree of coherence. This is not to decry recent eminent commentaries on the subject. Yet by inserting the word fashion into the debate, we can see a way in which artists, curators and the art-consuming public can make sense of this diversity. All modernized cultures have fashion. Fashion is part of the fabric of industrial society, it is a form of sociability, a measure of the ways in which people stage and register their belonging to a class, an idea, an approach and so on. But fashion is also an overarching principle that has emerged in contemporary art over the last thirty or so years. It can be directed at a culture, group or country (such as China) or to an approach (such as grunge art). This is not all negative. For example, the West directed its gaze to China knowing of its rise as a new superpower and in order to give artists a voice where they would otherwise have been denied one; grunge art emerged as a refusal of the phenomenon of gentrification in Soho in New York. This book oscillates in its use of the term 'fashion', between its pejorative sense – when it represents bandwagoning or art world strategies that all too frequently measure success by the gyration of

turnstiles – and fashion as a *necessary modulator* that brings coherence and direction to a group or those working in a particular way or style. Fashion is an idea that signals the realization that modernist utopianism can only exist through the disavowal of the temporariness of a style or approach. Once we invoke fashion, we recognize from the very outset that one or another style or approach will rise, and then fall.

If we apply the concept of fashion to mid-nineteenth-century modernism, we return again to Realism and its catch-cry, 'Il faut être de son temps' – one must be of one's time. The exhortation freighted in the word *faut* is like a Kantian moral *ought* extended into the public sphere. The relationship of the avant-garde and dress is well documented in the many histories of bohemianism,[4] and it is through sartorial and artistic style that artists grouped together. To be of one's time meant not to be of the past, and that past was the classical past. Classicism, or neoclassicism propelled by Jacques-Louis David, was very much the regnant style of the French Revolution and powerfully suggested that the ornate fripperies of the *ancien régime* were renounced and condemned. The successive classicisms that became part of the substance of the French academy in the nineteenth century were meant to be the sane antidote to Romantic recklessness, and because classicism delved into the past, it was sanitized of the temporariness of the present: news, fashion and anecdote. Classicist and history painting spoke a more profound language cleansed of the everyday. The academic styles were of course not free of their inconsistencies. Academic classicism was a project, from the point of view of the artistic avant-garde, destined to fail. But it was a style that was conservative, reaching towards values that were believed to be permanent and right.

It is the rise of the so-called pure artist and pure art, divorced from society, contemptuous of money and traditional labour, which in effect leads to a perception that affords art a higher monetary value. In his examination of the evolution of the notion of autonomous art in the nineteenth century, French sociologist Pierre Bourdieu explains how art – his main focus in this case is literature – came to have its own symbolic structure external from that of every other form of production. The signature of the artist or a couturier's label lifted the object to acquire a sacramental value according to collective assent.[5] The more artists portrayed themselves as indifferent to traditional social mores and interests, the greater the fascination in artistic production. Artistic heroism and suffering were key, since they raised the work of art decisively from something made, to something imbued with an essence unachievable by most humans. Even artists such as Millet or Courbet whose work had social function were not exempted from this, since they were opposed to bourgeois society; they themselves occupied a special social space as they came with the apparent nobility of the peasant without any of his/her actual stench. Along with the artist's detachment from society was the notion of invention and relevance – the artist as diagnostician – that set itself against the academy. It was also by the middle

[4]See especially Elizabeth Wilson, *Bohemians: The Glamorous Outcasts*, London: I.B. Tauris, 2000, and Mary Gluck, *Popular Bohemia: Modernism and Urban Culture in Nineteenth-Century Paris*, Cambridge, MA and London: Harvard University Press, 2005.
[5]Pierre Bourdieu, *Les règles de l'art*, Paris: Seuil, 1992, 287.

of the nineteenth century that the term 'academic' had a chillingly negative ring, since it meant the safety of tested codes over adventuresome newness. For the artist to be of their time, they had to offer something unacademic and something different. When we transpose these notions to the present day, we can say that the ethos of newness is less mythologized and far more relative, but nonetheless still essential to an artist's and a gallery's marketability. Fashionability is the condition of this newness which, we emphasize, has its good and bad sides; on the good side, fashionability provides a framework into which a diffuse range of artists can set up a constructive dialogue with the present, according to relevance and sustainability.

In our present era, the 'purity' of art, as Bourdieu names it, is maintained if not heightened, but it is one of the characteristics of the contemporary for such value to be unmoored from a stated ideology. The aspirational value of art is therefore freed, or bereft, of standards that link it to ethical aspirations, except for those ethics that inhere within the aesthetic itself. In this state, art is more reliant than ever on the perception of its newness – hence the rubric 'contemporary', a kind of eternal return of change collapsed in on itself. This is where the condition of art and the condition of fashion meet: the symbolic abstraction, art, is faced with the immanence of change.

Contemporary art is by definition new while also having the potential to command sums in excess of its material substance or labour. Since the 1980s, when the dalliances of Pop subsided to usher in the ersatz ethos of kitsch, recognizing that mass culture could not be separated from high culture, there has been no distinguishing highbrow from lowbrow. Decades later, art is a site of infiltration from all spheres of activity. It cannot be adulterated in the way it was when Manet lifted the veil of Maya by painting a prostitute as a prostitute, or when Picasso and Braque introduced newspaper clippings into their paintings. Kitsch, as Adorno defines it, is the 'pretense of nonexistent feeling'. It is 'art that does not wish to nor can be taken seriously and yet poses itself as putting forward the appearance of seriousness'.[6]

But Adorno's binary of fake and authentic emotion is no longer tenable, since fake emotion is typically used as a critical tool by artists to reflect that supposedly compromised affective space of popular culture. Art plunders popular culture with an efficacy and intricacy that has caused us to alter our frameworks for judging and criticizing. Is there a critique that one can lay over Damien Hirst's *For the Love of God* (2007)? Surely it can be read as the embodiment of the commodified status of the artwork lifted to a whole new level. Yet the work is also unabashedly complicit in what it comments upon. In the words of Russian art theorist Boris Groys, 'Artworks now become iconic not as a result of their displays in the museum but by their circulation in the art market and in the mass media.'[7]

[6]Theodor Adorno, *Ästhetische Theorie*, Frankfurt am Main: Suhrkamp, 1970, 466–7.
[7]Boris Groys, *Art Power*, Cambridge, MA: MIT Press, 2008, 47.

It is better, in fact, to perceive a work like Hirst's as having a critique yet one that has been sublimated. In other words, by being art, it has a critique. Art's critical status is that which sets it apart from other objects in the world. What makes Hirst's work so attractive, like his very popular and successful rotor paintings, is that this critique is relegated to the back closet. This dynamic is acutely similar to the semiotics of fashion in which comment and critique can be consumed on a take-it-or-leave-it basis. Alexander McQueen's *Highland Rape* (1995–6) collection can be read as a work mourning the historic coercive grip of England over its neighbour states, or it is just edgy and inventive, its political content laudable since most fashion generally stays clear of politics. What is important (and necessary) is that it is novel.

To place this condition in a larger socio-economic context, it is one of the features of late capitalism to attract what criticizes it in order to devour and absorb it. While not discussing art per se the words of American philosopher Brian Massumi aptly capture this condition:

> It's no longer disciplinary institutional power that defines everything, it's capitalism's power to produce variety – because markets get saturated. Produce variety and you produce a niche market. The oddest of affective tendencies are okay – as long as they pay. Capitalism starts intensifying and diversifying affect, but only in order to extract surplus-value. It hijacks affect in order to intensify profit potential. It literally valorizes affect. The capitalist logic of surplus-value production starts to take over the relational field that is also the domain of political ecology, the ethical field of resistance to identity and predictable paths. It's very troubling and confusing, because it seems to me that there's been a certain kind of convergence between the dynamic of capitalist power and the dynamic of resistance.[8]

Affect is drawn into the circuit of profitable excess. The packaging of high culture – from the three tenors to their quasi-boy-band offshoots, to the dramatization of artists' lives in film (Kirk Douglas plays the sexually inept van Gogh, Charlton Heston plays the homosexual Michelangelo) – is fair game to any and all forms of consumption. This is not to say that 'true feeling' in the Adornian sense has left us in the manner of some Baudrillardian real; we have not been reduced to automatons or ghosts. But what we can say is that in our own transports of feeling we are made to feel more and more uncertain as to its calibre, its rootedness – its trueness. Are we 'feeling' art or are we just spectators to a surrogate state of 'true feeling', as if true and authentic feeling were a particular category of its own, like boutique organic hand-roasted nuts as opposed to the cheaper generic brand variety? While we may embark on an effective deconstruction of all values like truth, or even if we turn back to philosophers such as Nietzsche, we are still left with questions. Even if our affect as post-Cartesian subjects is relative and decentred, what are the

[8]Brian Massumi, 'Navigating Movements', in Mary Zournazi (ed.), *Hope*, New York: Routledge, 2002, 224, cit . Slavoj Žižek, *In Defense of Lost Causes*, London and New York: Verso, 2008, 197.

coordinates of goodness in art? We experience good art and believe in it (no less than we may experience affection for our friend) but from what basis do we judge, what are the criteria?

The 'troubling and confusing' collapse of truth, criticism, feeling and resistance into the permeable capitalist fabric has, true enough, been incipient in debates surrounding the role of the intellectual at least since May 1968. Nonetheless criticality has always resided as the attribute implicit to its difference. *Yet criticality, now as malleable a term as 'modern' or 'romantic', is noticeably being observed as the very attribute that makes it attractive to its consumption.* The modernist stance of criticality as what alienates in order to cause one to reflect is now a given: one has alienation and reflection with the irritation of being alienated or needing to reflect. In his scathing commentary of the cosmetic ineffectuality of leftist ecology, Slavoj Žižek speaks about what he calls the 'Starbucks Logic', in which the higher price of the coffee is because a small percentage is siphoned off to the developing nations that coffee consumers, and the developed world, inevitably exploit. The passive ecologist is one consumed with 'fetishistic disavowal', in which altruism is conveniently, remarks Žižek, 'built into the product' so that in one fell swoop one can simultaneously participate not only in the problem but also its solution.[9] Similarly, criticality is built into the artistic product. It is thus an invisible remainder that is synonymous with 'being art'.

Art's embeddedness in the marketplace and in institutional systems, and the somewhat ceremonial, or supplementary, nature of the critical position, has prompted some writers to muse about an age of 'post-criticality'. In an essay on French artist Pierre Huyghe, the editor of *Artforum*, Tim Griffin, turns to a new vocabulary to compensate for contemporary art where 'critique seems precarious – when, in so many words, the historical context of critique's initial formulation in art is part of an increasingly distant past'.[10] Speaking more about art criticism and critical theory, American art theorist Hal Foster identifies the predicament of 'Post-critical', which was already an item for discussion in the early 2000s. It is 'the fatigue that many feel … especially when, taken as an automatic value, it hardens into self-regarding posture. Certainly its moral righteousness can be oppressive, and its iconoclastic negativity destructive'.[11] While acknowledging these foibles, Foster also laments the legacy of the dilution of art criticism as a whole whose purpose is not to guide but to comment and digest. It would seem that fashion journalism has far more influence; however, its terms of reference need not be as intricate and are far more avowedly based on individual taste and intuition. When it comes to art

[9]Slavoj Žižek, *Living in the End Times*, London and New York: Verso, 2010, 114.
[10]Tim Griffin, 'Compression', *October*, Vol. 135, 2011, 18. The alternative that he poses is 'compression' which, despite his definition, is still rather obscure (14): 'A sense of distance is created for the viewer here, but – as is the case with the commercial address of consumers – within this gap another kind of memory, another experience and history, is implanted. Memory is summoned but emptied, and only for the sake of introducing another memory (an "invented world"). To return more specifically to the model of compression algorithms: information is taken away while a picture, or experience, is provided.'
[11]Hal Foster, 'Post-critical', *October*, Vol. 139, 2012, 6.

itself, Foster notices the number of artists such as Olafur Eliasson or James Turrell who make work of 'atmosphere' and 'affect' 'in spaces that confuse the actual and the virtual and/or with sensations that are produced as effects yet seem intimate, indeed internal, nonetheless'. Such work is perforce fetishistic since it processes thoughts, feelings and perceptions and 'delivers them back to us for our appreciative amazement'. One problem that Foster perceptively cites is that those with critical insight are not trawling through the world to find truth, it is that truths 'are all too apparent'. By this he means that everyone knows that the Kardashians are trash; that Paris Hilton is famous for being famous; that news providers like Fox News and CNN doctor their information according to a whole range of political and corporate filters; that Hirst's self-promotion is feckless. Thus,

> 'I know the big museums have more to do with finance capital than with public culture, but nevertheless ... '. As a fetishistic operation of recognition and disavowal (precisely, 'I know, but nevertheless'), cynical reason is also subject to antifetishistic critique. Of course, such critique is never enough: one must intervene in what is given, somehow turn it, and take it elsewhere.[12]

Foster accurately describes the very subjective state of knowing that one is inscribed within a system that is ethically indifferent to one's wishes and one's will, and yet tolerates it. What Foster describes is of course valid beyond art to our entire immersion in mass media of which we are simultaneously separate and pathologically part. Foster ends his essay ('diatribe') with an analogy from the 1920s in which a state of socio-economic alarm is the norm which artists respond to, elaborate on or retreat from. His final point is that criticality, especially in this time, ought not be abandoned.

Comparatively earlier, the same sentiment prompted British art theorist Julian Stallabrass to coin the term 'High Art Lite' to describe the yBa phenomenon. The new wave of British art, that asserted a decisive mark on the 1990s following the New York 1980s, was characterized more 'in terms of temperament and tactics, rather than style or medium'. We have more to say about the yBa phenomenon later on, but suffice to note that their prominence as a group was based on a hyperbolic attitude to themselves which found an ardent ear in the press (Stallabrass asks whether the group term is just 'media confection').[13] Its meaning as a movement is only contained as a package appropriated by the media, as a byword for the ecstasy of hype and success itself. Efforts to resuscitate the hype in successive exhibitions of 'New British Art' in recent years have not enjoyed as much success, since the earlier luckier generations were blessed with the success that came from enthusiasm, and this could only have ballast if the media were in constant thrall.

But within this vacuum of positivity, the tsunami of consensus, Stallabrass maintains admiration for some of the artists under the yBa aegis, Tracey Emin for one. Stallabrass shares the anger of other art critics, theorists and commentators at the extent to which art courted the media, and, to quote Australian art historian

[12]Foster, 'Post-critical', 7.
[13]Julian Stallabrass, *High Art Lite*, London and New York: Verso, 1999, 2, 3.

Terry Smith, 'conspired in its own disappearance'. Stallabrass and his peers are blinded by their own opprobrium, for as Smith suggests, the achievements of artists such as Hirst and Matthew Barney are considerable, albeit uneven.[14] Stallabrass is occasionally dismissed as 'Marxist' (not by Smith), since he demands a certain degree of transparency, that is, sincerity on the part of the artist. There is much to commend this however; it's also important to add that all the writers named here avail themselves of a critical faculty. This sounds blandly patent and axiomatic, except when one asks the question as to what the critical eye asks of the artists. In contemporary art, do artists have something in addition to a critical eye? The answer is yes, and always has been, since the love of beauty for its own sake, or the call to a perverse or transgressive attitude, is not codifiable in concepts or reducible or conveyable through simple words alone. What we suggest is that this unaccountable and supplementary quality of pleasure is what the fashion industry has guiltlessly marketed, and that art, in the age of a watershed of capitalism and increasing world crisis, is beginning to do the same. Consider the following statement by Antonio Negri written in 2004:

> The society around me seemed like an enormous piling up of commodities, a piling up of abstract values which money and the mechanisms of the financial world were rendering interchangeable: a capitalist world stamped with unilateralism, in which tensions were as good as eliminated. In that world I could no longer find anything natural – I mean pre-industrial and not manufactured. Marxism distinguishes the exchange value of commodities from their use value. Of this use value – which, despite the systems of domination and the methods of exploitation, also valorized exchange – I no longer found the slightest trace. The world had become completely reified and abstract. What meaning could art have in such a situation? Within this reality, what could be the process of artistic production, or alternative creation, of reinvention of the real? This perception was not simply philosophical, it was also political. Since I was also working on Leopardi at that time, I remembered that the criticism of realities around him revealed to this great Italian poet of the first half of the nineteenth century: a world which he described as 'static', a world which annulled passions, that is, the only forces which render life worth living.[15]

There is a great deal here in miniature. As a socially aware intellectual, Negri is not only speaking as a standard-bearer for the entire humanist tradition. He goes on to bemoan the suffocating embrace of market forces, the seepage of capitalist production into both local and global, with the effect of 'stripping life and imagination of every trace of innovation and solidarity'. His refrain has been sounded by countless intellectuals before and since. It is a genuine anxiety at what is effectively the stripping away of free will, creativity – and affect. Our feelings

[14]Terry Smith, *What Is Contemporary Art?*, Chicago, IL, and London: Chicago University Press, 2009, 248.
[15]Antonio Negri, *Art and Multitude*, trans. Ed Emery, Cambridge: Polity, 2011, vii–viii.

are vicarious, monitored or diminished. Or to return to the High Art Lite view of things, artists and their world are married to celebrity over instructive agency.

We are not out of sympathy with this view. It is not the aim of this book to patronize genuine critique or genuine feeling as 'humanist' and to announce the age of the 'posthuman'. (The posthuman is most evidently with us with the growing multitudes who are not treated as human, a condition that far outweighs philosophical tropes.) We have felt the same anxiety and also think that Leopardi is a great poet. But we also identify that it is altogether vain, otiose and misplaced to call for, as Negri does, a dialectical, purer alternative to high capitalist schmaltz, to try to find the 'correct' point of vantage and an untainted realm where to think and breathe. It is precisely *because* this is an idealist hypothesis and that it is inoperable that we have sought a different, parallax angle on art's production and reception. This view must permit of a critical position. But rather we suggest that this is enacted within, rather than outside, the frameworks of mass consumption, namely that good art can still exist *within* the fashionable frameworks of whim, consensus and novelty, and according to them. The ennoblement of kitsch by Koons and others in the 1980s forcibly conveyed to artists and critics alike that the concept of the validity and viability of certain strategies, beliefs and tastes had changed decisively.

The contentions of this book are therefore the following:

1 If postmodernity was a continuation of modernity through different means (although there are other interpretations and none are concise), 'The Contemporary' is postmodernity unencumbered by modernist conscience. If postmodernity was anti-utopian, it was still self-conscious of it; contemporary art is not.

2 Contemporary art is mediated by mass communications, audience numbers and difference for the sake of garnering interest.

3 Contemporary art is navigated according to cultural codes of difference that package racial otherness allocating them into 'pavilions' of interest. The reflex against racial discrimination is a lack of aesthetic discrimination, for example, all Chinese performance art is ipso facto radical. It is indeed fashionable for artists, such as Yinka Shonibare, to mount devastating critiques of the system, without quite reflecting enough on the sense that this is what the art system, and capitalism, thrives on. These systems package the 'outside' and the other to make them supreme fictions whose critique is immanent to the product.

4 Contemporary art is characterized by giving preference at particular periods to certain methods and media. These preferences are always haunted by ideology.

5 Contemporary art, its look, its mechanisms, metaphors, tropes and trajectories are imbricated with mass media advertising and fashion. Our

visual literacy is increasingly less divided; however, it is in the interests of the art market to ensure that it remains discrete. On the other hand, conceptual and experimental fashion is tantamount to conceptual art and sculpture, also such that those sympathetic to it can be commensurately moved by it as any bona fide work of art.

6 The language of art, to use the term adopted by Boris Groys, is dominated by hyper-historicized referencing and signalling of ideas, languages and trends to an indiscriminate degree and order. This is the very same as what the fashion industry calls *inspiration*.

This book begins with an elaboration of the definition of fashionable art and is followed by a history of the artist as impresario since the Renaissance that has coalesced into the contemporary artist as celebrity. Postmodernism ushers another shift in the fall of the utopian promise, and with it the faith in art's philosophical aspirations. With the indomitable rise of media and mass communications, the cross-pollination between the flows of popular representation and artistic representation becomes so diverse and intricate that they are irreducible to a strict model. With the Contemporary, the confusion is more acute: the power of critics falls, while artists are elevated to brand. Commercial galleries become like boutiques of art, the worth of their stable built on the invisible foundations of prestige.

The next two chapters consider the role of race and identity, themselves attractive draw-cards for curators eager to show their fairness and their sympathy with the 'Other'. The rise of Chinese art is worth considering in this manner, as is Aboriginal art, which rose from obscurity in the 1970s, just at the time of the protest movements, critiques of colonialism and the urgency to identify and give recognition to indigenous minorities. But the question is, to what extent does Aboriginal art have its own agency, or is just another cultural pawn in the global art machine?

The following chapter considers formlessness and abject art with its grungy deliquescence, art that in its evocation of what exists prior to language and thought can at times tip over into not saying very much while still affirming its transgressive edge. Participatory art – Chapter 6 – has also become *à la mode*, having retreated from its origins in protest and entered, mostly tamed, into the gallery – although this too can jangle the loose change of the revolutionary brio of a bygone era in its pocket. Chapter 7 is devoted to video art, a form that has no previous tradition, such as painting, and which charged into the art scene with a velocity unmatched by photography. Contemporary art rapidly developed videophilia: whack a video in somewhere and you'll be sure that the work looks contemporary. Chapter 8 is about the tenacity of the Minimalist style, the other face of formlessness. Minimalism is 'pure' form, but is also desirable because it carries with a strong air of authority without, again, pressure to say much. The final chapter is on the new fad of Outsider Art, a term that begs the question of whether art has an 'outside'. It is ironic that Aboriginal art and Outsider Art were 'invented' at roughly the same time – a need to find a final bastion of authenticity in an increasingly mediated world perhaps?

Built into the title of this book is a wry sense of humour. Anyone who has spent much time with contemporary art will admit that one cannot survive without it, lest one become a curmudgeon with the weight of the rotting corpse of humanism on his/her shoulders. Contemporary art effectively elicits humour, by default or by design. Somewhere within that all is also tragedy, but stuccoed over by entertainment and pageantry which is so much of what contemporary art has become.

1 WHAT IS FASHIONABLE ART?

In the 1980s, the word 'postmodernism' still courted a quizzical response: Was postmodernism worthy of contempt? A threat perhaps? In architecture where the term was first circulated, postmodernism spelled a sizeable shift away from the sure values of modernism. In art, conservative critics such as Suzi Gablik called for 're-enchantment' while Robert Hughes remained intemperate about the apparent excesses of Julian Schnabel. Postmodernism was, among other things, associated with mourning, which was in fact a mourning at itself; it bemoaned the loss of the utopian, revolutionary spirit that marked modernism. Yet it was a discernibly disingenuous sorrow, since artists like Jeff Koons embraced commodification with zeal, and treated the deeper sociopolitical aspirations of the historical avant-garde with condescension and contempt. The death inscribed within postmodernism could be construed as secularism without moral responsibility. In the new millennium this attitude has changed to anxiety: this loss is something that must be salvaged, as embodied in the tottering US state. After 11 September 2001, many artists swerved away from a laconic attitude to a contemporary form of committedness and *ressentiment*, but with one striking difference; artist protest didn't seem to have the same social charge and didn't seem to change much except for the already converted. It was instead absorbed, and encouraged, by curators and institutions. This is where the concept of fashion kicks in, for in fashion meaning and critique occur from within the semantic and functional ambit of the commodity. Art is equally embedded within a complex set of economic and institutional strata in which the determinants of what is desirable cannot be isolated to artist, dealer or curator. This may sound a little bleak, but as we have indicated earlier, it needn't, and by the end of the book this will hopefully be clearer. There are two fields of fashionable art to be discussed: the present, the subject of this chapter, and the historical trends of dominance and imperatives of style, the subject of the next.

It is a mistake to perpetuate the charges of earlier critics and to say that art's embeddedness within the institutionalized system of itself – the art market, galleries, museums, festivals – is symptomatic of a loss of nerve or faith on the part of artists

and the art establishment. It is not as if art craves a spiritual leader to tell it to awaken from its stupor. It is more symptomatic of what Slavoj Žižek calls a post-ideological age that such exhortations have become permanently tainted by the fact that 'awakening' is more associated with Nazi hymns such as *Deutschland erwache*. We might also go further to say that no term or phrase is innocent: authenticity has a cynical taint after Theodor Adorno's broadside against existentialism and his critique of 'the jargon of authenticity'; purity is associated with mineral water; 'integrity' is a word that has become all but meaningless by overuse by politicians and so on. In other words, there is no outside in the way that the avant-garde was beyond the pack. The driver of this is mass culture.

Consider this statement by Fredric Jameson from his essay 'Postmodernism and Consumer Society' that postmodernism is characterized by

> the erosion of the older distinction between high culture and so-called mass or popular culture. This is perhaps the most distressing development of all from the academic standpoint, which has traditionally had a vested interest in preserving a realm of high, or elite culture against the surrounding environment of philistinism, of schlock, and kitsch, of TV series and *Reader's Digest* culture, and in transmitting difficult and complex skills of reading, listening and seeing to its initiates. But many of the newer postmodernisms have been fascinated precisely by that whole landscape of advertising and motels, of the Las Vegas strip, of the Late Show and B-grade Hollywood film, of so-called paraliterature with its airport paperback categories of the gothic and the romance, the popular biography, the murder mystery and the science fiction or fantasy novel. They no longer 'quote' such 'texts' as a Joyce might have done, or a Mahler, they incorporate them, to the point where the line between high art and commercial forms seems increasingly difficult to draw.[1]

Such points are well made, especially since they are from some two decades ago. Joyce, Mahler and others such as Twain, or Daumier, Manet and Courbet, used popular culture to their own ends, just as composers from Dvorak to Bruch used folk music – but they were all artists who sat comfortably in their own domain. Bruch's first violin concerto is not folk music per se but folk music is incorporated within it. The next stage after postmodernism is portended by Jameson: the shift from postmodernism to fashionability in art occurs once these lines are no longer in contest. This does not mean that Velasquez or Proust have departed their station as great artists, it is rather the case that one can have an educated grasp of contemporary culture without knowing much about them. One of the effects of deconstruction was to say that everything from Joyce to a teabag was a text; one of the effects of the birth of cultural studies was to broaden contours of study such that an expert on punk rock had to be taken as seriously as an expert on Debussy. These changes have their problems because it potentially leaves the achievements of Sid Vicious and Jordi Savall on the same footing; and to argue against this is to look like a snob. Casting the difficulties of this predicament aside, the shattering of

[1]Fredric Jameson, 'Postmodernism and Consumer Society', in *The Cultural Turn: Selected Writings 1983–1998*, London: Verso 1998, 1–2.

the distinctions that Adorno drew has the advantage of admitting of more diverse kinds of experience into culture. It is also endemic of the extraordinary porosity of high and low culture. It is of no great consequence for us to go to an opera on one night and a rock concert the next, something that Adorno would have considered a horrible betrayal.

It is in this vein that Jeffrey Nealon has speculated on the condition that he calls 'post-postmodernism', which he defines as 'an intensification and mutation within postmodernism (which in turn was of course a historical mutation and intensification of certain tendencies within modernism)'.[2] Regarding the *positioning* of art and critique in the present age – for which we have used words such as 'embedded' and 'absorbed' – Nealon writes,

> Under postmodernism and post-postmodernism, the collapse of the economic and cultural that Adorno sees dimly on the horizon has decisively arrived (cue Baudrillard's *Simulations* – where reality isn't *becoming* indistinguishable from the movies; it *has become* indistinguishable) we arrive at that postmodern place where economic production is cultural production and vice versa. And I take that historical and theoretical axiom to be the (largely unmet and continuing) provocation of Jameson's work: if ideology critique depends on a cultural outside to the dominant economic logistics, where does cultural critique go now that there is no such outside, no dependable measuring stick to celebrate a work's resistance or to denounce its ideological complicity?[3]

As we have considered already in the introduction, this is a question that many artists, critics and thinkers outside of the domain of art are currently grappling with. But for the moment, we wish to stay with this concept of being inside as opposed to outside.

In his foundational analyses on the subject, Georg Simmel argues that fashion is one of the central aesthetic mobilizers of modern, industrial society. Fashion is for Simmel 'a particular and significant form of socialization, in which a common relationship is formed according to an externally located point'.[4] What is 'in fashion' at a particular time is less important than the social fact of there being fashion as such. This fashion is not an external quantity to modernism, as, say, the steam engine, but is rather internal to it: it is the way it organizes itself into groups but also, simultaneously, how individuals differentiate themselves according to gender, class, wealth, taste and whatever else. There are places where fashion is more pronounced and intense (he predictably cites Paris) but that does not mean that it does not prevail in other cities. Anticipating Walter Benjamin, Simmel articulates how fashion is a way that modernism expresses its newness.

Marx, also, some time before observed that fashion was one of the most visible forms of the machinery of capitalist reproduction. Fashion must therefore be seen,

[2]Jeffrey Nealon, *Post-Postmodernism, or, the Cultural Logic of Just-In-Time Capitalism*, Stanford: Stanford University Press, 2012, ix.

[3]Nealon, *Post-Postmodernism, or, the Cultural Logic of Just-in-Time Capitalism*, 176–7.

[4]Georg Simmel, 'Die Mode', in *Philosophische Kultur. Über das Abenteuere, dis Geschlechter und die Krise der Moderne* (1923), Berlin: Klaus Wagenbach Verlag, 1998, 43–4.

as its earlier theorists argued, as an attribute internal to modernism itself, both the material symptom *and* the immaterial presence of individual consumption and desire on the one hand, and mass market capital on the other. In short, just as there is no outside of global capitalism, there is no outside to fashion. One can be more or less fashionable, or can have a good or bad sense of style, but one cannot be immune or insulated from fashion. To put it differently again, fashion is the nebulous embodiment of the vicissitudes of the individual appetite and the assertion of a personal image of self, as much as it is the ways in which capitalism inspires consumers to consume anew.

Given these claims, especially with respect to the centrality of fashion as a modality of capitalism's function, it is surprising that fashion theory as it is now called has encountered difficulties in intellectual discourse, criticism and the academy. Perhaps this is on account of two prejudices: one is the close association of fashion with femininity and therefore with the tenacious clichés surrounding female emotional caprice and material frippery (and in this regard Simmel is very much of his time). Another is the division between fashion and art. It is a debate that originated between craft and art in the second half of the nineteenth century, at the very same time as the birth of fashion. Allied to its generic gendering, fashion was deemed beholden to the pressures of the market, to novelty, and was seen as the handmaiden of capitalism's perpetual renewal of commodity fetishism. This is to some extent correct, but it elides an additional point, namely that art since it left the age of patronage has been beholden to these very same forces. One of the readings of modernism is that art cultivated avenues of escape and release from the bind to money and material desire; from Dada to Fluxus, art could be raw, dirty and base to serve ideas and instincts, to serve a higher cause than that in which politics and theology were muddily combined.

But as the last two to three decades have shown, the works of Duchamp and Beuys participate robustly in the art market. This is because of their historical relevance – in short their value as cultural signs. In 1967, Roland Barthes wrote his doctoral dissertation on what he called 'The Fashion System'. Here he makes the important delineation between clothing and fashion. Breathing new life into theorists such as Simmel and Veblen, Barthes explained that fashion is what he calls 'represented clothing', that is, clothing that is imbued with greater or lesser connotations external to its implicit function.[5] In our present age, clothing is always a statement: it can be one related to class, to effort or even to how quickly one has had to leave the house – one is always inhabiting fashion.

Unlike art, however, the signifying systems germane to fashion – from a Hepburnesque long black dress to a Brando jacket – were less prone to ideology, although they were subject to social pressures. Both art and fashion are related to aspiration, except art's aspirations were a lot higher and more abstract than fashion. This has changed considerably. For if postmodernity marked the weakening of faith in this aspiration, our contemporary ('post-postmodern') age marks the dissolution of this faith. The historicist turn of postmodernity and after means that, like fashion, styles and approaches are integers to an artist's practice. There is no seditious or radical

[5]Barthes, Roland, *The Fashion System*, University of California Press, 1983, 8.

outside, although there are more fashionable approaches as instigated by curators. An artist is never an artist: he or she is a white male painter from Chicago as opposed to a black lesbian performance artist from Niger. How one is curated and deployed is at the behest of what is most interesting at the time, most fashionable.

Again the best analogy of the state of contemporary art comes from fashion theory. To cite Simmel again, artists are *within* a style, approach and cultural delineation while announcing something special to them; they are simultaneously generic and *sui generis*. In a significant book on fashion theorists, Michael Carter comments on Simmel's examination of certain fashion types such as the bohemian and the dandy:

> The 'dandy' and the 'bohemian', in fact what has become known as cultural sub-groups, can be differentiated by specifying the precise ways, and amounts, in which opposite tendencies are brought together. For instance the 'dandy' achieves an increase in the degree of individual differentiation by intensifying the rules of dress that are the norm within the group while the 'bohemian' may attempt differentiation by violating such rules. *But the violation of these rules of appearance is not singular because the 'violators' imitate one another.* This is borne out by the ease with which it is possible to discriminate between the dress of an eccentric and the styles of a bohemian.[6] [emphasis ours]

Yet in art there is no equivalent to the eccentric. The possible exception is 'Outsider Art', an extremely fashionable tendency that has emerged as prominent cultural currency since the 1990s as a reflex to the conditions we map out, and as the tactile, intuitive extreme to digital art – which we will examine more closely in another chapter.

[6]Michael Carter, *Fashion Classics from Carlyle to Barthes*, Oxford and New York: Berg, 2003, 67.

2 THE ARTIST AS IMPRESARIO, THE ARTIST AS BRAND: FROM BAUDELAIRE TO BARNEY

So much of the world is advertising, and because of that, individuals feel they have to present themselves as a package.

—JEFF KOONS

In societies without art, those once designated as 'primitive', the corollary to the artist was the shaman. He was the gatekeeper of signs and symbols that connected the material and spirit worlds. The ancient Greeks did not have a word for artist, the closest word being *poetes* whose meaning tipped more towards making and creating. There was a certain magic invested in great skill. When such skill was allied to empathy and insight, this was better still, as the 'poet' was one who could breathe life into matter – hence the story of Pygmalion. Artists with such powers understandably inspired awe, since the ability to give life to form, that is to give it compelling force, was designated as the closest that humans could come to divine power. And it is the ability to create something that is entirely unexpected and hitherto unthought of that continues to be a highly prized quality in all societies. Certainly this ability is not limited to art, as it is to be found in all disciplines, but when one turns to a style such as Cubism for instance, or masterpieces such as Michelangelo's *Last Judgment*, we are seized by something entirely unexpected yet somehow logical, albeit after the fact. But artistic fame as it began to burgeon in the Renaissance was not won from talent alone; it was always courted by wealth and influence. Commissions for large work were at the behest of patrons. Some artists outside this circuit have survived in memory such as Caravaggio, but that is also in part due to his colourful life. Hence when art comes in contact with money, there is an ever-muddier line between being the artist and playing the artist, of making and offering the promise of what could be made. We might say that Michelangelo, Raphael or Rubens had celebrity status but it is a value that does not adequately translate to the celebrity artist or 'cultural producer' in the age of mass media and global commodity markets. This has to do with the manner in

which the art market has internalized the broader market, and the way in which the market unforgivingly insists on a reciprocal relation between the artist-as-celebrity and the art object.

Picasso was perhaps the harbinger of this, then superseded by Duchamp. This shift became noticeable when Picasso indignantly remarked of his rival that he had produced almost nothing yet Duchamp's influence was beginning to outstrip his own. But the artist as readymade came to full fruition with Warhol, for whom celebrity, its virtues, attributes, offshoots and casualties, was the epicentre of his project. More than Picasso, Matisse or Duchamp, Warhol himself was his project; the artist qua artist, the artist as his own embodied readymade. Warhol was unusual, perhaps unique to his time, which, we can now say retrospectively, makes him and his art a fascinating and apposite step into high capitalism. While back then it was still the exception, it is now more the rule, albeit not as staged, or as camp, or as flamboyant. But this dilution makes the persona of the contemporary artist a complex affair that many artists themselves are not always aware, or in control, of. Just as the neighbourhoods to be gentrified are those where the artists and bohemians once lived, so how artists act and what they wear are seen as indicators of the now or of what is to come. From the twentieth century onwards, 'to be' an artist was far different from being a doctor or an electrician: it was to enact a special quality that had privileged purchase over perception and creation. It is in this persona that fashion, art and fashionability intricately, and agonistically, conjoin.

Pre-modernism

The first significant marker of the self-marketing of the artist is the sixteenth-century sculptor and goldsmith Benvenuto Cellini whose *Vita* [*Life*] is an essay in self-aggrandizement, a litany of tall tales in a tone full of bombast and brio. Written between 1558 and 1566, its purpose was not self-reflection or what later Baudelaire would say, *mon coeur mise à nu* [my heart laid bare], or self-immolation, but to generate an auratic power over a career that was far from as glorious as that of Michelangelo or Giotto. But the importance of this document is that Cellini saw it worthwhile to add spice to the meaning and value of this work through a narrative, and it was indicative of his time that there was an audience willing to bring the two factors together. Cellini was ignored by his contemporary Vasari, whose *Lives of the Most Excellent Italian Painters, Sculptors and Architects from Cimabue to Our Times* was first published in 1550, which added extra pique to his determination to solder his mark.

It was not uncommon for the men of the late Renaissance to write their memoirs, but these were customarily statesmen or nobles for whom such a task served as a vindication of deeds and reminder for posterity. Cellini's work is remarkable for the way it attempts to bring putative genius and a picaresque life into reciprocity. Cellini pointedly states at the beginning of his book that men who believe they have achieved something special 'or something that may truly resemble those things of special merit, should, if they are truthful and good people, write in their own hand

the story of their lives'.[1] Given Cellini's mastery of hyperbole, the exhortation to truth is noteworthy, and telling. It is his evident bombast that distances him from earlier masterpieces of the confessional such as those of St Augustine, or his French contemporary, Michel de Montaigne, who went to great lengths to emphasize the inconstancies and ambiguities of the human spirit. On the contrary, Cellini's is the closest thing to a marketing campaign for an artist that his era had. There would be no comparable example for several hundred years to come.

But it was in the shift of patronage from the nobility to the bourgeoisie that occurred gradually from the end of the eighteenth century to the end of the next that palpably altered what artists did, what they depicted and how they were seen. The better, or more graphic, example of this change is in music as opposed to art, because unlike art, which was still at a much higher behest of state-controlled institutions such as the Salon or the Royal Academy, musicians were more largely dependent on who attended their concerts, not only for the money from ticket subscriptions but also as markers of their popularity. Thus, the virtuoso musician who emerged in the early nineteenth century was not a freak of social evolution but the product of market forces.

The artist who stood on the threshold of this change from patronage to subscription was Beethoven. He straddled the period of musicians and artists serving exclusive tastes to those needing to appeal to the many. The approval given to musicians as a result of this was far less arbitrary than from a patron, but it required nurturing the public, in a nascent form of what we would call marketing and advertising today. The musical virtuoso, and ultimately the artist or poet, had to play out, or better, inhabit a constructed typology that ensured that (well-nigh exclusively) his slight difference from the rest of society could never be in doubt. More than Paganini, it was the Hungarian Franz Liszt who is credited with shaping the idea of the modern virtuoso. Liszt invented the solo piano recital but also the need to wear the hair long and to affect the air of diabolical force. (Paganini himself was rumoured to have sold his soul to the devil in exchange for his genius.) It is Liszt who gave rise to countless epigones, for he and peers like Berlioz became the example of a certain kind of artistic embodiment without which good, exciting, incisive art was barely possible.

Before Liszt, it was Beethoven who was the most instrumental in the transition from the composer as court functionary to one in possession of a special power of creation. Beethoven placed himself at the centre of public taste and public opinion, understanding that artists had the power to shape both. While it was also true that musical celebrity was beginning to emerge at the end of the eighteenth century, with the aristocrats as gatekeepers, Beethoven was highly sensitive of the need for high-ranking backers. When he moved into the residence of Prince Lichnowsky in 1792, he was granted extra approval through his position and made good use of it through seeking out the instruction of Haydn, and other composers renowned in the time such as Albrechtsberger and Schenk. These sources of

[1]Benvenuto Cellini, *My Life*, trans. Julia Conaway Bondanella, ed. Peter Bondanella, Oxford: Oxford University Press, 2002, 5.

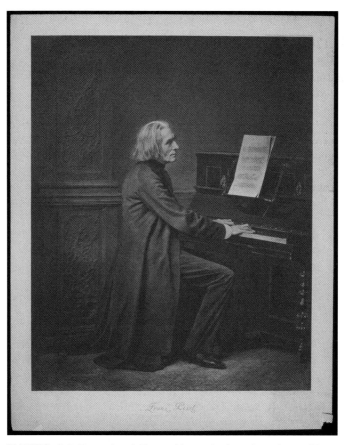

FIGURE 2.1 Portrait of Franz Liszt playing the piano. Harry Beard collection, Victoria and Albert Museum.

ratification allowed him a greater space to manoeuvre and to experiment. What is worth mentioning now is the extent to which these sources of approval and currency are applicable to art dealers, who have a branding quality on the artists they represent. It was one of Beethoven's major innovations to introduce the idea of artistic unity and expressive creation to a musical work. His *Pathétique* sonata (1800) is an example of this. But it was also the very sense of purveying pathos and the tenor of the man himself – turbulent and uncompromising – that gave his works when he performed them their special fervour. That Beethoven was a genius is undisputed, but he was also deeply instrumental to the way that genius became mythologized in modern life, and made a category unto its own. What is most crucial to emphasize here is that with genius comes the relativity of value. For paradoxically, the artist-genius is unique and untouchable, yet entirely at the behest of his or her audience. With the demise of genius somewhere during the 1970s, we have celebrity.

Dandies and the artist as the embodied work of art

In the mid-nineteenth century, typified in the figure of the dandy, the artist is a self-conscious player within the capitalist spectacle. With studied aloofness, the dandy is the epitome of artistic detachment and subjective engagement. The dandy, as it was often noted, was at root impossible to define, and in this regard he (there were female dandies but they were the exception rather than the rule) was able to enact the unaccountable wellspring of artistic creation, irrespective of whether they produced art or not. The dandy was the carrier of the air of artfulness; he was the embodiment of the artistic self without the encumbrance of the artistic product.

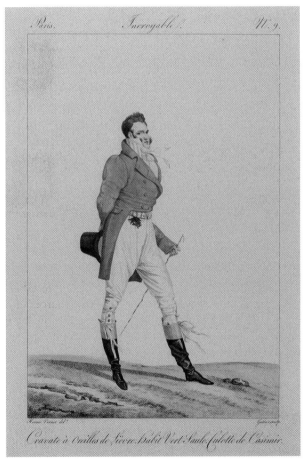

FIGURE 2.2 Incroyable et Merveilleuse, Horace Vernet, born 1789 – died 1863. Victoria and Albert Museum.

But it was also the dandy's – and by extension the artist's and the bohemian's – claim to the intangible that makes him a highly fluid concept, since the dandy and bohemian encapsulate an economic subclass but also a cultural group which drew on fashion and art with equal measure. The dandy, as he later came to be defined by Baudelaire and Barbey d'Aurevilly (the latter after Beau Brummell), was an ironically phlegmatic spirit, but for that, highly desirable. The dandy's very receptivity yet indifference to the world was what made him super-fashionable. As Baudelaire puts it, 'the word *dandy* implies a quintessence of character and a subtle intelligence of every moral mechanism of the world; but from another angle, the dandy aspires to be insensible'.[2] The discourses of gender and fashion with respect to performance are especially important here. For the dandy was the personification of the artistic persona, a performance of self, or to put it in other words, introjected artistic creation. Dandyism is 'an institution beyond that of laws'.[3] While Baudelaire does not make the equation of artist and dandy, the implication is always there, given that the father of all dandies was Beau Brummell, who in many respects was also the single biggest influence on modern male dress. It is of no little significance that Brummell was not of noble origins nor was he known for anything except himself. Unlike a king whose airs and whose courtly pomp are a proxy for state authority, Brummell's authority was self-ordained and self-invented. As his own invention, Brummell is an important marker in the making of the modern subject. His achievement was to be *sui generis*; he was performer of himself, proof of Nietzsche's dictum that the greatest artist is one who no longer feels the need to produce, although Brummell's ignominious demise tends to tarnish the more Brahminic gloss of Nietzsche's conception. Baudelaire stipulates that the dandy is outside the boundaries of utility. This marries well with the mythology of the singular artwork whose specialness as a commodity is simultaneously measured according to the extent to which it is outside the normal chain of commodities.

The dandy is the subjective and internalized counterpart to the spectacle that characterizes modernity. As various studies have shown,[4] much of the painting that grew out of the middle of the nineteenth century had a strong affinity with the nature of being seen within the social realm, with the public persona and the different trajectories of observation and judgement within the modern metropolis. The idea of the *flâneur*, which derives largely from Baudelaire, is much cited and is key to understanding modernity and the nature of specularity. It is not only in the *flâneur*, but in the bohemian and the artist at large, that the spectacle becomes a site of conflict and struggle. To quote T.J. Clark from his classic book on the art of Manet's time, 'The notion of spectacle … was designed first and foremost as a weapon of combat'.[5] The art of modernity – which we acknowledge is a term battling with its own specificity – is situated within what Clark, after Marx, calls 'the relations of production' of 'tourism,

[2]Charles Baudelaire, 'Le Peintre de la vie moderne', in Y.-G. Dantec (ed.), *Œuvres complètes*, Paris: Pléiade, 1954, 889.
[3]Baudelaire, *Œuvres complètes*, 906.
[4]Most notably see T. J. Clark, *The Painting of Modern Life. Paris in the Art of Manet and His Followers*, London: Thames & Hudson, 1984, rev. ed. 1999.
[5]Clark, *The Painting of Modern Life: Paris in the Art of Manet and His Followers*, 10.

recreation, fashion and display'.[6] Thus for Clark artistic modernity, but perhaps the nature of modern life in general, only became such when art inserted itself into the specular nature of city life, while also posing as objectively outside it. Thus again we return to the paradox that Baudelaire traces with regard to the dandy. The stakes of modernity were that to be a part of it, one also had to be removed from it, at least in name, hence the dandy's aloofness. It is instructive to note that in the rather large literature on the dandy,[7] his/her relationship to the work of art is commonly mentioned but has not been the singular focus of discussion. That is, the extent to which the outward sartorial style of the dandy and his/her persona has bearing on the art itself is under-theorized. This is largely because fashion, and by extension the everyday detritus of life, has an instable relationship with the art object. What is moot in the histories of art in the twentieth century at least is the extent to which fashion and fashionability have an integral role. To be modern is to be detached and this must be confirmed in how the body itself transacts with its world.

The artist-hero

Like all clichés, the expression 'he died for his art' has an element of truthfulness. But the truth lies less in what it means for the artist than what it means for those who say it. The greatest living embodiment of this in popular memory is van Gogh, with Gauguin and perhaps Modigliani both coming a close second. Van Gogh would probably not have died for his art had his mental illness not been so acute, Gauguin neither but for his syphilis, although Modigliani had it coming. Modigliani is also fascinating because he produced so little and was arrestingly handsome; his Italian good looks were eroded by the most lethal of cheapest alcoholic concoctions shared in large quantities by fellow swillers Maurice Utrillo and Chaim Soutine. Indeed to look at the paintings of any of these three is to call up colourful biographical associations: Utrillo the alcoholic *ingénue* who took to paint with no training and only the insight he and his drink afforded; Soutine the Polish eccentric who lived in his studio with rotting meat so that his visceral reaction could be translated into paint; and Modigliani the mercurial tubercular hero who lived a life of the senses.

Dying at the young age of thirty-five, Modigliani lived on as a very conspicuous ghost in the streets of Montparnasse that he used to frequent. To this day people visit *Les Deux Magots* because of Sartre and de Beauvoir, and the *Dôme* because Derain and Vlaminck were habitués, and *La Coupole* because Hemingway went there and because of Cartier-Bresson's famous photograph of Samuel Beckett. But it was perhaps Modigliani who instigated this kind of tourism in earnest. In the words of one of his biographers June Rose:

At a time when it was the fashion to represent painters as over-sexed, alcoholic, brilliant, immoral and full of dangerous fascination, writers and restauranteurs of

[6]Clark, *The Painting of Modern Life: Paris in the Art of Manet and His Followers*, 10.
[7]For a comprehensive overview of the dandy and its related literature see Adam Geczy and Vicki Karaminas, 'Gay Style: From Macaronis to Metrosexuals', in *Queer Style*, New York and London: Berg/Bloomsbury, 2013.

the Quarter sensed the need to preserve the myth and the glamour of Modigliani. They grew rich on his false reputation and Montparnasse developed into a leading European tourist attraction, with nightspots offering sophisticated vice, far beyond the means of the poverty-stricken artists of the First World War.[8]

The most famous artist of all of these times, Picasso, shares a sizeable chapter in this mythology. Anyone who has some familiarity with art of the twentieth century will have seen photographs of Picasso, a great many of which are far from incidental, but instead rather staged. Thousands of the artist exist. There is an early photograph in which the artist posed shirtless (something to which he would become accustomed) as a toreador-like figure.

Artist as brand and go-between

An accompanying attribute of postmodernism and contemporary art's diffusion of styles, and its self-conscious historicizing, is that the edifice of the artist as the awe-inspiring font of creation was dismantled. The postmodern critique of the artist is that he or she is a nexus of forces, desires and influences; the artist is a respondent of a certain need, a receptor of contemporary expectations and influences. This largely suits our purposes except for two main concerns. The first is that such a schema does not account for the creation of good art that cannot be programmed, no less than the shaping of a persuasive (and beautiful) scientific hypothesis. The second is that the myth of genius persists like never before, except that the word 'genius' has been replaced with 'celebrity'.

In his book on the contemporary art market, Canadian economist Don Thompson refers to 'brand artists', 'brand galleries' and 'museum brands'. Brand artists and brand galleries have a reciprocal relation. (Note that the common idiom for the containment of artists in a gallery is a 'stable', suggesting that artists are like an assembly of prize horses for a race or display.) A brand gallery is so by virtue of the number of brand artists it has, while an artist can potentially become a brand artist with the auspicing of a brand gallery. Like Warhol, living artists such as Hirst and Koons have become respected brands where anything they do will command high prices. Making the analogy with a fashion house, Thompson explains that

> The motivation that drives the consumer to bid at a branded auction house, or to purchase from a branded dealer, or to prefer art that has been certified by having a show at a branded museum, is the same motivation that drives the purchase of other luxury consumer goods. Women purchase a Louis Vuitton handbag for all the things it may say about them. The handbag is easily recognized by others, distinguished by its brown colour, leather trim, and snowflake design. A woman uncertain as to whether her friends will recognize this symbolism can choose a bag with 'Louis Vuitton' spelled out in block capital letters. Men buy an Audemars

[8]June Rose, *Modigliani: The Pure Bohemian*, London: Constable, 1990, 214.

Piguet watch with its four inset dials and lizard-skin band even though their friends may not recognize the brand name, and will not ask. But experience and intuition tells them that it is an expensive brand, and they see the wearer as a person of wealth and independent taste. The same message is delivered by a Warhol silkscreen on the wall or a Brancusi sculpture in the entrance hall.[9]

To maintain their brand status, artists must navigate the landscape of taste and value, a position tightly analogous to fashion, since the artist must do something different but not so different that he or she alienates the audience from what it expects. So a Hirst must look like a Hirst otherwise its brand effect is diminished, lest it be seen as non-representative of the artist. Other artists known for their variety like Bruce Nauman must maintain the impression of variety, but the work nonetheless needs to have the 'Nauman effect'. In his films of the 1980s, Woody Allen alienated his fans who expected comedy by producing a string of slow, poetic, melancholy Fellini and Bergman-inspired films such as *September* (1987) and *Another Woman* (1988). For the artist this could amount to a renaissance but it would most likely be suicide.

The British critic Adrian Searle writing about Gary Hume discusses the way artists are constrained by the single idea which they are expected to exploit such that the idea governs them: 'If you change track now, will people think you're ambulance-chasing? Keep your head down, stay low. You're a character trapped by a chance remark, stuck inside an old routine.'[10] We might recall Duchamp's comment that he did not produce much because he did not want to repeat himself. The artists within a gallery's stable, particularly prominent ones, form part of a composite of different representations, no different from the artists on a record label. Galleries promote artists like any agent or corporation, or like a modelling agency that has a group of workers to suit anyone's taste.

We might survey the listing of artists at Mary Boone gallery at the time of writing this book. First, there is a generous spread of generations from artists born after 1970 to before 1940, assuring that there is the right mix of newness and track record. While most of the artists hail from the United States, there is at least one (Liu Xiaodong) born in China who continues to practise there. There is a European contingent (Clemente, Beuys), a nod to the British scene (Marc Quinn) and some 1980s classics (Kruger, Salle, Bleckner). The list of artists in the London Gallery Haunch of Venison yields similar results. There are older 'historical' artists such as Richard Long and John Wesselman, even a dead one (Ed Kienholz), a Japanese artist (Gajin Fujita), artists born in India (Rina Banerjee, Jitish Kallat) and Argentina (León Ferrari). Of course there is no exact formula for this, but a survey of galleries shows a striking regard for a certain kind of balance, in which, it must be said, gender balance is not a major consideration. Women continue to be chronically under-represented in major commercial galleries.

For artists who have achieved an appropriate level of acclaim and monetary success, it is customary and indeed necessary to employ a team of assistants to

[9]Don Thompson, *The $12 Million Stuffed Shark: The Curious Economics of Contemporary Art*, New York: Palgrave Macmillan, 2008, 13.
[10]Adrian Searle, 'Shut That Door', *Freize* 11, Summer 1993, 49, cit. Julian Stallabrass, *High Art Lite*, 183.

maintain supply to the art market. Successful artists (the term 'successful' is used here in the most colloquial sense) will have galleries around the world, with one or two flagship galleries in London and New York. Exhibitions are every two to three years where he or she will be expected to tread the balance of resemblance to previous work and of newness. (Note how Marc Quinn produces a new *Self* (a frozen death mask made of his own blood) every five years, and Hirst has had to remake his shark work *The Physical Impossibility of Death in the Mind of Someone Living* and rebottled the 1991 idea in 2009 with a hammerhead shark entitled *Fear of Flying*.) Despite the tenacious mythology surrounding the artist's own individual mark on the work of art, the artist's assistant has a long and lively history in Western art. Renaissance and Baroque artists had assistants who were indentured apprentices and students; it was not uncommon for contracts to the master-artist to stipulate that he alone paint, say faces and hands, while it fell to the assistants to paint surrounding scenery and so on. For an artist like Rubens, who was also as busy as a diplomat, it would not have otherwise been possible to paint in such quantity (some 1,000 paintings).

A watershed in this process in recent times occurred with Warhol and Donald Judd. Partly as a response to the conflation of tactility and truthfulness that surrounded Abstract Expressionism, as a Minimalist sculptor and designer Donald Judd cultivated a distance from the manufacture of the object, to the point of not touching the object at all. Judd was therefore more a go-between and impresario. More famous is Andy Warhol, whose studio was called The Factory, which as the name explicitly signals, was a place where artworks were manufactured. The Factory was also something of social experiment: it was a place where other artists, musicians, film-makers, models, art-groupies and wannabes came together, with Warhol presiding over them. On a more complex and elaborate scale, Jeff Koons runs a studio not unlike how a successful designer would oversee his label where dozens if not hundreds of designers at various levels of experience and authority have a hand in design and execution. Having made his fortune earlier on the stock market, Koons' studio is very much a business: it is just that the business happens to be art.

Gregor Muir, a writer from the same generation as Damien Hirst, describes in great detail the ascendance of the artist. Hirst's earliest works had nothing too shocking about them (such as his wall dots); however, it was as much Hirst's personality as his talent that made him what he was. Muir describes Hirst as an energetic, restless character always on the make, with a radar for opportunity. He also makes a rather elaborate assertion about the associations around his image drawn from recent popular culture:

According to the nominative imperative whereby people's names predetermine their careers, any mention of the word Damien is readily associated with the devil himself, and the youthful antichrist in *The Omen*. Another reference recalled the kind of image that Hirst may have wished to project during his formative years: in particular in *Silence of the Lambs*, Jodie Foster enters a serial killer's lair filled with caged butterflies and medical supplies, an interior of how one might imagine Hirst's studio to be.[11]

[11]Gregor Muir, *Lucky Kunst: The Rise and Fall of Young British Art*, London: Aurum Press, 2009, 41.

It does not matter too much how long a bow Muir is drawing: the images he conjures do nonetheless serve to illustrate the extent to which artists have the power to gather references from the mythologies shaped by mass media, once they have reached a certain level of notoriety.

With the work that is still his best known, *The Impossibility of Death in the Mind of Someone Living*, Hirst reached the status of celebrity. An enormous amount of literature has been devoted to this work, and to his peers such as Rachel Whiteread, Tracey Emin and Sarah Lucas. Looking back now over two decades, what is striking is the extent to which opinion about Hirst and his yBa colleagues is critically split between rapture and indignation. In one of the less palatable paeans Gordon Burn comments that 'It is one of Hirst's strengths, both in the cool medium of his work and the hot medium of his person, that he is always pushed to full disclosure.'[12] Burn also supplies a literary patchwork of quotations that draws from an eminent pantheon of writers including Don DeLillo, V.S. Naipaul and even Marcel Proust.[13] In the smallish essay in Hirst's large tome on himself, *I want to spend the rest of my life everywhere...,*[14] Burn invokes the seventeenth-century aphorist La Rochefoucauld and the great Austrian philosopher Ludwig Wittgenstein. One can only think what Marcel Proust would have thought, but celebrity is above those kinds of scruples.

One of Hirst's main haunts was the Groucho Club, a melting pot for artists, film-makers and media personalities. It was a place where people not only socialized but made contacts and scored work. In Burn's words, it was

> the kind of place, that is to say, where the Warhol dictum, 'Making money is art and working is art and good business is the best art' is likely to be nodded at sagely than chuckled at wryly.... The least likely place, in other words, to risk rubbing up against any serious art talk or any sort of serious activity. The kind of place, therefore, that Damien nominated as the perfect arena for the spectacle of his fame, and adopted as his second home (with a fiery spin painting over the sofa to prove it).[15]

The self-congratulatory swagger of this writing should not distract from its accuracy. Hirst had courted the prosperous minority of the Thatcher era. It is worth remembering that in the final incarnation of The Factory, after the murder attempt by Valerie Solanas, Warhol eschewed the hipsters, beatniks and beautiful unemployed in favour of slick, suited uptown types. It was as if Hirst took up where Warhol had left off, but in London.

When in 2007 Hirst produced *For the Love of God* his connection to a different hemisphere of art and that of corporatized big business was decisive. The work is a platinum cast of a skull encrusted with 8,601 diamonds, with a pink, pear-shaped diamond on the forehead. It is said to have cost £14 million to produce and was

[12]Gordon Burn, Damien Hirst, *Sex & Violence, Death & Silence*, London: Faber and Faber, 2009, 317.

[13]Burn, *Sex & Violence, Death & Silence*, 318–21.

[14]Damien Hirst, *I Want to Spend the Rest of My Life Everywhere, with Everyone, One to One, Always Forever Now*, New York: Monacelli Press, 1997.

[15]Gordon Burn, 'Is Mr Death In?', in Damien Hirst, *I want to...*, 11.

placed on sale at Scott Jopling's White Cube Gallery for £50 million. The rest of the story regarding the sale is relatively obscure since the buyers were an anonymous consortium. In what might be called legal or ersatz insider trading, Hirst himself was part of the consortium that purchased the work. To add to the aura of glamour, it is rumoured that the pop singer George Michael showed interest in the purchase. *For the Love of God*, whose title apparently derives from an exclamation from Hirst's mother, 'for the love of god, what are you going to do next', travelled to a handful of A-list venues and museums such as the Tate Modern and the town hall in Florence. In what was little more than elaborate window dressing, when it was displayed in the Rijksmuseum, Hirst was invited to curate works to complement it. The director Wim Pijbes defended the move because he thought the 'controversy' of the bedizened skull was bound to attract visitors.[16]

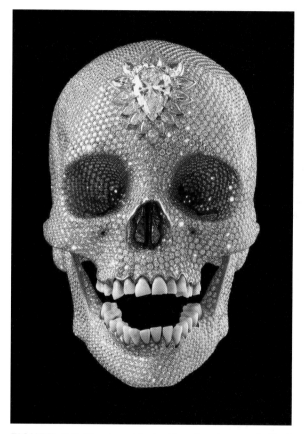

FIGURE 2.3 Damien Hirst, *For the Love of God*.
Prudence Cuming Associates Ltd via Getty Images.

[16]Wim Pijbes in conversation, in R.J Preece, 'Damien Hirst's diamond skull at the Rijksmuseum: *Behind the scenes* (2008)': http://www.artdesigncafe.com/damien-hirstrijksmuseum-diamond-skull-2008, last accessed 7 January 2015.

For the Love of God is certainly another historical benchmark for art, and of the kind that an artist such as Hirst is primed to set since it exposes the arbitrariness, and the fragility, of the symbolic value of art against the relative value of high-level commodities such as gold, platinum and gemstones. Ironically one of the largest prices paid for a work of art, $135 million, by Ronald Lauder, the son of the cosmetics magnate Estée Lauder, is for Gustav Klimt's portrait of Adele Bloch-Bauer, a huge canvas dominated by gold leaf. Hirst may have liked to have exceeded this record, although he now owns the record for the highest price for a living artist. What Hirst's work emphasizes beyond all measure is the disparity between the fluctuating, abstract value of art against the market value of commodities. It is a difference that is far less pronounced with a standard painting made from a wood frame, cotton canvas and pigment since the prices of these are modest in comparison to what has been made from them. But Hirst's work is as much a ploy since it is pre-eminently crafted and works with skulls are a dime a dozen. So from this we may deduce that the work's conceptual worth lies in the way the beauty we perceive in objects like gems trips into the domain of the value we ascribe to a work of art – and then the capacity of the market to abide by this. In short, if this work is about anything, it is about the market itself and about the ability of Hirst as brand to navigate it. In reaction to Hirst's diamond skull, Germaine Greer commented in the *Guardian*: 'Damien Hirst is a brand, because the art form of the 21st century is marketing. To develop so strong a brand on so conspicuously threadbare a rationale is hugely creative – revolutionary even.'[17]

For the Love of God is what in the 1980s would be called 'endgame' work, but in this case it is the endgame for the artist whose next ventures will always be seen against the audacity and magnitude of this work. In the interim the artist is in a permanent holding pattern, with his own shop in Marylebone near the famous Wallace collection that sells limited editions and T-shirts with butterfly prints, while his studio assistants studiously crank out circular spatter rotor paintings. The nature of these objects as fashionable high-end commodities is somewhat insulated by the discourses of Minimalist art and of the ironic 1980s, in which the artist was a purveyor of banality and wry detachment. Notwithstanding, they are no different from a one-off Cavalli dress, only this one goes above your couch.

The end of the critic, the rise of the agent-dealer

The kind of eulogizing that we saw critics such as Gordon Burn lavish on Hirst above is nothing new since art criticism began in the eighteenth century. One only need remember Diderot's paroxysms of appreciation for Chardin and Greuze. But the last two decades have seen a marked decline in the worth of the critic's word except to be voice of legitimation in the shadow of the artist and the dealer. Arthur C. Danto,

[17]Germaine Greer, 'Note to Robert Hughes: Bob, dear, Damien Hirst is just one of many artists you don't get'. London: *The Guardian*, 22 September 2008.

the art theorist and art critic for *The Nation*, once pointed out that most art critics are not remembered, and the ones who have been (from Gautier and Zola to Ashbery and Updike), have been because of other types of writing. It is now common for critics to play into the hands of dealers who regularly commission them to write catalogue essays for an artist who is having a commercial exhibition. In this way, a critic with a position in a name or 'brand' newspaper is enlisted in advance to give extra buttress to the artist. Since these are commissioned and often handsomely paid for, the words critic and critical have to be used in the liberalist sense. Here the critic has devolved into a lucid appreciator. The catalogue text is a decoy, or distraction, from the sole purpose of a commercial gallery, which is to sell the stock of their stable, since it suggests that the artwork is worthy of critical attention before it need be considered a commodity.

In October 2012 *The Observer* posted an article in which the distinguished critic and curator Dave Hickey mounted a broadside on the 'nasty, stupid' art world, in which rich collectors are 'in the hedge fund business, so they drop their windfall profits into art. It's just not serious. Art editors and critics – people like me – have become a courtier class. All we do is wander around the palace and advise very rich people. It's not worth my time.' For Hickey the art world has become radically debased, and has turned into a branch of tourism: 'If I go to London, everyone wants to talk about Damien Hirst. I'm just not interested in him. Never have been.'[18]

If critics have not been reduced to courtiers, groupies or lackeys, they have been rendered toothless. Since at least the 1990s, numerous commentators have remarked on the extent to which public opinion is not wavered by unfavourable critical responses. The cardinal example from the 1980s is Robert Hughes' relentless onslaught of Julian Schnabel that did nothing to dent the artist's reputation. On the contrary, it may have helped to cultivate his wayward image that is so useful to an artist's persona: that he is not like the rest of us. But it was also at this time that art and artist's profiles had begun to hit the lifestyles pages, in both newsprint and glossy magazines. Unlike the nineteenth and early twentieth centuries when artists' lifestyles were perceived as squalid, photographs and profiles of artists in their studios in issues of magazines like *Belle* have become *de rigueur*. This phenomenon naturally diversified the number of those writing about art, to the extent that art in newsprint is more about description and promotion than about underscoring some philosophical mandate. Or rather, the mandate has shifted from philosophy to marketing.

The artist as pure image: Matthew Barney

With the benefit of hindsight, one could say that the rise of Matthew Barney was inevitable. Barney was an athlete as well as a competent academic mind, a quarterback and a wrestler in high school before being recruited in 1985 for the Yale football team. In his university years he made extra money as a catalogue model. From the start, Barney was initiated into a world of privilege and glamour. It was the obverse of Hirst's

[18]Paul Gallagher and Edward Helmore, 'Doyen of American critics turns his back on 'nasty, stupid' world of modern art', *The Observer*, 28 October, 2012.

very meagre working class upbringing and the early days of the 'Freeze' art collective. (For in the United States the blue chip universities attracted dealers directly to their graduate exhibitions. 'Brand' academies such as Rhode Island School of Design, Yale and Columbia have such an influence over new collectors and dealers that one can say that the American professional system, to which art is but a small component, runs according to different tiers of educational facilities, as if one were dealing with one- to three-star Michelin restaurants.)

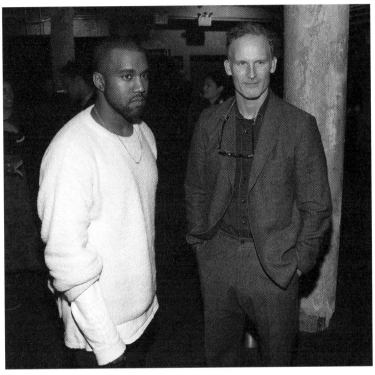

FIGURE 2.4 Kanye West and Matthew Barney attend the 'River of Fundament' world premiere at BAM Harvey Theater on 12 February 2014 in New York City. Photo by Theo Wargo/Getty Images.

Barney's career is also part of a long line of artists since Duchamp and Warhol who dressed up, including as themselves. With the benefit of hindsight we can speculate that dressing up is one of the best ways to make it in New York: from Duchamp's Rrose Sélavy and his staged photographs playing chess, to Warhol's many contrived personas and his famous wigs, to Cindy Sherman who has made an entire career of masquerade, to Jeff Koons who at the beginning of his career self-consciously styled himself as an outward product culminating in dreamy porn with his short-lived wife, Ilona Staller, better known by her stage name La Cicciolina. Barney, as he emerged from the debris of the fallen 1980s, became best known for

his dandified satyr, a sexually menacing figure with a goatish face and pointed ears wearing a white suit.

Barney established himself as a performance artist known for his athletic moves in gallery spaces. In the early 1990s, in a series of works under the rubric of *Drawing Restraint*, the artist created various intricate impediments for himself with industrial rubber, harnesses, industrial lubricant and a handful of materials that would have talismanic force for the artist much as felt and fat had for Joseph Beuys, another artist who did nothing to discourage his own cult of self. In number seven of the series, Barney is transformed into a satyr and the act of drawing under constrained conditions is transformed into a dyspeptic orgy that both delighted and disgusted the critics who saw it in 1993 in the Whitney Biennial.

Barney's most celebrated achievement is the *Cremaster Cycle*. Made over a period of eight years (1994–2002), it has been hailed as a masterpiece of its kind (although of what kind is not certain). Some see it as video art, while these works could also be seen in the manner of Surrealist film. These works defy description and take on the character of a highly fanciful dream. The artist is once again in an extravagant costume: a mysteriously camp, buff, phantom-like highlander with a large conical shape in a bloodied mouth. Certain 'in' figures make cameos, such as Richard Serra and the singer-actress-photographer Marti Domination who is in a strange interior arranging grapes. What differentiated these works from previous 'art' videos was their sumptuousness, their economies of scale, attention to detail and ultimately the expense lavished on them. To align them with art rather than mainstream film, while some of the series are sold commercially, the 'original' twenty editions were sold for $100,000 each. Later, single components of the series were attracting over five times that much (in 2007 *Cremaster 2* sold for a reported $571,000).[19]

Predictably the work has divided its audience, some seeing it as seminal to its era, others as self-indulgent twaddle. What is certain is that it did markedly shift art video into the realm of film such that the divide between the two has grown increasingly muddied. As with Hirst, there is now a welter of information available on the *Cremaster Cycle*, but we conclude this chapter with one observation that remains omitted from most of this literature. Around the same period that Barney was producing these works there began to develop in the fashion industry a new phenomenon now known as fashion film. Its pioneers are the fashion photographer Nick Knight as well as the film-maker Gerald Pugh who work through the production company 'Show Studio' in London.[20] In many respects they are the inheritors of Helmut Newton who has been claimed by much of the art fraternity but who actively managed to straddle both camps of art and commercial photography. The innovation of fashion film is that since it carries its own epithet it does not need to have any pretensions except to itself. Among its collaborators has been the Icelandic singer-actor Björk, who was also Barney's wife. And it is Lady Gaga who has harnessed this new sub-genre into the mainstream.

[19]Horowitz, Noah, *The Art of the Deal. Contemporary Art in a Global Financial Market*, Princeton and Oxford: Princeton University Press, 2011, 228.
[20]See showstudio.com

To see some of the fashion films is suddenly to understand the flamboyant, stylish, self-conscious sensuousness of Barney's project. By inserting himself into these works with their implausible excesses and conceits he has made himself internal to the very process of self-propagation and mass imaging. In *Cremaster* he is 'The Apprentice' and he does not talk. But we know it is the artist, the artist who has wilfully objectified himself into a space that elicits our desire, and ultimately our desire for him and his art. Early in his career he commented on a documentary about the supermodel Linda Evangelista: 'And she's talking. She's from somewhere in Canada. I can't believe it, hearing her speak. And I thought at that moment she lost all her … resonance, all her flexibility of character. That, I think, dissipates as soon as they open their mouths.'[21]

As opposed to the dandy who is all style and presence before the art, or the artist-hero whose presence is known for his rambunctious action, Barney heralds the artist for the new millennium; one who inhabits the picture frame just as he inhabits an outrageous persona that although it derives from him, also exceeds himself, since it is mutely at the service of the image, such that the genuine subjective self is radically compounded, becoming an imaginative product for its dissemination everywhere. It is curious to reflect on Lady Gaga's proclamation that she is a cyborg, which is of a piece with Barney's reduction of his body to a set of tensile trajectories or to alluringly grotesque walking sculptures. Between Matthew Barney and Lady Gaga there are only differences of degree rather than kind.

[21]Cit. Gordon Burn, 'Matthew Barney', *Sex & Violence, Death & Silence*, London: Faber and Faber, 2009, 216.

3 'LOOK AT ME I'M DIFFERENT!': IDENTITY ART AND THE EXPECTATIONS OF RACE

Today, when artistic identity has become a carapace almost as contrived and self-consciously projected to the outward world as a celebrity – remembering that 'being natural' is itself already a style – contemporary art also finds itself obsessed with cultural identity. While the previous chapter concerned itself exclusively (with the exception of Warhol) with straight white English-speaking males, it is both despite and because of this that the art world or worlds have become preoccupied with packaging race, gender and identity. Even if Koons, Hirst and Barney occupy the A-list of artistic production, the second tier of art production is an array of races and sexual non-conformities. Once detested, the 'Other' has become valuable tender in contemporary art.

The taste for 'balance' was already touched on in examples of artists represented in two big galleries. This is a tendency that runs deep in contemporary art yet its nature and meaning have, in the main, eluded comment for the simple reason that to discuss racial issues in enlightened 'Left' circles such as art is fraught. The scare quotes around 'Left' is an important component to this issue, for it concerns, once again, the now knotted notion of 'critique' as a modality in contemporary art. To use a neo-Kantian, Enlightenment formula, art is about freedom. Through its beauty, truth, audacity, inventiveness and courage, in one or another combination, art draws us into a space where we think we ought to be: as respite from the unwelcome world, or through the refreshing truth of showing us the unwelcome world, warts and all. In doing so, art engages in a critique that is predominately an ethics directed at forms of exposure, forms of revealing that are superior to the everyday appearances – what is seen and experienced in a conventional or conventionalized sense – of life. Art ushers us into the spaces of the quasi-religious 'something else' by giving us a taste of different modalities of perception, belief and understanding. Because art can be about

care and duty – and it can have these qualities at its most violent and offensive since these may be strategies for a better way of knowing things – art is associated with the political Left. It shares with the political Left a struggle of becoming directed at care and betterment, albeit that the strategies of art and politics need to be divergent: art demonstrates and offers a promise (depending on your philosophy), while politics must submit to a plausible course of action. Art's course of action is justified within the framework of the aesthetic.

But the 'Left' for our purposes needs the irony that the quotes infer, since art is in the main the purview of an elite, and ultimately the rich. The great collections of the United States, from Mellon to Morgan, were initiatives not only to restore an air of cultural grace to the dirtiness of industry; they were also a form of redemption. Art collecting has always been the rich person's safe passage to redemption, in which the safety is not that afforded by divine beneficence but by not losing money. If done correctly, art was an indemnifiable means of sanitizing one's image. What has already fallen from more recent memory is the famous sale of van Gogh's *Sunflowers* in March 1987 by the Yasuda Fire and Marine Insurance Company of Tokyo for the then record sum of $39.9 million. This was not a random exercise in interior decoration, or a whim on the part of an executive. One reason was sentimental, given that another similar version had been destroyed by fire in an air raid on Yokohama in 1945. The other was far more strategic. The painting was purchased eight months before the stock market crash in 1987. Japan's economy was booming; its massive trade surplus was the envy of other developed countries, even prompting derogatory justifications for their success to what in Western terms was considered an inhuman work ethic. Thus it was no coincidence that the company invested in the Western artist known for his humanity *par excellence*. The subliminal message that was sent out was that its new owners were not only fabulously rich but also had it within them to appreciate compassion and beauty. This sort of gesture only shows how the most innocent work of art can be used to collude with corporate power.[1]

In his essay 'Commitment', Adorno railed against the so-called committed art, the art at the service of ideology, and championed autonomous art, which was not beholden to the minutiae of life's travails.[2] While Adorno makes the very valid point that committed art serves a cause other than art, it would seem that autonomous art can also be made to serve a particular cause as well, but in a more insidious way than art in which politics is writ large. This is when it is dragooned into the service of national identity. The obvious example of this in recent memory is when the Nazis held up certain artists as epitomizing their artistic vision and the ideals of Germanness while execrating others they deemed degenerate. This turned out to be a failure in more ways than one. But a more acute example of such retrospective manipulation occurred in literature and philosophy, for example, Johann Gottlieb Fichte held up as describing a lineage to the Nazi cause for German supremacy in his *Address to the German People* (1807/8). But it is more acute because logical lines can

[1] See http://www.nytimes.com/1987/04/09/arts/sunflowers-buyer-japanese-insurer.html

[2] Theodor Adorno, 'Commitment', in *Aesthetics and Politics* (1977), New York and London: Verso, 1980, 1995.

be, if dubiously, drawn, while in art there are no verifiable points of reference, only rhetoric, suggestion and consensus. This is what allows Lucian Freud or Francis Bacon to be held up as a quintessentially English painter. But the nature of quintessence lies precisely within the rhetorical urgency placed in the word. The need to assert an idea of absolute essence (like unique an essence is either an essence or it isn't) hides a deeper instability. Žižek identifies this very well in a passage that is worth quoting at length:

> National identification is an exemplary case of how an external border is reflected into an internal limit. Of course, the first step towards the identity of the nation is defined through differences from other nations, via an external border: if I identify myself as an Englishman, I distinguish myself from the French, German, Scots, Irish, and so on. However, in the next stage, the question is raised of who among the English are 'the real English', the paradigm of Englishness; who are the Englishmen who correspond in full to the notion of English? Are they the remaining landed gentry? Factory workers? Bankers? Actually, in the political imagery of Thatcher's government, a revolution has taken place, with the shift in the centre of gravity of 'the real Englishness': it is no longer the landed gentry who preserve the old traditions, but self-made men from the lower strata who have 'made themselves' English. However the final answer is of course that *nobody* is fully English, that every empirical Englishman contains something 'non-English' – Englishness thus becomes an 'internal limit', an unattainable point which prevents empirical Englishmen from achieving full identity-with-themselves.[3]

But it is the power of art and mass media representation from advertising to television series to mask, or compensate for, this deficiency. In such cases attributes and criteria, images and their supporting narratives, are sought out as selective epitomes of a national character, and what makes that nation different from others. Thus national attributes are an imaginary ideological constellation that is, like the AIDS virus, constantly permutating in resistance to outside stimuli. We may look at painting from the Baltic region in the early 1800s and discern family values in light, composition and colouration, or we can certainly see that the *ukiyo-e* prints of the Edo period in Japan have their very particular values, and no one can deny that the Impressionists have preserved for us a rounded vision of Paris at the end of the nineteenth century. But when individuals are held up as embodying a nation it is vaguely absurd when taken at face value, although it may be mildly forgivable as an expression of national pride, something we shall come back to presently. Usually artists are raised as emblematic of nation by virtue of their fame and influence – Jackson Pollock is a prime example of this. But the logic is one of sheer tautology: Pollock embodies American art because he was a great American artist. The vision of nationality and identity, especially in art, arrives to us after the fact, not according to

[3]Slavoj Žižek, 'Hegelian Language', in *For They Know Not What They Do: Enjoyment as a Political Factor*, London and New York: Verso, 1991, 110.

predetermined criteria, although as we shall see, artists, self-consciously or not, use particular identifiers as assurance that they register their belonging to a place.

In the chapter 'Culture' in her *Critique of Postcolonial Reason*, Indian literary theorist Gayatri Spivak suggests that the word 'culture' in the era of globalization is as all-encompassing and yet as hard to define as Foucault's notion of power. The era of globalization, she argues, albeit cryptically, is an era that exposes the elusiveness of the specificity of culture, both for the Euro-American Westerner and for the exotic other. 'Culture alive is always on the run, always changeful,' she writes.[4] Similarly, power has two faces, the subjective holder of power who is generally believed to be the embodiment of power, and the actuality of power, which is unlocatable. Culture simplified is that which exists within borders, under a flag, according to the colour of skins, and acquainted with national dress and certain landscape characteristics as defined by tourist and media representation. Culture in actuality is a zone of constant redefinition and in constant contest. It is interrogative and fluid, shapeless but very much alive. Spivak's definition of culture as protean is acutely applicable to the Western countries that vaunt a paternalistic notion of 'tolerance' and their widespread multiculturalism. For multiculturalism is yet another reminder of the way in which it seeks to enframe its various minorities under a generalized banner, especially since the racial and cultural type who is not multicultural cannot be reasonably defined. In *Vanished Kingdoms* Norman Davies traces the evanescence of countries and cultures since the time when the Visigoths overran the Romans in the fifth century. In example after example he demonstrates how states are a mobile, and ultimately transitory, phenomenon.[5] But this is not an argument congenial to art, which survives off cultural labelling.

It is perhaps specious to say at any point that the notions about national identity have become increasingly prominent, since civilization itself is defined by the traits that subtend from belonging to one group rather than another. But now with the mounting rhetoric of globalization, with the appearance of new states between Europe and Russia, the freeing of Hong Kong, the rise of China and India, the financial tribulations of the European Union and more recently the waves of revolution in North Africa and the Middle East, national identity arises as an inevitable symptom, a symptom that always likes to read itself as the cause. The fold of the political, the personal and the aesthetic is what concerns us here. Our focus is on the ways in which signifiers of identity are trafficked within the cultural sphere and how these signifiers differ from brute social realities, particularly the lived experience within one place or another. Cultural and racial identity is fundamentally defined through negative criteria, namely according to what a group lacks and to what it is not. The need to assert one's identity in the public realm is caused by unease or distress over the threat to that identity, a response to forces that threaten either to unhinge it or that do not give it what it deserves. We examine this in more detail in respect of Aboriginal art in the following chapter. But the contours of cultural identity within global curating assume a very different face from that which may be asserted in, say, a political march or protest. On the contrary, if Nero fiddles while Rome burns, then races and groups

[4]Gayatri Chakravorty Spivak, 'Culture', in *A Critique of Postcolonial Reason: Toward a History of the Vanishing Present*, Cambridge, MA: Harvard University Press, 1999, 355.
[5]Norman Davies, *Vanished Kingdoms*, London: Viking, 2011.

continue to be subjugated while contemporary art is filled with examples of difference. It is now a prerequisite of any international Biennale to have a proportion of races and sexes that is commensurate with the pie chart mentality of commercial galleries. In short, in the international art industry, the presiding force behind identity, which can be formidable in racial and economic terms, is reduced to a simplistic schema of curiosity and compensation. Artists without the benefit of patronage from the art centres of London or New York are reduced to playing out their identity, an identity waged in the marketplace of symbols as different if not unique. Yet the facts implicit within these signs are of limited interest to the global market, thus revealing that globalization is a Euro-American construct realized in the twenty-first century.

Globalization – here understood as the technological Euro-American aftershock of imperialism – sublimates actual hunger and poor living conditions through a series of marketing images that in turn feed the idea of globalization as the world made present through accessibility and cross-pollination. Globalization is therefore more an image than a structure. It is another form of suppression that is most visible in the international art circuit in which cultural difference has now supplanted stylistic difference, which characterized the modernist avant-garde. But whereas the avant-garde harboured beliefs that radical styles could instil radical beliefs, the idea of radical style has devolved into the phantasm of exoticism. These are a series of cultural phantasies that are played out under the normative aegis of Euro-American power. The pavilions that originated in the middle of the nineteenth-century World Fairs and Great Exhibitions have now insinuated themselves into art. Cultural difference, as defined by theorists such as Edward Said, Homi Bhabha and Gayatri Spivak, is in contemporary art *not* a contested space but an assumed one. The international face of art is nothing without it.

Transorientalism

The condition of cultural identity within Euro-American culture is what is called Transorientalism, a concept first applied to certain trends in fashion since the beginning of the twentieth century.[6] It is the use of exotic signifiers with a relaxed sense of their material or ritual provenance. In art, this is played out slightly differently insofar as one is simply categorically different, as, say, a Dane may differentiate himself or herself from a Swede, or one is exotic. The exotic, defined as 'attractive or striking because colourful or out of the ordinary',[7] is underscored, by measure of being out of the ordinary, by anxiety. This anxiety has a venerable history that is the titillating principle behind the Oriental other. This has two sides, the erotic and the savage. When social otherness is reduced to a spectacle, as it is in art, we experience this with pleasure. This is arguably analogous to the pleasures we encounter in horror films. It is the most perverse form of vicariousness that rests on the security of not experiencing the plight of others. Transorientalism has three faces. One is completely innocent and has a de facto relation to foreignness,

[6]Adam Geczy, *Fashion and Orientalism*, London and New York: Bloomsbury, 2013.
[7]Oxford Dictionaries Online: http://www.oxforddictionaries.com/definition/english/exotic, last accessed 7 January 2015.

as when we, say, wear paisley designs that are now a remote appropriation of the Indian *buta* design. The other disavows the plight of the less privileged other while playing out the signs of otherness is free form. This is Orientalism as defined most famously by Edward Said, which is used as a technique for asserting Western domination. It will be noticed that we have taken an especially loose definition of 'Oriental' at this point. This intentionally draws out its arbitrary and shifting usage for over two centuries with respect to the cultural other.

The third is more curious and delves to a deeper relationship than is allowed for in Said's writings, namely the ways in which non-Western countries have indulged in their own Orientalizing. This happens in both fashion and art when signs of foreignness are foregrounded not only for the sake of Euro-American consumption but for social rejuvenation, a kind of cultural marketing. In fashion these modifications can be seen to be strategically social and economic, creating a sort of glue between peoples, but in art the aims can be more sinister. The imbalance between the stark realities and the compensations of the liberal 'Left' art world is best summed up by Žižek in his response to the 9/11 disaster. In this eloquent diatribe he mentions how after the invasion of Iraq, the Left academia rallied to the cause of Islam, arguing that the West failed to understand the 'true' Muslim. Certainly symposia and publishing flourished on this overcompensation to understand the enemy better. According to Žižek,

> In the days after September 11, the media reported that not only English translations of the Koran but also books about Islam and Arab culture in general became instant best-sellers: people wanted to understand what Islam is, and it is safe to surmise that the vast majority of those who wanted to understand Islam were not anti-Arab racists, but people eager to give Islam a chance, to get a feel for it, to experience it from the inside, and thus to redeem it – their desire was to convince themselves that Islam is a great spiritual force which cannot be blamed for terrorists crimes. Sympathetic as this attitude may be, (and what can be ethically more appealing than, in the midst of violent confrontation, trying to put oneself inside the opponent's mind, and thus to relativize one's own standpoint?), it remains a gesture of ideological mystification *par excellence*: probing into different cultural traditions is precisely *not* the way to grasp the political dynamics which led to the September 11 attacks. Is not the fact that Western leaders, from Bush to Netanyahu and Sharon, repeat like a mantra how Islam is a great religion, which has nothing to do with the horrible crimes committed in its name, a clear sign that something about this praise is wrong?[8]

In many respects Žižek goes to the nub of the problem, which is far subtler when transposed to art. After the September 11 attack, galleries and curators rushed to get their share of Middle-Eastern cachet that took over from the fever for South American artists (including Helio Oiticica, Ana Mendieta and Ernesto Neto), that in the 1990s had subsided in favour of China and the Middle East. What Žižek very

[8]Slavoj Žižek, *Welcome to the Desert of the Real*, London: Verso, 2002, 33–4.

aptly outlines is the ideological power that takes over after catastrophe or concern. In the art world, it appears sympathy and interest are often converted into a marketing ploy that conceals voyeurism and guilt. When the art world overcompensates for what is being perpetrated *en masse* in industry and foreign policy, it is often *colluding* with it. In the age of globalization, art is the perfect vehicle for these operations because art *does not need to do anything*. It is a denigration of art's purpose to go outside of the frame of the aesthetic lest it be deemed too literal or prescriptive. Artists may undertake decoys of altruism – such as making observers active – and use the language of inclusion, which creates a filter in which visitors and viewers can forget the real tempestuous woes of contemporary society. In this sense, to redirect Žižek's comments, in contemporary art race subsists in frameworks that are inherently ideological. For the imperatives of perception in global cultural markets adhere to a tacit expectation that the other be allowed purchase in some form or another. So inured are we to this that when we turn to the stable of artists of Castelli Gallery we are struck by its generational focus, but also by the fact that it is almost all straight white males based in New York.

Basquiat: Martyr of the exotic

It was when political correctness and racial compensation were beginning to take root, that there emerged the figure of Jean-Michel Basquiat, a singular and significant example of a martyr at the altar of the exotic. Born in Brooklyn in 1960, Basquiat had a Haitian father and Puerto Rican mother. His work is known for its cryptic mixture of graffiti and Outsider Art, quickly attracting the attention of Andy Warhol, with whom he later collaborated, and major dealers of New York. He died an early death of a heroin overdose at the age of 28 having left a sizeable legacy as both an artist and a public roué – he supposedly bedded Madonna and consorted with David Bowie, among other celebrities. Just as we will see in the following chapter with Australian Aboriginal painting, Basquiat's work had sufficient resemblance to Abstract Expressionism (in Basquiat's case a fair dose of de Kooning) but enough markers to register a satisfactory difference. Crucially, Basquiat was co-opted as the ill-spent *primitif*, in the same mythology as Tarzan being brought to civilization. In other words, we can only speculate whether he would have had the same success had he been white without dreadlocks, a laconic air and a handsome face. It did not hurt that Warhol paired up with him to do a collaborative exhibition. What is certain is that he satisfied contemporary art's insatiable nostalgia for innocence and untouched purity. His art symbolized dirt and derailment but had an ebullient verve that could enliven any New York loft.

In 1996 the artist Julian Schnabel made a smart biopic on the artist (with himself played by Gary Oldman and Warhol played impeccably by Bowie) filled with star cameos such as Dennis Hopper who had always been an art enthusiast and knew both Basquiat and Warhol personally. In one scene a dealer who has given Basquiat a space to work brings two ostentatious uptown visitors and introduces him to them by saying, 'This is Jean-Michel Basquiat. You have seen his graffiti everywhere. [pause] This is the true voice of the gutter.' What is salient of course is that the rich can buy the gutter without getting their hands dirty.

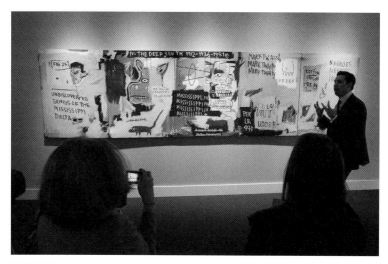

FIGURE 3.1 *Undiscovered Genius of the Mississippi Delta* by Jean-Michel Basquiat is on display during a preview of Sotheby's contemporary art evening sale in New York, 2 May 2014. Emmanuel Dunand/AFP/Getty Images.

After his success and fame, a reporter, played by Christopher Walken, interviews him:

Journalist: Do you see yourself as some kind of primal expressionist? And do you see you yourself as a painter or as a black painter?

Basquiat: I use a lot of colours not just black It's more a Creole you know, and what I mean by Creole is that it's a mix of Africa and Europe, in much the same way that an African in Haiti speaks French.

Journalist: Your father's from Haiti. [pause] How do you respond to being called the pickaninny of the art world?

Basquiat: Who said that?

Journalist: It's from *Time* magazine.

Basquiat: No they said I was the Eddie Murphy of the art world.

Journalist: [laughs] Oh, my mistake. [laughs again] Let me just open something out here: you are from a middle class home. Your father's an accountant. Why did you live in a cardboard box in Tompkins Square?

[Basquiat gestures uneasily]

Journalist: Do you feel that you are being exploited, *or*, um, are you yourself exploiting the white image of the black artist from the ghetto, y'know.

Basquiat: Ghetto? I don't exploit it no other people ... you're gunna make me put my foot in my mouth ... Other people, it's possible, other people might exploit it, it's possible.

Journalist: Is it true? [Basquiat drags on his cigarette uneasily] Um, your mother resides in a mental institution, is that right? [pause] Angry?'

Basquiat: Now, right now?

Journalist: No, as an artist – in general.
[Basquiat drags again on his cigarette without answering].
The journalist wraps up the interview with a smile, 'Good!'[9]

Even allowing for its triter moments, the film is a good one and clearly motivated by amicability and admiration. But these two exchanges hit very close to the mark of the problem that Basquiat embodied. Baudelaire called the Realists' penchant for grim and sordid subject matter *nostalgie de la boue*, roughly translated as hankering after muck. So the nostalgia for what Basquiat was is far from new, but rather graven firmly in the Western attraction for alternatives that represent authenticity.

In an essay about Tiger Woods and American multiculturalism, C.L. Cole and David Andrews describe how America and its media engage in 'racially-coded celebrations which deny social problems and promote the idea that America has achieved its multicultural ideal'.[10] Let us now apply this definition to the artistic sphere, especially biennales and art fairs. Here two standards operate: representational accuracy, or fairness, and marketability. When it is not from the 'Western', Euro-American standpoint, the art points to certain social conditions. Meanwhile the non-Other (for want of a better word than Western or Euro-American) together with the Other – not to mention the quasi-Other of India or China – speaks about the plight of others. There is no priority given under such circumstances, social hierarchy is momentarily suspended, because to do so would be perceived as racially compromising. Representations of duress and hardship – and this even leaving aside the effectiveness of such representations in and for themselves – must be equalized lest they betray a democratic principle. 'Culture' is undermined on more than one level. First it must be represented according to trappings of a culture; what others are not. Differences must be aesthetically foregrounded. Emotions of pity and guilt abound but are never articulated. Culture must enact its caricature in asserting its independent worth. Second, such assertions stand cheek by jowl with other cultures whose own assertions must be considered as valid. The final judgement of what is best is aesthetic again, which inevitably sublimates the concerns of culture in favour of a debased form of what Kant called the freedom of the faculties. Culture is therefore upheld for its destruction. This is the Transorientalist moment: floating signifiers of culture, that are constantly reorganized according to the principles of fashionable excess, where issues of cultural responsibility are sidelined for the sake of marketability.

Global curating

In early 1916, while the First World War was still raging, Paul Wittgenstein, the elder brother of the famous philosopher, was about to give his first public concert as a one-armed pianist. He was to play an especially composed piece (the famous concerto

[9]Julian Schnabel dir., *Basquiat*, Miramax Films, 1996.
[10]C.L. Cole and David Andrews, 'America's New Son: Tiger Woods and America's multiculturalism', in P. David Marshall (ed.), *The Celebrity Culture Reader*, New York and London: Routledge, 2006, 345.

by Ravel was to come some years later) and various well-known pieces that had been arranged for one hand. As well as having made a more than passable debut as a conventional pianist before the War, Paul Wittgenstein was a scion of one of the wealthiest families in Europe. His family knew most of the glittering personalities in Vienna and beyond, many of who had been regular guests to their musical salons. Instead of cutting short Paul's career, his traumatic accident only strengthened his resolve to become a pianist of international renown. Ludwig on the other hand, who had always been critical of his brother's playing, was feeling unnerved on the eve of the performance. Although the advertisements for the concert made no mention of his brother's injury, everyone in Vienna knew of it. Ludwig had the nagging suspicion that its audience would be made of sympathizers and those curious, like visitors to a sideshow to see an oddball repeat his extraordinary feat over and over again. Years later, after Paul played the famed Ravel concerto at the Proms, Ernest Newman writing in the *Sunday Times* courageously asserted that the performer was maybe trying to do what was impossible.[11]

This historical anecdote illustrates a handful of conditions that curating exhibitions in a global context faces: the first is the role of curiosity in attracting audiences to cultural events, the second is whether such curiosity is enough to sustain itself, whether an 'Other' can ever compete with the normative standards of production. To this we may ask other questions. One may be the present-day role and relevance of criticality in its Kantian moral sense, its evolution from the twentieth-century avant-garde and its commodified hardening within institutions. Another is the 'critical' direction of art within the ambit of class and racial relations. If art is sublimation, is art in the age of globalization a cultural sublimation on a grand scale? A way of watching the world's woes that insulates us from any need of action? And what is the extent to which the central and 'undeprived' socio-economic bodies – the 'West' – celebrate the other all the better to absorb, or consume it? The 'West' is given scare quotes here not only because it is now a rather nebulous and overblown generalization, but also because its dominance is all the more called into question in recent years, the economic dominance of the Europe and the United States stemmed by their own profligate arrogance. Nonetheless, 'Western' working models for curating still pertain. They harken back to organizational principles of genre, prestige-building, spectatorship and capital that were already well in place by the time of one of the first art critics, Dénis Diderot, in the mid-eighteenth century.

In his day, French painting had experienced over a century of refining its institutionalization of art through the taxonomic grouping of what had begun over a century before. Painting was divided according to the levels of moral edification it could enshrine, from still life at lowermost rung, to history painting at the uppermost. Today, while the organization of genres is implicit in the language and reference internal to art's history, it is but one component in the diffuse 'post-medium condition', to use Rosalind Krauss' famous phrase. A similar organizational spectrum is also present today, except that it has shifted *globally* into the realm of the *organization of culture*. Instead of categories internal to art that relate to its subject

[11]Alexander Waugh, *The House of Wittgenstein: A Family at War*, New York: Anchor Books, 2008, 106, 185.

matter and its formal capabilities, the categories are external, and based on the various imaginaries of national identity. Just as we have global marketing and global fashion, we have global art.

This is articulated as something far more than art that has a broader reach than its own country or local vicinity. Rather, global art is a concept that extends far beyond the reach and agency of the artist. Global art is art subject to what can be understood according to a discernible grab bag of national attributes. Alternatively, national attributes are generated *a posteriori*, that is if an artist is of culture X, then the work is reflective of X-ness. Despite our age of indeterminate and frenetic flux, we are witness to a kind of cultural warfare in which countries vie for credibility and interest. Despite boundaries being more porous than they have ever been, physically and through the immaterial channels of the cybersphere, there is widespread enthusiasm for national branding.

Thus we have Chinese art 'now', Korean art 'now', contemporary art from Lebanon, Turkey and wherever else. Disregarding the historical fluidity of borders not only now but since the dawn of civilization (nations are mobile ideas not essentially determined), conveniently ignorant that states such as Slovenia or Latvia are, in terms of independent sovereignty, only decades old, each country is expected to account for itself. Hence the morality that was once internal to the artwork's content has shifted to a cultural morality in which the imperative is on the curator to choose art and artists that most appositely reflect a series of cultural conditions within a particular space at a certain time. It is expected that the art of a country represents the meaning of that country in a desublimated form, that it diagnoses and discloses a cultural essence to which the outside viewer is then privy.

The packaged and survey exhibitions where this takes place are a kind of tourism, but of a mendacious kind. For whereas with traditional tourism the threat of descent into exploitation and kitsch is self-consciously present or at least imperfectly concealed, exhibitions packaging countries ride on the rhetoric of high culture, a rhetoric that is as silencing as it is baffling. Such exhibitions suggest that there are circumstantial qualities that can be raised to ideology, and that culture lies innocently reified in the art object.

Among the revisionist and postcolonialist debates about Orientalism and the colonial Other since the 1990s there appear to be two salient points of emphasis. The first is to explore the nature of cultural exchange over that of cultural hegemony. The second states that the first position is only revisionist softening. The first re-reading emphasizes that imperial dominance is not overriding but riven with cracks of resistance (not only on the part of the colonized but among the colonized) and complicity (among the colonized). They emphasize the fluid nature of economic and aesthetic exchange, from textiles and jewellery to visual motifs and artistic styles. Dressing gowns, for instance, have a mixed provenance, hailing first from Japan (the *yukata*) but subsequently manufactured since the seventeenth century in India. The word used at this time, 'banyan', has a suitably exotic ring – as in the banyan tree, an Indian fig – but it comes to us via the Portuguese which modified it after the Sanskrit. Or take the famous Tree of Life design from China that was transported by the British in the seventeenth century to India. There the textile designers and embroiderers promptly took their own liberties which, when transported back to China, were then

greeted by delight, and responded by superadding to the design originating with themselves and modified outside. Such 'exchanges' are typical but easier to locate in design than in art where, for the last 500 or so years, we are encouraged to stop quietly at the by-station of the artist's own individual choice and agency. But these cases from four centuries' past are occurring at a much higher rate and with incomparable speed in the cybersphere, the largest, fastest and most active site of exchanges – aesthetic, economic, personal, ideological – ever conceived.

Notwithstanding, the other postcolonial perspective, advanced by the likes of Spivak, insists that the equalizations of global economies are either superficial or non-existent, and all the more nefarious because they are silenced and concealed. The aesthetic, cultural equalization – we all know about and maybe eat McDonalds, we all know about and maybe have an iPhone and so on – is incommensurate with the social inequities between the euphemistically named 'developing' countries. Nike profits from sweatshops, and Apple from labour conditions so dire that they result in incidences of suicide. The connotations of the term 'globalization' are highly misleading, since many of the third-world economies have not witnessed any substantial changes, and have been hotbeds of warfare for several decades. Africa continues to be the place where medicines are either scarce, exploited or tested, it is also home to numerous gang states that live in a seemingly endless state of conflict and chaos. This is to the benefit of the capitalist markets, which can play off the individual groups rather than negotiate with a unified state that would then be able to concentrate on infrastructural development for higher production and stronger international negotiability. Sierra Leone, Namibia, Rwanda and the former Belgian Congo are all examples that the New World Order is a farce. Slavoj Žižek has also contributed greatly to illuminating the mendacity of Euro-American policy, which is the patina of political benevolence (financial and military aid, etc.) made possible from the exploitation of mass corporatization. The Congo is not an anomaly:

> On the contrary, this 'regression' to a *de facto* pre- or sub-state is the very result of their integration into the global market and concomitant political struggles – suffice to recall cases like Congo or Afghanistan. In other words, pre-modern sub-states are not atavistic remainders, but rather integral parts of the 'postmodern' global constellation.[12]

Complaints such as these openly demonstrate that globalization is less than a fixed concept. The strong implications of cohesion built into the word 'globalization' may speak to the markets for mass branding and for the Internet, but it belies a problem since, as a term, it devalues to the point of suppression, circumstances that have not changed at all. When featured, expressed or critiqued on the international art scene, it is a situation that both recognizes this but in a context in which its truth, its urgency and its physicality are disavowed. Contemporary art is a contradictory site since its agency and political entitlements remain more diffuse than ever (than say, when history painting was the best thing for academicians to test their mettle), and where ambiguity and metaphor, intrinsic to good art's power, are convenient mechanisms for

[12]Slavoj Žižek, *Living in the End Times*, London and New York: Verso, 2010, 172.

deflecting sticky questions. So the problem may seem to lie as much, if not more, in the places where art is shown, how it is chosen, how it is delivered and organized. The romantic notion of the individual artist, which in today's term is the artist as brand, habitually obfuscates the fact that the production of art and its modes of organization for display are in fact seamless.[13]

Venice held its first Biennale in 1895, Sao Paolo in 1951. The Sydney Biennale began as a small festival in the Opera House in 1973 with Anthony Winterbotham as the curator but was not rigorously biennial until 1984. The Whitney Biennial also opened in 1973, but after annual exhibitions that had been mounted since 1932. The Biennial in Istanbul opened in 1987, the Guwangju Biennale in 1995, the Biennale in Shanghai in 1996, in Liverpool in 1998 and in Singapore in 2006. As for the fairs, the first Art Basel was held in 1970, but more recently the Frieze Art Fair opened its doors in 2003. The fairs comprise a carefully timed circuit that includes the European Fine Art Fair that opens in Maastricht in March, Art Basel in June, the Foire Internationale d'Art Contemporaine in Paris in October and Art Basel in Miami Beach in December. The latter is a graphic case of global branding in action, in which a city is literally transplanted as brand, idea and essence all in one, to another city across an ocean and a city to which it bears no resemblance or affinity except for the transplantation of itself. Finally, there is the birth of the hypermuseum with Frank Lloyd Wright's Guggenheim in New York in 1959, culminating in Gehry's Guggenheim Bilbao in 1997. Contemporary wisdom appears to suggest that the puff has begun to go out of the Biennales, although the Art Fairs continue to boom because they are commercially driven. Perhaps the waning of the Biennales' 'critical' power is revealed in the Gehry phenomenon, Bilbao and its successors: it is not the ship's contents that count, it is the ship itself.

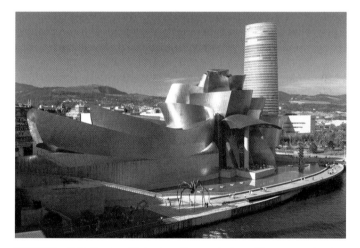

FIGURE **3.2** Frank Gehry's Guggenheim Museum, Louise Bourgeois' *Maman* Iberdrola Tower and River Nervion at Bilbao, Spain. Photo by Tim Graham/Getty Images.

[13]Although about literature, the most important contribution to this idea is by Pierre Bourdieu, *Les règles de l'art. Genèse et structure du champ littéraire*, Paris: Seuil, 1992.

Gehry's building, which set off a rash of others like it, with all their stray, angular space-age amphibiousness, is according to some, a bit of failure as a museum. But then again, is it? It caused a complete rethinking of art museums on more than one level. Through the 'Bilbao effect', Gehry's building showed that a single building with the high-flown rhetoric of cultural cachet could revitalize a city into a place of interest and make it be taken seriously. While Duchamp had revealed the tacit systems that surround our acceptance and appreciation of an object as art, Gehry's building and others like it seemingly reaffirmed this revolutionary principle in a counter-revolutionary way since it returns the art object to the bosom of the institution, where the institution's importance is no longer built on the quality on its content, but on its own superficial aesthetics: the label (the Guggenheim) and its look (the blue chip architectural design). Gehry's Guggenheim inaugurates the museum as a phenomenon unto itself, and as a marketing exercise that exploits the objects within it. It is not a collection – like the Wallace, Sackler or Frick – which is a sum of its parts, it is a museum whose parts are supplementary. Like the Libeskind Jewish History Museum unveiled just after it in 1999, the contents are incidental. When people visit Bilbao, they go to visit the museum, not the collection. Daniel Libeskind's museum, another clattering, asymmetrical metal-clad wonder, was in many ways a coming-to-truth or resolution, an entelechy, of the hypermuseum: for two years it remained open to paying visitors who marvelled over an empty building. Many Berliners subsequently lamented the fact that it was filled.

As we well know, such institutions share the majority of responsibility for how we consume and understand contemporary art, in which what is good is of a piece with what is said to be good, a chain of immaterial approbations that become more forceful the more they build on one another, no different from the stock market. They are phenomena that encompass roughly three tiers of artistic activity. Because the work is not ostensibly for sale, it welcomes more experimental and ephemeral practices; the fairs are vast department stores for the world's most voracious art plutocracy, while the museums ratify into permanency the transient and set it against the historical relief of artists of the twentieth century who are now the 'modern masters'. These activities were all efforts of cultural ascendency. They were, and continue to be, public rituals of financial excess and phantasmagoria. In the 1990s Biennales vaunted themselves as events that were a snapshot of a particular cultural Zeitgeist, but this has now largely been discredited. Why? The first reason is that it was until recently only Europe and America that could afford to house their collections in edifices of hyperbolic grandeur. The second is the ideological contradictions within the curated art festival themselves, particularly the Biennales, which sought to address the proverbial Other, while affirming the institutional frameworks of dominance, both intellectual and fiscal exchange. The arbiters for the fairs are the galleries, or for Biennales, the curators. The major galleries are like fashion houses within which other major designers work (as John Galliano once did for Dior), and Biennale curators are like film directors; one talks of a Robert Storr Biennale as one would a Spielberg film, irrespective of the curator's evident gifts and intellectual mettle.

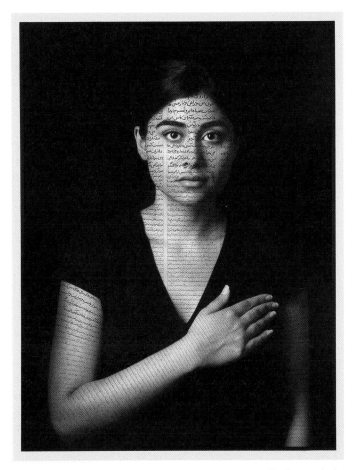

FIGURE 3.3 Shirin Neshat, *NIDA*, 2012, Ink on LE silver gelatin print 60 × 45 inches (152.4 × 114.3 cm). Copyright Shirin Neshat, courtesy Gladstone Gallery, New York and Brussels.

The incorporation of the Other in contemporary art into discourse is socio-economic and curatorial. Curating art of the Other usually begins with the expatriate Other (e.g. Jacir (although now living back in Palestine), Neshat, Hatoum, Ai Wei Wei) internal to whose practice is already a constructive, speculative nexus between two cultures. The word 'constructed' is used intentionally here, because the nexus is not reasonable or 'researched', it is imagined, fabricated. It is only once the instinctual demands of climatization have been met that more adventurous steps can be made. The entry of contemporary Chinese art into the international circuit, beginning in New York, is the best example of this. Its platform and its means of circulation are still, however, the 'global' paradigm of Western historical art making. The artwork is created and understood under terms inherited from the avant-garde such as 'critical' and 'political', and postmodernity, such as irony, banality and kitsch. These cultural

productions are supposed to be advanced enough to comply with the Western system – as opposed to the traditions of calligraphy which is exhibited but more as commodified cultural artefacts rather than as an international 'engagement' – while at the same time reaching deep into the heart of the country's own difference. Chinese art is meant to smell and feel Chinese. Meanwhile works of art from the centres of New York and London need not bespeak a culture since their responsibility is to benchmark The Contemporary for that year or that fashion season. What is more complex and poignant is that the artists cited above are sophisticated enough to know that their otherness is liable to be taken on in a caricatured and typologized way, yet they seize the advantage of the fascination bound to their exposure. Artists like Neshat, Zang and Ai are energetic activists in their own way and their work, despite their insertion into fashionable impulses, is resonant with personal conviction. As a result of this, their work transcends the vulgar levels of fashionability and has given us new and complex insights into culture, gender, pain and alienation.

Koons, Barney and Hirst provide the standards by which difference is gauged. They are also the talismanic centrepieces in the fairs, like the American dollar on the global financial market – with all the same spuriousness that lurks behind power that resides purely in perception and coercion – by which the Others can be measured. The Other or the half-Other, the artist with a hyphenated identity, must remain thus if he or she is to remain marketable. Once they are purchased and displayed by grand institutions they are situated as points of contrast, and to vouch for the truly liberal, multicultural ambit of that institution. What is most cynical about this exercise is not the exercise itself, but the apparent lack of self-awareness of the curators who engage in it.

In his review of Spivak's major work, *A Critique of Postcolonial Reason* (1999), Terry Eagleton with wry candour comments that

> Gayatri Spivak remarks with some justification … that a good deal of US post-colonial theory is 'bogus', but this gesture is *de rigeur* when it comes to one post-colonial critic writing about the rest. Besides, for a 'Third World' theorist to break this news to her American colleagues is in one sense deeply unwelcome, and in another sense exactly what they want to hear. Nothing is more voguish in guilt-ridden US academia than to point to the inevitable bad faith of one's position. It is the nearest a postmodernist can come to authenticity.[14]

Eagleton later affirms that her outsideness, as it were, is in fact nurtured and conceived on the inside, in the United States where she receives numerous accolades and honours.

Beneath Eagleton's grudging respect for Spivak lies a very clear point, that holds for artist or theorist or film-maker, namely that the West – here the places that command and commission discourse – not only thrives on but must enlist the voices that appear to rupture the structure. It is a commonly made error to think that places of power are coherent. Yet what is demanded of foreign artists, writers and so on is that they be highly literate in a packaged performance of attributes that appear under a certain

[14]Terry Eagleton, *Figures of Dissent: Critical Essays on Fish, Spivak, Žižek and Others.*, London and New York: Verso, 2003, 158.

cultural banner. Thus the coherence of the so-called West is its very incoherence and its systematic aesthetic absorption of cultures it exploits, denigrates and denies economically and politically. The politics of curatorial inclusion much resembles a supermarket filled with exotic, rare ingredients.

What Eagleton ultimately locates is that discourse in its approval if not its circulation stays in the West. But, this 'West' is now more of a regulating idea: the West as brand. While manufacture of Ralph Lauren, the highest grossing fashion and lifestyle company worth over four billion dollars, is carried out in China, Macau, Tunisia and Turkey, the brand remains in New York. The same can be said of myriad other brands which were once made in Italy – Diesel and Armani Jeans – and have moved their production offshore to China. Okwui Enwezor as an Igbo Nigerian can talk of his humble origins, but they are only heard through a Euro-American filter. His own label, we assume, is more authentic because it is tempered by hardship. It is more critical because it isn't vitiated by the charmed life of a Westerner. The outsourcing of culture in terms of the value of the more authentic 'primitive' other mirrors the economy of the developed countries themselves that have moved production away from the country of origin. The short-term gains have been felt and the long-term effects are now only becoming apparent. Is this a harbinger of things to come in art as well?

If in the first years of its life, Libeskind's Jewish History Museum marked an architectural realization of the museum as a museum without contents, then the Louvre Abu Dhabi is a climax of the museum as brand.[15] Designed by Jean Nouvel, the project ran against a chorus of protest, not just for conflating a historic site once residence of kings with a bequest – the Guggenheimization of the Louvre if you will – but for the connection of high art to human rights abuses. For the labourers in Abu Dhabi, from Bangladesh, India and surrounding countries, work in dire conditions for wages that barely meet their own costs of living. This is well known (and not acted upon), but the Louvre case is a special collision of human rights abuse with high culture. Headed by the French art historian Didier Rykner, over 4,650 petitioners signed against the France-Emirati enterprise. But the French Culture industry was steadfast, the Minister for Culture Renaud Donnedieu de Vabres proclaiming, 'We're not selling the French legacy and heritage. We want this culture to radiate to parts of the world that value it. We're proud that Abu Dhabi wants to bring the Louvre here. We're not here to transform culture into a consumer product.'[16] Needless to say, in the denial is the confession. But that is not all that is remarkable about this statement. It also perpetuates the imperial civilizing mission that began at around the same time in the French Salon in the early seventeenth century. References to the sun king are there, whether conscious or not: France is 'radiating' its cultural might to willing consumers. This is the truer, more accurate definition of globalization: preserving cultural capital through its immaterial dissemination. The modern, proto-globalized cultural institution protects its

[15]See also Terry Smith, *What Is Contemporary Art?*, Chicago, IL, and London: Chicago University Press, 2009, 88–90.
[16]'Louvre to Build Branch in Abu Dhabi', Associated Press 3/6/2007, msnbc.com. http://www.msnbc.msn.com/id/17482641/#.TwzQMM2BL9o

contents on site, occasionally packaging a portion of its riches for tour. Now, like a sinister alien that can grow an extra appendage at will, the Louvre gives its essence, which is an idea. It transports its prestige, a prestige constructed out of a venerable and intricate history. Yet what makes the situation so fraught, and yet so lucidly revealing, is that now we see the use of history to make an alias, even though this history is now a hollowed-out shell. Abu Dhabi, the city itself designed by Rem Koolhaas, is the ultimate post-postmodern city. With the prospect of an institution such as this, it outranks the Singapore or Shanghai Biennales. Unlike these, it has taken more than the framework and the concept (the structure has a vast space intended to house a Biennale), it has been able to buy its kudos rather than build it. Unlike Disneyland that traffics in representations, Abu Dhabi seeks to reground these representations within an active sociopolitical context.

And as to the gesture of protest: this rehearsing of French Left outrage ought not cloud the fact that the curators and other 'art workers' who signed the petition were already engaging in a commensurate form of exploitation, albeit in a more immaterial and less bloody form. This is to say that from the point of view of cultural marketing, some cultures are more interesting than others. For instance, an Iranian-Australian will attract more curators than a German-Australian. To curate an artist with Iranian blood is to afford crucial cultural insights into a time of brutal slippage between the Christian and Muslim worlds. It is also to show that as a curator you are unsympathetic of a politics of militant opposition, but can play a sort of quasi-Habermasian game of solution-seeking communication. As a German-Australian you are just a migrant. The singular advantage of curating minorities is that one can undertake a humanitarian project without having to get one's hands dirty, and it potentially makes money, or at least carries cultural credit. In the 1980s, progressive curating had one imperative, which was to include women; today it has three: women, minorities and indigenous people (Aborigines, First Nation, etc.).

In a recent lecture Spivak made a plea for something similar to 'counter-globalization', a movement that seeks to safeguard local practices to maintain an energy resistant to corporatization and the violent simplifications of economic rationalization. This is a nationalism that differs from the nineteenth-century kind in that it abjures a historical base. It is linguistic, imaginative and therefore inventive. These are generative mechanisms that ensure that the invention on the so-called inside is not subordinated to sloganeering or even the dominance of global language, namely English.[17] But Spivak in no way suggests that we should decry English for being a, or the, Global language, rather that it not be the language that other languages are translated into, for in doing so stories and messages become corrupted. When a language is made untranslatable, by its nature or through the miracles of literature, then it is able to endure unto itself and keep itself alive. The problem that Spivak faces with this is that such resistance also deprives a voice of its audience and influence.

Her standpoint is an important turn away from a Saidian standpoint. In his examination of the migration and acceptance of theories, Said writes about the stages of understanding and application. The fourth and final stage is when 'the now full

[17]Gayatri Chakravorty Spivak, *Nationalism and Imagination*, London and Calcutta: Seagull Books, 2010, 27–31 and passim.

.

(or partly) accommodated (or incorporated) idea is to some extent transformed by its new uses, its new position in a new time and place'.[18] This kind of alteration is certainly true of the passage of Chinese art to the mainstream via a protracted pit stop in New York. Said, like Spivak, benefited greatly from being an outsider cum insider to the US academic system who criticized the Western grasp of Middle Eastern society in groundbreaking *Orientalism* (1979). But Spivak's recent deliberations depart from Said's more dialectical approach towards a constructive localization that maintains an ironic stance, as opposed to indifference to outside interpretation, and therefore consumption. Spivak poses a system that is resistant to consumption for being resistant to translation, and 'a reluctance to cohere' to use the words of the Portuguese poet Pessoa.

When transposed into artistic practice, Spivak's formula becomes all the more problematic. Art thrives on, feasts on, processes that appear to be outside of the mainstream system, similar to the way that multinational corporations pour large sums into diagnosing the latest subcultural movement, language or fashion only to reabsorb it into its marketing image. But it does have enormous relevance to Australia. Australian art, not including Aboriginal art, is perhaps already there, but for the reason that the international scene has proportionately little impulse to translate it or to absorb it. Aboriginal art is currently undergoing its own ad hoc review, especially since it has become increasingly self-aware as a look and a brand that is divorced from the real, lived circumstances of its making. Before it is traduced and simplified, Aboriginal art is often produced by collaborative groups or is circulated among a small fraternity.

It would seem that one solution to the predicament of art sketched out here is to foster in artists a self-reflexive attitude to their identity, and to educate them and curators alike in the great extent to which identity is manipulated, rewritten, fabricated and imagined. This is not a taste of Lebanon, or of Cameroon, Namibia, Haiti, Cuba, or of Korea, but this is what he or she imagines it to be. This would mean that the kinds of collaborations and exchanges can occur outside of the culture. The age of criticality is now passing, as the editor of *Artforum* Tim Griffin has also begun to suggest.[19] This does not mean that we are dealing with complicity of kitsch; rather, it means that strategies of resistance and complicity need to be reformulated yet again. Why can't an Australian do Korean art, or Egyptian art? If Koreans and Egyptians in Australia can, after all, do Australian art, why not stretch the membrane of immanence? It would test the grounds of political correctness. It would also make the consumption of false, falsified or forced authenticity a lot harder.

[18]Edward Said, *The World, the Text and the Critic*, London: Faber, 1983, 227.
[19]Tim Griffin, 'Compression', *October*, Vol. 135, 2011, 3–8.

4 EXOTICISM AT THE BRINK: CONTEMPORARY CHINESE AND ABORIGINAL ART

Contemporary Aboriginal and Chinese art may seem an uneasy coupling, but the key is in the subtleties of the ostensibly unambiguous word 'contemporary'. Although visually they have next to nothing in common, they share the fact that they were shaped and nurtured by outside hands: in the case of Aboriginal art, by the non-Indigenous art establishment, in the case of Chinese art, by New York, Paris and Sydney.[1] Both mark the seeds of their 'birth' as contemporary art 'movements' within five years of one another: Aboriginal art – that is the initiation of Aboriginal ritual into the Western institution of art – started in 1971, while Chinese contemporary art can be said to begin with the death of Mao in 1976. While Aboriginal art still occurred mostly on home soil (this will be explained shortly), the phenomenon of Contemporary Chinese art as we know it today took place as much outside as inside of China. Australian Aboriginal art continues to be Australia's largest cultural export, while Contemporary Chinese art, which appears now to have increased in interest and acceptance inside the home country, remains an important point of focus for curators and collectors. For Aboriginal art, the reason for its popularity lies not solely in the decorative nature of some of its styles and designs, but also in what might be called the last bastion of 'the primitive'.[2] For Chinese art, the reasons lie in the reversal of fortune of the once distant Orientalist other: for now Euro-American eyes look on agitatedly at the inscrutable new superpower. Its success is not only out of fascination for something different but by necessity.

At this point it would be fair to level the accusation that these summations are cynical and two dimensional. Are not the beauty and quality of the work enough to buoy it up in the art world? The answer is a blunt no, for conflicting reasons.

[1] For an account of the diaspora of Chinese artists, see Melissa Chiu, *Breakout: Chinese Art Outside China*, Milan and New York: Charta, 2006.
[2] See Adam Geczy, 'Djamu Gallery: Some Thoughts on Exhibiting Aboriginal Art', *Postwest*, Vol. 14, 1999, 12–16.

One is that art can seldom be taken at face value; it benefits from understanding of its motives, context and the kind of knowledge it is supposed to embody. The other, as we have touched on already in this book, has to do with the tribulations of curatorial fashion whose goals are strongly oriented towards audience consumption. Curators and collectors are therefore on the lookout for the novel and the new. To support art such as Aboriginal art has the added bonus of including minorities, while support of Chinese art shows that the curator is wide ranging and no longer confined to (anachronistic) Euro-American standards. But it is also because of these displacements that neither art was born naturally from the system that supports it, that both Aboriginal and Chinese art – and these are used as benchmarks only as we could just as well speak of art from Maori culture or of Korea – raise major questions as to the frameworks within the present age of exhibiting and producing art. In the previous chapter, we saw how cultural identity is trafficked and by degree constructed. The examples of Aboriginal and Chinese art fit into this mould to some degree, but they are also different, since they both come from cultures that have an ancient history of independence from Europe and the United States. It is indeed because of this independence that Euro-America wants to preserve the qualities that are different from itself. But paradoxically, to make this happen, the work of the Other must be adapted and packaged in a way that differs from its original incarnation (Aboriginal art), or must respond to the strands of practice that are close to, but still different from, what was historically typical to their own country (Chinese art). Their art remains fashionable while their mythic locus in an outside realm remains. But at the same time, both Chinese and Aboriginal art were invented elsewhere.

Aboriginal art and the dot

For a better understanding of this conundrum, it is useful to digress briefly using another analogy from the fashion industry proper. At the same time as Aboriginal art was 'born' in the 1970s, Parisian couture began to experience an extraordinary change with the entry of new designers: Kenzo, Rei Kawakubo (Comme des Garçons), Issey Miyake, Yohji Yamamoto and Hanae Mori are the most successful of these, now hailed as bringing about a new wave of fashion in the 1970s to the 1990s, and of integrating Orientalist styling into the very substance of haute couture. The French had already become accustomed when Japan opened its doors in 1868, with their arts and crafts having a profound effect on the development of Impressionism and Postimpressionism. But in haute couture and in the 1970s, this was altogether another matter. As Yuniya Kawamura in her book on this subject remarks, many of these designers were quick to play the race card. Kenzo, and those who followed him, began to use their marginality as an asset: 'Japanese designers began to use their "race" card to be acknowledged by the French'[3] Mori drew on a panoramic history of Kyoto with silk sashes and

[3] Yuniya Kawamura, *The Japanese Revolution in Paris Fashion*, Oxford and New York: Berg, 2004, 95.

dresses designed with Mt Fuji, and Kenzo bombarded his public with flowers in which the fields of Grasse melded with the blossoms of Japan.

This desire to be acknowledged as an exotic while enacting a post-colonial critique of assimilation and recognition as an individual subject was part of a much larger post-colonial entry into Western life and discourse whose ethical and aesthetic ramifications are still to be thought through thoroughly. This is once more the double game where the Other plays out his or her role as Other within a revisionist environment. The Western response is to embrace this identity with a mind to correcting former colonialist injustices; however, the assimilation of the Other, willing as it is, is only on the unspoken condition that the Other never foregoes his or her otherness. Instead he or she plays out this otherness for the revisionist pantomime within a global system that is still, really, a Euro-American system. This dynamic holds for Orientalist fashions, novelists, musicians – and for Aboriginal art.

In other words, Aboriginal art lives out a contradiction: it has been a constructive means by which Aboriginal cultures have stated their claim within Australian culture and yet it is only within culture *qua* culture that they are able to serve. It is nothing if it is not 'Other', as inscribed as an alternative – the guilty dark secret laid bare – to the culture that defines it as other, exceptional and interesting. No other agent than art has been as effective and pervasive in bringing Aboriginal cultures to the fore in Australia, and integrating them into the popular imagination. Art not only gave Indigenous Australians self-esteem, recognizing that they were doing something of value, but also gave them visibility in places where they in the past (or even now) would not have been permitted entry, least of all into the residences of the wealthy and powerful. While the incongruencies of this are deeply disturbing, this compromised situation has made Aboriginal art Australia's single biggest artistic export, with regular auctions dedicated only to it occurring abroad, notably in New York. Non-Indigenous artists have accomplished no such feat, and it is unlikely in the near future either. The Australian expat art critic Robert Hughes proclaimed Aboriginal art the last great art movement of the twentieth century – a comment that continues to be cited. Even if movements had ceased to have the same validity at the end of the twentieth century, and even if Aboriginal art is not a movement, however obtuse or sententious this statement can be taken to be, it is still worth citing for reason that it could never plausibly apply to the art of white Australians.

There are still far too many Australians who are unaware that their Indigenous population was only granted citizenship in 1967, before which they were categorized as belonging to the category of flora and fauna. And it is common to say that Aboriginal art was born four years later when a schoolteacher, Geoffrey Bardon, encouraged artists to paint on boards while languishing in a Mission station in Papunya in Australia's Western Desert. From there, Aboriginal art flourished from artefact to art in museums well beyond the original ken of practices that had existed for over 40,000 years. It is from these origins that the association of Aboriginal art with dots has been so pervasive and tenacious, although there are many other art forms, many of which are not as successful because they do not look Aboriginal enough; they do not fit the fashion and the look. In fact, the dot has become so ubiquitous that it is common

practice for young Aboriginal artists not from the particular region of Papunya to use it as a now universal characteristic of Aboriginal mark-making and identity. The dot can be understood as the stylistic *sine qua non*, central to the Aboriginal 'brand', which is significant to Aboriginal livelihood and both the mainstay and evolution of its identity.

Before 1971, the original dots from the Western Desert were much larger, and originally not executed on board or canvas. Rather, they were indexical signs executed in the sand as part of the process of sharing stories, or of invoking totemic animals in ritual. The resultant forms or designs were only there as a component of the telling – which could also involve song and dance – and were removed once the ritual, or storytelling event, had ended. The design itself was also not art per se. Like many cultures (including the ancient Greeks), especially those with a rich ritual awareness, Aboriginal cultures had no word for art and indeed no place for it, since the practices which the Western concept associates with art were part of a much larger complex of sacred activity. By extreme contrast, what became art was now permanent, as opposed to ephemeral marks in the sand.

This radical alteration in spiritual representation immediately caused a number of objections within certain Aboriginal communities themselves. The earliest debates among elders at this time concerned the exposure of sacred designs to non-initiated eyes, whether those of their clan, or complete outsiders. The dots, it is often observed, as they evolved in the ensuing decade, became finer, more gauze-like to act as a covering layer for the secret and sacred content beneath. In acting as a protective skin, the dot assumed greater significance, not only as something for itself but also as an intermediary between iconography not to be disclosed and the outside world. Since then the dot has come to have talismanic significance for Aboriginal art and artists well beyond the boundaries of the Papunya region. In the words of Indigenous artist and film-maker Janelle Evans,

> Suffice to say though that when white Australians discover they have Aboriginal heritage, one of the first things they do is try to 'learn' how to be Aboriginal – this includes painting 'Aboriginal Art' using dots – 'Ooga Booga Art' (coined by proppaNOW).[4]

It is fair to argue that the dot in the Papunya sense assumed far more universal importance once Aboriginal art was 'invented' or conceived. With the displacement from sand to canvas or board, certain motifs and styles became hypertrophied and appropriated by other Indigenous people. Its closest ally in this renegotiation of objects and styles once specific to language and region is the didgeridoo. Most people in Australia – and one could possibly assert also some of Indigenous heritage – believe it to be the national instrument of Indigenous people, which it has become, although it comes from a relatively small region of the north-east cape of Arnhem land belonging to the Yolngu people. Its proper name is the *yidaki*, didgeridoo being the onomatopoeic pidgin.

[4]Email correspondence with the author, Adam Geczy, 30 June 2013.

FIGURE 4.1 Turkey Tolson Tjupurrula, *Tingari Men at Mitakutjirri*, 2000, acrylic on linen. Courtesy of the estate of the artist licensed by Aboriginal Artists Agency Ltd/Papunya Tula Artists Pty Ltd Alice Springs NT.

But on the other hand one cannot help feeling sympathy with the contempt that the collective proppaNOW have about such a practice, because it is very much the symptom not just of the Western-oriented 'invention' of Aboriginal art but also its marketing and proliferation. Dot paintings are among the most popular because they are not only associated with Aboriginal art's 'birth', but because they appear decorative. Added to that, they show the visible signs of manual labour, which is always a winning component to lay purchasers of art (with Barton being another beneficiary of this banal truth). The work of Tjakamara and of other greats like Johnny Warangkula Tjupurrula is that their stunning diaphanousness has a deeply seductive, hypnotic quality. But the undeniable aesthetic qualities of such work have also led to an ongoing concern about Aboriginal art and its sacred content: not only do most buyers have no knowledge of this content, nor have any right to it, but their response to it is according to the work's sensuous qualities, that are given a turbo boost of legitimacy through the promise of unspoiled, innocent spiritual profundity.[5] The fact that the Papunya dot has now adorned a famous BMW, airplanes and the Qantas uniform makes it all close to a ubiquitous sign of Aboriginality. But usually, the design exists as a safe remnant, with the people and their place remote from the motifs and practices that were once seamless with it. These issues do not dampen the importance of the founding Papunya painters, but they do however bring to light the extent to which Aboriginal art is something that has been taken well out of the context of the very meanings that the works themselves are supposed to enshrine.

[5]See also Adam Geczy and Adam Hill, 'Aboriginal Art Diagnostic', *Contemporary Art + Culture Broadsheet*, Vol. 40, No. 2, 2011, 27–30.

By the early years of the new millennium, Aboriginal art had found itself central to the ways in which Indigenous and non-Indigenous people alike understood Australian art. Just as it had become attractive to acknowledge Asian roots if one had them and to become what cultural theorists call a 'hyphenated identity' (Asian-Australian, Greek-Australian), it was advisable to recognize one's Indigenous roots. But while Australia still has the Union Jack on its flag, and upholds the day in which their Indigenous population was invaded as their national day (26 January), the cultural sphere will go to great lengths to ensure wide and varied Indigenous representation.

This has become no less so on the international stage. But here, Aboriginal artists are far more insulated than when in Australia, because international curators do not dare to question a culture not their own. Post-colonial arrogance has now come full circle: where once the white man would speak patronizingly about the burden of his civilizing mission, the enlightened intellectual will take a respectful backward step for fear of any presumptuous or intrusive judgement – such that very little judgement goes on at all, except the chain of approbation. In other words, if an Indigenous artist continues to be popular and to be exhibited, that is enough for his or her continuing exposure. This also means that some Aboriginal artists can say and do almost anything they like.

An example of this was foregrounded recently by the eminent artist and writer Fiona Foley. Foley took Aboriginal art star Brook Andrew to task for playing loose with the details of his heritage and identity, and disregarding the important minutiae of Aboriginal life, especially the differences between communities. According to Foley,

> Forgotten negatives and relics of 'exotic types' in colonial collections are being colonised for a second time by some artists, a 'double colonising', if you like. In the past, Brook has been accused of using images from collections without seeking permission from the relevant Aboriginal people or language groups. It is a practice that has seen him use rare photographic images in works like *Sexy and Dangerous* (1996), *I Split Your Gaze* (1997), and *Gun-metal grey* (2007). Under the umbrella of a pan Aboriginal identity, opportunities continue to arise for the artist.[6]

Foley is scathing about Andrew's work for the 2010 Sydney Biennale, the *Jumping Castle War Memorial*, exhibited at Cockatoo Island, a spacious and much visited venue. Here Andrew had used a children's jumping castle to comment on years of oppression. Foley continues,

> Andrew cites the work as addressing 'the people who have been affected by genocide, oppression and diaspora, et cetera'.[7] The viewing public were fed a grab bag concerning the world's inhumanity to man spanning time and geography.

[6]Fiona Foley, 'When the Circus Came to Town', *Art Monthly Australia*, #245, November 2011, 5.

[7]COFA Online, Artist Talks, 17th Biennale of Sydney, Cockatoo Island, Brook Andrew; http://online.cofa.unsw.edu.au/cofa-talks-online/cofa-talks-online?view=video&video=99

Political histories from other countries were also presented through the jumping castle's central black figure, which now took its cue from the Russian and/or Chinese Soviet era. When listening to Andrew speak to the work, there was further confusion about what the inflatable represented. He stated, 'In Australia we don't have a proper solid war memorial to Indigenous people here'.[8] He appeared to suggest the global was competing with the local, with an abstracted notion of pan-Indigenous suffering added to the mix.[9]

Foley's continued use of the term 'pan-Indigenous' is not to be ignored, since it makes the apposite distinction between a generalized experience and a specific one. She is not discounting the suffering of all Indigenous peoples after colonization, rather she is calling for a less sweeping form of commentary. While most curators, collectors and artists abroad continue to speak of Aboriginal people as one people, at the time of colonization in 1788 they were at least as diverse in custom and language as medieval Europe. So for an Indigenous person to avail himself or herself of this 'grab bag' as Foley terms it, is to buy into clichés and generalizations that serve in the end to perpetuate the problem. While Andrew's work appears well credentialed for speaking against mistreatment of Australia's blacks, it appears to do so with a conceptually blithe air in which carnival is conflated with tragedy, or in which tragedy is so sugar-coated that the pill is no longer bitter. But it is precisely this that makes him attractive to the global curatorium: he can be seen to be fighting 'the just cause' but the message is so diluted that no one, except perhaps the Aboriginal communities themselves, feels challenge or remorse. Andrew's work could be seen to exemplify how the fashion for Aboriginal art can be exploited.

On the other hand, to what extent do non-Indigenous artists avail themselves of Aboriginal art? In the 1940s the major Australian modernist painter Margaret Preston was the first to absorb Aboriginal art, which at that time was viewed as anthropological artefacts, with some degree of seriousness. But if she is to be given acknowledgement, albeit not in an era of cultural revisionism, she appropriated the look of Aboriginal art without any understanding of meaning or ritual use. Since the 1980s, with the emergence of feminist and post-colonial critique, the entitlements and responsibilities relevant to Aboriginal art were more circulated and conspicuous. Not that a non-Indigenous artist appropriating Aboriginal art was subject to lawful retribution but certainly exclusion from shows and opprobrium.

In late 2012, a small furore erupted in Australian art circles over a young artist, Lucas Grogan, who was appropriating Aboriginal art in an overt way. The national newspaper, *The Australian* reported that a young Indigenous artist, Ryan Presley, walked out of the Brisbane gallery that represented him (Jan Manton Art) in protest over the new inclusion of Grogan. One of the most radically outspoken Aboriginal artists, Richard Bell, lambasted Grogan on his social media page, sparking a welter of informal comment. In a more formal published statement Australian art theorist Ian McLean observes that

[8]COFA Online, Artist Talks, 17th Biennale of Sydney, Cockatoo Island, Brook Andrew; http://online.cofa.unsw.edu.au/cofa-talks-online/cofa-talks-online?view=video&video=99
[9]Foley, 'When the Circus Came to Town', 5–6.

Indigenous art is so interesting at the moment not just because there are talented Indigenous artists but because the world is in it big time. The real world of social relations (or more precisely their lack) is what gives power to symbols (and takes it away). This is why many white people, including artists, are drawn to Indigenous art: they sense its symbolic power. So this particular issue of reactions to a white artist appropriating Indigenous art is not dilettantism or political correctness, but symptomatic of how power is organized in this postcolonial age of globalization. The surprise is not that it happened, but that it doesn't happen more often. The important question is now where to from here?[10]

McLean rightly signals that Indigenous art is very much the 'it' thing and an entirely attractive resource to tap into. He asks why more artists have not done what Grogan did. But from a different angle it is just as feasible to say that to appropriate Aboriginal art so obviously and without close dialogue with an artist or group is doubly egregious. It may have had some weight if Grogan had done so in dialogue with Indigenous artists and had done so in the name of 'the cause', say in a work that deals with the continuing stereotypes of Aboriginal identity. But the obverse is the case: Grogan was adding to this very problem of exploitation and flagrant neglect, apparently doing what he did because he could, and for his own personal profit. There are non-Indigenous artists, Imants Tillers and Tim Johnson, for example, who have appropriated Aboriginal art, and they have done so in collaboration or with permission from certain Indigenous groups. Permissions are not universal and some Aboriginal people feel conflicted about what they see as opportunism.

But if it gets people in the doors and ignites comment, then why not? This book has repeatedly demonstrated that in contemporary art, the interests of the market are put before those of individuals. Debate was sparked afresh in the following year when an artist won Australia's most publicized portrait prize with a painting of the actor Hugo Weaving (*The Matrix, Lord of the Rings*) surrounded with a design whose provenance from the classic Papunya style is unmistakable, despite the change in colouration. It seemed that institutional taste had won out over cultural delicacies. This is what the fashion world euphemistically calls 'inspiration'.

Contemporary Chinese art

If Contemporary Aboriginal art begins in 1971, Contemporary Chinese art begins first in 1976 and finds its principal watershed in 1989 with the June Fourth Movement at Tiananmen Square that caused numerous artists, intellectuals, journalists and authors to escape China and seek a new life in the United States, Europe and Australia. This was timely, since when these artists began to make themselves known by the late 1990s, the art world had already begun to cast about for something new. The yBas were not so young any more. What next? The horrifying events of Tiananmen

[10]Adam Geczy and Alan Cruickshank, 'Appropriation: No Longer Appropriate', *Contemporary Art+Culture Broadsheet* Vol. 43, No. 1, 2013, 11.

Square did much to turn attention to China, which in turn opened the possibility of readdressing the balance on 'benign' liberal democratic shores.

While the events of 1989 appear decisive, there had already been some changes brewing a few years before with the 1985 New Wave Movement, which was not so much a style but a tendency to emigrate and look abroad. This small diaspora of Chinese artists was understandable, since it was, and relatively speaking still is, hard to earn one's living as an artist in China, especially if one subscribes to freedom of expression, which is read along official lines as putting one's own interests over party and people. But in these years, many artists had problems adjusting, since their ways of living were so different from the West. As the former editor of China's *Art Magazine*, Fei Dawei (writing from Germany), puts it,

> Westerners want to observe a variety of elements of culture existing simultaneously, for from this they can draw inspiration, and at the same time free themselves from the egocentricity in which Western culture is trapped, and thus gain new vitality. However Western people are not always aware that the present cultural differences between East and West do not lie in the realm of superficial form, but rather in the realm of spiritual needs. This gap is based on the differences of tradition, history and social structure. The superficial forms of culture are by definition neither permanent nor immutable, but are controlled by the overall state of the culture itself.[11]

Fei is perhaps being generous when he sees the West as looking for new vitality – more to the point the West relies on and sucks the marrow out of outside influences, shaping and reshaping them to suit its complex forms of consumption. The constant of vitality is a modernist concept exemplified by Japonisme and primitivism. The nineteenth century was a period of febrile Orientalist exchange, with many Chinese artists maintaining close contact with cultural centres such as Paris.[12]

Today's West, or Euro-America (and states emulating their standpoint), is constantly hungry for stimulation and novelty. With this extract of Fei's from 1993, it is certainly true that in the early 1990s there was a divide between what Chinese artists were trying to say and what the West wanted it to mean – if anything, the presence of Chinese art was good enough because it was the presence of something different from yesterday. But 1993 was evidently a big year for addressing this problem; the 1990s was the heyday decade of Asian art abroad. The year 1993 witnessed the biggest survey in Europe to date of contemporary Chinese art with *China avant-garde: Counter-currents in Art and Culture* staged at the House of World

[11]Fei Dawei, 'The Problems of Chinese Artists Working Overseas', in *China's New Art, Post-1989*, exh. cat., Hong Kong: Hanart TZ Gallery, 1993, 41. Writing in 2002, David Clarke was to observe again 'So far, however, art history has proved much less adept than the curatorial world in addressing Asian artistic output of recent times, and much needs to change if art history is to meet this challenge adequately.' David Clarke, 'Contemporary Asian Art and Its Western Reception' (2002), in Melissa Chiu and Benjamin Genocchio (eds), *Contemporary Art in Asia: A Critical Reader*, Cambridge, MA: MIT Press, 2011, 159.

[12]See for instance *Artistes chinois à Paris*, exh. cat., Paris: Musée Cernuschi, 2011.

Culture (Haus der Kulturen der Welt) in Berlin, curated by German Andreas Schmid and Belgian Hans van Dijk. This coincided in the same year with *China's New Art, Post-1989*, in Hong Kong curated by the dealer and writer Chang Tsong-zung and the critic Li Xianting. Also in 1993, the inaugural triennial festival of Asian art, the Asia Pacific Triennial in Brisbane, opened. This was not established purely as an altruistic mission for exposure for Asian artists. Before such considerations could be entertained, the triennial was a move to establish Australia's cultural credentials as having a special Asian cachet superior to its much larger American and European rivals. It was also the opportunity for the relatively obscure city of Brisbane to put itself onto the cultural map. To some extent it had its effect – the new Gallery of Modern Art was opened to great fanfare in 2006 – but the various triennales have helped to demonstrate how diverse and large Asia is, and that to try to make sense of it, or represent it for want of a better word, is as unmanageable and as absurd as the obverse, a Euro-American festival. (Although that might be the Venice Biennale, an essentially European festival that 'colonizes' its differences.)

But the divide between Chinese artists' intentions and Western perceptions, that Fei and others describe, is only half the story. Since Mao's death, Chinese art increasingly became divided into roughly three groups: the first clung to age-old traditions, the second kept subservient to the standard social realism that had been used to propagate the party's more and aims, while the third were thirsty for a more international perspective, believing Chinese art to have long been insular and contrived. In short, they wanted to catch up, and to be seen as being up with the times, 'contemporary'. For instance in the late 1980s, imagery of Mao was rife within China, suggesting, as Geremie Baumé argues, a new wave of tolerance, or at least a transition of power, with artists such as Wang Guangyi, Liu Dahong, Yu Youhan, Wang Ziwei and Liu Wei. But as Baumé presciently observes:

> It is not surprising, however, that much of the cultural iconoclasm that plays with Chinese symbols tempers its irony with a disturbing measure of validation: by turning orthodoxy on its head, the heterodox engages in an act of self-affirmation while staking a claim in a future regime that can incorporate them. On this most sublime level Mao has become a consumer item.[13]

In other words, Chinese artists of this time could have it both ways. With Warhol always waiting in the wings for potential iconographic legitimacy in the act of appropriation, the artists could play at burlesquing the great leader while continually also lionizing him. But one can only speculate whether Mao imagery would have been as widespread among artists had Warhol's famous versions not existed. And it gives rise to the greater speculation as to the extent to which Chinese artists, once access to the West had become greater and when the West began to train more eyes on China, began self-consciously to produce work with a more international and contemporary flavour, or their version of what that could be. It is this very important

[13]Geremie Baumé, 'Reformist Baroque: Liu Dahong and the Chinese Fin-de-Millennium', in *Liu Da Hong: Paintings 1986–92*, exh. cat., Hong Kong: Schoeni Fine Oriental Art, 1992, 8.

consideration that tends to subvert the notion that the chasm between contemporary Chinese art and other contemporary art is fallacious, or at least ought not be treated too simplistically.

One of the most important watersheds in Europe and America's taste for contemporary Chinese art occurred in 1998 when a doctoral candidate from Harvard, Gao Minglu, curated *Inside Out: New Chinese Art*, held at the San Francisco Museum of Modern Art and at the Asia Society and PS1 in New York. The appetite within the art world had already been whetted: after previous surveys, the work had moved from a trickle to a flow in the commercial market, while the founding of the publishing house that would later be called Timezone 8 by Texan-born Robert Burnell consolidated the dissemination of a wealth of material on Chinese art and artists to an Anglophone audience. As with any exhibition whose chief intention is to introduce what a culture had to offer, *Inside Out* was uneven, but contained artists that from then on became the staple Chinese artists in ensuing surveys and festivals. Zhang Huan exhibited photographic records of his now famous performance, *Twelve Square Meters* (1994), in which the artist sat naked in a public latrine covered in fish oil and honey attracting a myriad of flies to his skin: a comment on the poor state of public sanitation in China. Zhang Xiaogang exhibited a painting with his now characteristic softened brushwork and impassive faces. Geng Jianyi exhibited a suite of his gigantic canvases of laughing faces. While these and others have become multiply reproduced and discussed since, there were numerous embarrassing forays in political comment and allegory, revealing that the literalism of Socialist Realism had not fully loosened its grip.

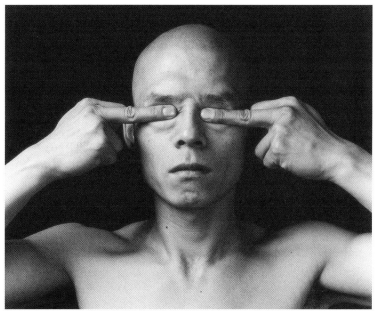

FIGURE 4.2 Zhang Huan, *Skin*, 1997, Beijing, China. Courtesy of Zhang Huan Studio.

FIGURE 4.3 Zhang Huan, *Pilgrimage, Wind and Water,* New York. *Skin*, 1997. Courtesy of Zhang Huan Studio.

FIGURE 4.4 Zhang Huan, *To Raise the Water Level in a Fishpond*, Beijing, China. Courtesy of Zhang Huan Studio.

In the catalogue, Gao made much of the changes that had taken hold in Chinese art over the past two decades, averring that

> Chinese artists overseas may play the most important role on confronting and communicating with an international cultural mainstream. Rather than being part of a 'diaspora', the identity and visual world of recent émigrés may be shaped by, and may be shaping, a 'third space' that truly is between East and West.[14]

[14]Gao Minglu, 'Towards a Transnational Modernity: An Overview of Inside Out: New Chinese Art', *Inside Out: New Chinese Art*, exh. cat., Berkeley and London: California University Press, 1998, 19.

In the same catalogue, art history guru of the late 1990s, Norman Bryson, weighed in with comments about the recent radical transformations in Chinese culture: 'The terrain opened up by colliding forces affords singular opportunities for aesthetic invention and critique.'[15] But the question remained as to the effectiveness of this critique and the nature of its audience. If critique could only take place within certain boundaries, then it was for the satisfaction of Western viewers who were more in a position to fulminate about the social constraints imposed on the majority of China's population – and this was all the more attractive as politically 'engaged' art, since the West was powerless to do anything. So you had your critique without the need for action: a perfect high Capitalist combination.

And the 'third space' that had magically opened up was perhaps not necessarily a desirable place, but a place more of dilution than imbrication. Speaking not of Chinese art per se but of modes of appropriation and adaptation, the film and cultural theorist John Conomos has coined the term 'Xeroxed culture', where a group freely copies models of behaviour, language, genre or imagery with the effect, like an old Xerox, of being an inferior copy of the original. This was effectively what Jenny Liu remarked in her review of *Inside Out* that appeared in the art journal *Frieze*. Her final paragraph raises many issues that are even more relevant today:

> With globalisation the current big thing, and China increasingly a power to reckon with, this survey was both inevitable and ambivalent. The intentions are good, the effort and curatorial impulses admirable, but the work, however, is too often turgid and uncritically adoptive of Western artistic frameworks. The show tells us something about the pitfalls facing Chinese artists, whose work at its worst veers between the tediously derivative and the hopelessly provincial. At the same time, the many successes and near-misses bring up questions about what we, in the West, expect in terms of a global Modernism or Postmodernism. Is contemporary art, wherever it originates, supposed to address itself to an international community? And how do we reconcile the popularity and success of installation art among non-Western artists, at a time when it is becoming a trifle stale to young Western ones? I'm not convinced that the homogenisation of contemporary art is so desirable. Nor that the only worthy art is that which explores previously unoccupied territory.[16]

The last point is particularly worth reflecting upon, touching on how cultural capital benefits sharply from possessing something unexplored, or unknown. It proves to be even more beneficial when, like traditional Aboriginal art, that thing cannot be known. And, like Aboriginal art, where a consumer can absorb the rays of spirituality without needing to have anything to do with the people themselves, to support Chinese contemporary art was to show fealty with the desire for free comment and personal freedom. The sentiment was enough. Critically speaking,

[15]Norman Bryson, *Inside Out: New Chinese Art*, Berkeley and London: California University Press, 1998, 27.
[16]Jenny Liu, 'Inside Out: New Chinese Art', *Frieze* 44, January-February 1999; http://www.frieze.com/issue/review/inside_out_new_chinese_art/

there is also something comforting about the ignorance of language and context since one is disallowed from the very start from passing too harsh a judgement. So with the worst of the painting in *Inside Out*, was it really bad or are we just not seeing it for 'what it really is'? Similarly in the last decade or so discussion has gathered apace regarding appropriate and admissible methods of critically assessing traditional Aboriginal art, whose apparent content is different from its spiritual content, with the meaning of its motifs occasionally withheld by elders from the very artist who paints them.

One of the more lasting and popular legacies of the Chinese contemporary art rage was performance art. Not only Zhang Huan, but others such as He Yunchang, Yang Zhichao, Song Dong, Qin Ga and Zhu Yu quickly became celebrities who toured the circuit in Europe and the United States. In 2006, He Yunchang held the performance *Touring Around Britain with a Rock*, doing just that. It was Richard Long with a special transcultural inflection, and probably a sore neck and arm at the end. Zhang Huan, accustomed as he was to disrobing, had a multitude do the same and pose with him. In the Seattle Art Museum in 1999 he staged *My America (Hard to Assimilate)*, a Chinesification of Vanessa Beecroft, in which he sat on a stool surrounded by three tiers of scaffolding containing rows of upright naked men and women. Strewn on the floor was all manner of white bread, in loaves or broken into bits. The title itself was desirable enough to an American audience, since capitalist culture thrives off messages that criticize it, while devouring and denaturing them to its own ends. After all, the artist's purported difficulty in assimilating was precisely what assisted his safe passage into the museum.

One of the biggest sensations in the new millennium is Ai Wei Wei. He also exemplifies the extent to which the popularity of Chinese Contemporary art is oriented towards Western markets and minds. For reasons that reach beyond art proper, Ai is easily the biggest star of both the local Chinese scenes and the diaspora. Enrolling in the Beijing Film Academy in 1978, Ai soon found his way to New York in 1981, where he lived until 1993 and continued his studies at the New School (Parsons) and the Art Students' League. Back in China in 1997, Ai founded the China Art Archives and Warehouse, a home for experimental art in Beijing for Chinese artists. From then until the present Ai has shown himself to be adept in many media, including architecture, such as a collaboration in 2006 with HHF Designs for a home in upstate New York, that was subsequently selected for the International Architecture Awards of the Chicago Museum of Art and Design.

Perhaps his most celebrated work is *Fairytale*, which he executed for Documenta 12 in 2007. Here the artist organized for 1,001 people from all over China to come to Kassel. While there were residual material components – purpose-designed clothes and luggage, the makeshift accommodation in a disused textile factory and films of earlier interviews of people while still in China – the 'actual' work was the wandering of the people throughout the city for the three-month life of the exhibition. Whether this is another case of large-scale relational aesthetic box-ticking is something we will leave for the reader to judge. But Ai, for all his globetrotting and his artistic expansiveness, had always been a man of conviction, an outspoken advocate for human rights. The triumph at Documenta made him a household name among contemporary art-goers, which only made more spectacular Ai's condemnation of the corruption and

misrepresentation used to cover up inadequacies that led to the collapse of a school caused by the 2008 Sichuan earthquake. As a result he was, equally spectacularly, arrested at Beijing airport in 2011 and held in custody for two months owing to alleged tax evasion allegations. Thus Ai was catapulted to the status of world figure. For a Chinese citizen grounds for this were, and are, the most savoury to Euro-American tastes: the injustices within China and muzzling of any criticism. These issues indeed come to the fore within art, which in the Western sense is about the celebration of personal expression.

Just as 1993 is a landmark year in the evolution of Chinese contemporary art, its popularity and dissemination, so is 2008. Not only had the financial crisis that rattled Europe and America left China barely bruised, but it was also the year of major retrospectives of Cai Guo-Qiang at the Guggenheim, and Japanese artist Takashi Murakami at the Brooklyn Museum.[17] The presence of the solo survey as opposed to the group exhibition was but a smaller indication of a much larger trend, namely that Chinese or, more broadly, Asian art had begun to imbricate into the fabric of the Euro-American art scene. Thus globalization had offered up what it had promised (or threatened), a kaleidoscopic mixture of race and identity of many modulations of cultural inheritance, migration and representation. This evolution is also due to the rise of markets within Asia in the last two decades, a stronger awareness and interest in contemporary art, and the desire to beat the old with the new: The Hong Kong Art Fair, the Singapore Biennale and the Shanghai Biennale (note that the Shanghai Museum of Contemporary Art was opened as recently as 2005) are examples of Asia's energy in vying for a stake in the global art market, a stake they are fast increasing, to the consternation of some. Nonetheless, festivals such as the Basel Art Fair, the Venice Biennale and Documenta continue to hold the largest critical cachet and the most serious attention.

With the former Orient in the form of India and China proving to be far more than subaltern, the question remains as to whether Chinese and other Asian artists, knowing that Euro-American approbation is key to their professional longevity, are willing to play the subaltern to a West which is all too willing, in its arrogance, to be its own dupe. We stress 'dupe'. From a political and economic standpoint the 'West' is now continually warning itself that it ought not to underestimate the 'emergent superpowers'. In the theatre of art, it has become difficult if not impossible to distinguish the Other from the Other-player. Iago the deceiver and Othello the outsider have merged into one, by default and by design.

[17]See Melissa Chiu and Benjamin Genocchio, 'Introduction: What Is Contemporary Asian Art? Mapping an Evolving Discourse', in Melissa Chiu and Benjamin Genocchio (eds), *Contemporary Art in Asia: A Critical Reader*, Cambridge, MA: MIT Press, 2011, 1 ff.

5 LESS IS LESS: FORMLESSNESS

Well, concerning civility or public morality, you can now see what's happening in art. For any art exhibition in London, for example, to be effective, it must be something disgusting: show some dead fish or the excrement of cows. At one exhibition, my god, they showed a video of a colonoscopy. Today, more and more, the cultural-economic apparatus itself has to incite stronger and more shocking effects and products. These are the recent trends in the arts. But the thing is that transgressive excess is losing its shock value. I don't think these transgressive things shock people any more. They have become, to such an extent, part of the system – the operation of today's capitalism. The apparent radicality of some postmodern trends should not deceive us here. So the transgressive model should no longer be our model.

—SLAVOJ ŽIŽEK[1]

The anti-aesthetic was a powerful undercurrent in modernism. It eventually breached the cultural surface to become one of the ruling principles of postmodernism – and its effects are still powerfully felt in the art of today. The 'abuse of beauty', as Arthur Danto calls it by reference to a poem by Rimbaud, characterized many early modernist strategies – from Cubism to Expressionism, *Art Brut* and *Tachisme*, from Dada to Surrealism. Beauty and aesthetics came to be equated with the bourgeoisie and the official culture against which the avant-garde defined itself. One particularly influential strain of the anti-aesthetic, manifest in a number of approaches in the early twentieth century, was that which

[1]Slavoj Žižek, 'To Begin from the Beginning', in Yong-june Park (ed.), *Demanding the Impossible*, Cambridge: Polity, 2013, 77.

sought to attack form as such. These included *l'informel* and *l'informe*, the roots of two different traditions, namely *art brut* or Outsider Art on the one hand, and 'critical surrealism' and its legacy on the other. *L'informel*, 'an aesthetic of brute materiality and formlessness' where the 'collapse of structural cohesion' was a 'deliberate negation of the utopian prewar geometric abstraction epitomized by Mondrian', was consecrated in critical terms by French writer Michel Tapie in relation to artists such as Wols and Jean Dubuffet.[2] *L'informel* retained links to organic or bodily subject matter and was commonly evoked through 'worrying of the picture surface' by artists' scratchings and spillages.[3] Dubuffet saw the 'celebration of a massively ravaged and distorted body image, splayed out like a map to the picture's limits', as part of 'an enterprise for the rehabilitation of scorned values'.[4] The legacy of this take on formlessness is discussed in more detail in the chapter in this book on Outsider Art. Here, the focus is primarily the theoretical influence of and artistic inspiration taken from Georges Bataille's notion of the formless (*l'informe*) that also invokes related philosophical terms such as the sublime and the unrepresentable.

American art theorist Hal Foster identifies the return of the 'Surrealist revolt' as a significant characteristic of postmodern art.[5] In *Compulsive Beauty*, Foster argues that as the founding impulse of Surrealism, 'compulsive beauty' is less about beauty – love and liberation as Breton would have had it – than about 'traumatic shock, deadly desire, [and] compulsive repetition';[6] less about beauty, indeed, than the sublime. 'Compulsive beauty' not only stresses the formless and evokes the unpresentable, but also 'mixes delight and dread, attraction and repulsion … a negative pleasure'. Despite Andre Breton's efforts to distinguish death from beauty, it is like the sublime; it 'involves the patriarchal subject in the inextricability of death and desire'.[7] Foster's re-reading of Surrealism, together with the interpretations of Rosalind Krauss and Yve-Alain Bois (whose *L'informe: Mode d'emploi* [*Formless: A User's Manual*], 1996, proved a highly influential text and exhibition), secured Georges Bataille's critical ascendancy over his former rival Breton, who until then had undisputedly been Surrealism's central figure, its arbiter and its policeman (he was notorious for admitting and de-admitting his cadres in and out of the Surrealist fold). This postmodern recuperation pitted Breton's idealism against Bataille's base materialism; Breton's (highly mannered) romantic love against Bataille's raw sex (also highly mannered!); and Breton's exoticization of the feminine (as seen in the fanciful narrative, *Nadja*) against Bataille's dissolution of sexed identity in the 'continuity' of eroticism (and death!). Such a binary analysis may appear objectionable and

[2]David Hopkins, *Art after Modern Art 1945–2000*, Oxford: Oxford University Press, 2000, 17–18.

[3]Hopkins, *Art after Modern Art 1945–2000*, 19.

[4]Hopkins, *Art after Modern Art 1945–2000*, 19.

[5]As early as 1983 in Hal Foster, *The Anti-aesthetic: Essays on Postmodern Culture*, Port Townsend, Washington: Bay Press, 1983, then in Hal Foster, *The Return of the Real: The Avant-Garde at the End of the Century*, Cambridge, MA: MIT Press, 1996.

[6]Hal Foster, *Compulsive Beauty*, Cambridge, MA: MIT Press, 1993, xi.

[7]Foster, *Compulsive Beauty*, 29.

reductive, yet the *October* group's interpretation of the deep ideological rifts among the Surrealists in the late 1920s and early 1930s has had an important, and tenacious, legacy for contemporary art. Unsurprisingly, the fashion in the 'disenchanted' late twentieth century and early twenty-first century has been for Bataille.

Bataille's 'critical surrealism' was a source of inspiration for many of the key voices of post-structuralist criticism, not least Michel Foucault and Julia Kristeva, two theorists highly fashionable with the contemporary artists of the 1980s, 1990s and beyond. (Kristeva's now signature conception of the abject could be seen as Bataille's idea rebadged and slightly rejigged for feminism: mythic woman as pure matter (*soma*) vs male spirit (*psyche*); the male disgust at menstruation and so on.) Bataille's concept of *l'informe* became a cipher for his broader ideas around the impulse to resist categorization and the forced boundaries of identity. As often happens with fashion, the flash of originality and innovation dims with every duplication until such replication becomes something close to mass adoption. This was certainly the case for the formless, which moved from its roots in Bataille's writings of the 1920s and 1930s, to be taken up by art theorists from the 1980s onwards, and artists of the 1990s and early twenty-first century. It was invoked in installation art, which sought to explore entropy; it lurked beneath a strain of visual arts grunge; and, despite its distinct theoretical roots and argument, it was taken up as a key point of reference for the genre that became known as abject art (thus confounding the Bataille–Kristeva nexus all the more). As its interpretation became more and more literal, its critical agency diminished both through its institutionalization and its abuse, in providing an excuse for poor art. In other words, it came to pass that much art that looked like shit literally was, well, just shit.

L'informe

Here are two definitions from Bataille:

> …formless is…a term that serves to bring things down in the world…What it designates has no rights in any sense and gets itself squashed everywhere, like a spider or an earthworm … All of philosophy has no other goal: it is a matter of giving a frock coat to what is, a mathematical frock coat. On the other hand, affirming that the universe resembles nothing and is only formless amounts to saying that the universe is something like a spider or spit.[8]
>
> Spittle is finally, through its inconsistency, its indefinite contours, the relative imprecision of its colour, and its humidity, the very symbol of the formless, of the unverifiable, of the non-hierarchized. It is the limp and sticky stumbling block shattering more efficiently than any stone all undertakings that presupposed man to be something – something other than a flabby, bald animal, something other

[8]Georges Bataille, 'Formless', in *Visions of Excess: Selected Writings, 1927–1939* (Edited and with an introduction by Allan Stoekl, translated by Allan Stoekl with Carl R. Lovitt and Donald M. Leslie Jr.), Minneapolis: University of Minnesota Press, 1985, 31.

than the spittle of a raving demiurge, splitting his sides at having expectorated such a conceited larva: a comical tadpole puffing itself up into meat insufflated by a demigod.[9]

As these passages suggest, Bataille's *informe* attempts to invoke an energy that undoes settled meanings and, in particular, that questions the common-sense value attributed to dichotomies that structure our thinking, such as high/low, human/animal, matter/ philosophy. As American art historian Nina Athanassoglou-Kallmyer reminds us, Bataille's notion of the *informe* 'evoked not only lack of significant form or meaning, but also a process of aesthetic, moral, and physical degradation, the bringing of "things down in the world" by stripping them of all lofty references ... Bataille viewed [the operation of the *informe*] as an aggression against established, academic, and bourgeois aesthetic demands and norms'.[10] Yet, in seeking to keep these binary terms in play without coalescing them into fixed meanings, Bataille does not simply invert the established hierarchy. For, underpinning his writing was a 'vision of excess' that sought to undo the very notion of 'project', that was unwilling 'to submit what has been instituted to any recuperative dialectic'.[11]

The impulse of the *informe* is associated with both heterogeneity and 'the politics of the impossible' in Bataille's writing, the latter calling 'for a revolt against anything that pretends to be completed, full, transparent, and necessary'.[12] As Bataille wrote in an essay entitled 'Politics', 'It is a strange paradox: if one perceives the profound lack of a way out, the profound absence of an end and of meaning, then – and only then – can one actually, with a liberated spirit, lucidly tackle practical problems'.[13] As Besnier reminds us, Bataille's thoughts emerged under very specific historical circumstances; Europe was experiencing the rise of fascism, the aftermath of one war and the impending threat of another that proved to be more calamitous than the first. Given this, his impulse towards the radical dissolution of orthodox thought and established categories of knowledge and behaviour is no surprise. However, how translatable are his ideas?

Postmodern anti-aesthetics

This was art that saw ... beauty, anger, love, innovation, original information, art in fact, as a grand narrative bereft of credibility. It was vital to display not art but products totally devoid of the qualities that define art and its function
—*Jeff Nuttall (2001)[14]*

[9]Georges Bataille et al., 'Critical Dictionary', *October*, Vol. 60, Spring 1992, 25–31.

[10]Nina Athanassoglou-Kallmyer, 'Ugliness', in Robert Nelson and Richard Shiff (eds.), *Critical Terms for Art History*, 2nd edition, Chicago, IL: University of Chicago Press, 2003, 291.

[11]Jean Michel Besnier, 'Georges Bataille in the 1930s: A Politics of the Impossible' (trans. Amy Reid), *Yale French Studies*, No. 78, On Bataille 1990, 175.

[12]Besnier, 'Georges Bataille in the 1930s', 177.

[13]Bataille, *Oeuvres Complets*, 6, 251, cited in Besnier, 'Georges Bataille in the 1930s', 179.

[14]Jeff Nuttall, *Art and the Degradation of Awareness*, London and New York: Calder/Riverrun, 2001, 122–3.

Let us look at how Bataille's *informe* and its impulse to undo categories and 'abase' the world have influenced contemporary art. One starting point could be the anti-aesthetics associated with postmodern art, grounded in early negative critiques of value, the stable speaking subject, formal considerations, 'official representations' and the expectation that art 'communicates'.[15] This early postmodern anti-aesthetic developed in two ways in the following decade: one as a move towards affectlessness – the exclusion of the viewer in the mode of certain art inspired by Minimalist forms which is the focus of Chapter 8 – and the other as what Foster (some years after identifying the anti-aesthetic as the marker of the postmodern) called 'the return of the real'. In trying to make sense of this turn in contemporary art, Foster looked to Surrealism and the sublime, in a gesture that placed Bataille's *informe* centre stage:

> The breaching of the body, the gaze devouring the subject, the subject becoming the space … : these conditions are evoked in recent art … It recalls the perverse idea of the beautiful, redefined in terms of the sublime, advanced in Surrealism: a convulsive possession of the subject given over to a deathly *jouissance* … [comprising] ecstasy in the imagined breakdown of the … symbolic order; … horror at this … event followed by despair about it.[16]

The sublime captured the imagination of many a post-structuralist thinker and postmodern artist for its infinitude, unrepresentability and elusion of language. These were appealing qualities for a project that aimed to challenge the perceived 'univocal authority of dominant discourse' as the jargon went, through avenues for the expression of difference. According to one of the fathers of postmodernism, Jean-François Lyotard, the sublime in art is enticing to philosophers as 'the gap through which the work escapes being converted into meaning'.[17] That is, the sublime appeals to post-structuralism's embrace of formlessness, of the unbounded, of that beyond of representation that does not fall captive to the straightjacket of reason and definition inherent in language. By contrast, the beautiful 'concerns the form of the object, which consists in the object being bounded'.[18] Lyotard ventures that with modern art, artists turned from the presentation of form – beauty – towards an attempt to grasp matter, presence, without form, hence the sublime. Such artists turned from assuming an affinity between nature and understanding in form, to a desire to dispense with understandings that necessarily subscribed to pre-existing concepts. To have matter without form, Lyotard enthused, means to experience an 'invasion of nuance', an 'infinity of harmonies'.[19] His theories inspired a great deal of art that sought to evade meaning through formlessness or evade language and representation through silence. In some senses, such 'formless' art affirmed its critical credentials – its fashionability – by 'abusing' beauty. As such

[15]First captured in Hal Foster's *Anti-aesthetic*, 1983.
[16]Foster, *The Return of the Real*, 165.
[17]Mark A. Cheetham, *Kant, Art and Art History*, Cambridge: Cambridge University Press, 2001, 102.
[18]Kant, cited in Cheetham, *Kant, Art and Art History*, 105.
[19]Jean-Francois Lyotard, 'After the Sublime: The State of Aesthetics', in David Carroll (ed.), *The States of Theory: History, Art and Critical Discourse*, Stanford, CA: Stanford University Press, 1990, 301.

beauty once again became the superannuated concept of about a century before, when the Austrian architect Adolph Loos equated ornament with crime. Beauty was a sort of commodity whereas the goal of the postmodern artist was to attain ungraspable truths. And if you were dealing with the inarticulable, then you really didn't need to have anything to say. Quite often the sublime in the 1980s and 1990s meant the obverse: the nullity of being above reason (*sublimus* literally means 'above the lintel') means you could just have nothing, or nothing much.

In *Venus in Exile: The Rejection of Beauty in 20th Century Art* (2001), American literary and cultural theorist Wendy Steiner argues that the Kantian sublime – incommensurable, unattainable, overwhelming and terrifying – became the guiding spirit of the modernists and has characterized modern and contemporary art since. Steiner associates the sublime with a profound negativity, with hopelessness and an acceptance of the inevitability of devastation that distinguishes much modern art from its premodern counterparts. She also associates the championing of the sublime and the concomitant derogation of beauty with a pervasive misogyny in Western culture. Beauty came to be associated with the feminine – domesticity, ornament, modesty of scale, sensual pleasure – and just as femininity was marginalized as conservative and frivolous in the avant-garde stakes, so was beauty. This is a point we will return to shortly in terms of the gendered assumptions underpinning the theoretical uses of 'formlessness'.

In *The Return of the Real*, Foster links the sublime, formlessness and the turn 'from reality as an effect of representation to the real as a thing of trauma'.[20] The most compelling instance of this 'return of the real' was abject art, a phenomenon that continues the anti-aesthetic impulse of the postmodern through a reliance on the negative affects of horror, shock, disgust and revulsion (in contrast to the affectlessness of hyper-minimalism). Foster positions abject art as a type of anti-illusionist art, one that tries to 'evoke the real as such', its ambition being 'to tease out the trauma of the subject'.[21] Its critical framework relied largely on Kristeva's definition of abjection in *Powers of Horror: An Essay on Abjection* (translated in 1982). For Kristeva, abjection marked the limit of subjectivity – the abject is what must be ejected for the subject to properly constitute himself or herself – and is what becomes evident when subjectivity is threatened. Hence, abject art continues the early postmodern assault on subjectivity, although at the same time seeks to access the truth of the subject outside the chimera of representations.

In general, according to Foster, abject art took two directions: one, identifying with the abject and probing the wound of trauma; and the other, representing the condition of abjection in order to provoke its operation. Foster compares these strategies with the divergence in Surrealism in the 1930s between 'excrement-philosopher' Bataille and 'idealist aesthete' Breton. On the one hand, in the Bretonian tradition, abject art amounted to 'Oedipal naughtiness' where artists provoked the paternal law 'as if to ensure that it is still there – at best as a neurotic plea for punishment, at worst a paranoid demand for order'. The artists Foster

[20]Foster, *The Return of the Real*, 146.
[21]Foster, *The Return of the Real*, 152–3.

associates with this direction tended to be women, including Kiki Smith and Rona Pondick. On the other hand, in the Bataillian tradition, abjection amounted to 'infantile perversion', wallowing 'in shit with the secret faith that the most defiled might reverse into the most sacred, the most perverse into the most potent'.[22] The artists identified with this direction tended to be men, including Mike Kelley and Paul McCarthy, whose 'shit movement' Foster interprets as 'a turning from the father that is a twisting of his law'. In describing Kelley's practice, and the central role that trash, shit and detritus play within it, Foster evokes many of the qualities of late postmodern anti-aesthetics:

> The result is an art of lumpen [from the German word for rag that gives us Marx's *lumpenproletariat*: 'the scum, the leavings, the refuse of all classes'] forms (dingy toy animals stitched together in ugly masses, dirty throw rugs laid over nasty shapes), lumpen subjects (pictures of dirt and trash) and lumpen personae (dysfunctional men that build weird devices ordered from obscure catalogues in basements and backyards). Most of these things resist formal shaping, let alone cultural sublimating or social redeeming.[23]

Drinking deep from the cup of Bataille's transgressive *informe*, Kristeva's liminal abject, and Theodor Adorno's notion of the 'nauseating and physically revolting' as decrying domination, Foster's analysis locates abject art in terms of its purported challenge to the social law and the cultural exigencies of subjectivity.[24] The abject tests the boundaries of sublimation set by bourgeois society, it disturbs identity, system and order in the individual and in society.

The critical value of formlessness

Anti-aesthetic gestures underpinned by the critical valency of the formless –such as bad or degraded technique, an avowed refusal of the notion of value, the exhibition of unadulterated detritus as work and the apparent desire to repel the audience – are still fashionable in contemporary art. They have been thoroughly consecrated in the institution – the museum, the market and the educational network – and continue to be held up and replicated as instances of critical practice. In a full reversal of the original impetus of Bataille's formless, the normalization of formless anti-aesthetics perpetuated a new hierarchy where those artists and critics who longed for an alternative value structure were marginalized. In Australia, for example, artists such as Hany Armanious, Kathy Temin, Mikala Dwyer and (the late) Adam Cullen produced art of lumpen formlessness, including a tattered bear splattered with naphthalene flakes and

[22]Foster, *The Return of the Real*, 159.

[23]Foster, *The Return of the Real*, 164.

[24]For Adorno, in modern art's 'penchant … for the nauseating and physically revolting … the critical material motif shows thorough: In its autonomous forms, art decries domination': Theodor Adorno, *Aesthetic Theory*, 1997, 49, cited in Athanassoglou-Kallmyer, 'Ugliness', 293.

'a strange-looking object like some kind of backyard afterbirth incubating machine' (Cullen); a grimy carpet, skid-marked underpants, gooshy industrial soap smears and 'intransigent dumb blobs of matter' (Armanious); and a golf bag stuffed into a pair of red pantyhose (Dwyer).[25] Shown at first in artist-run spaces, this 'formless', self-consciously 'bad' work soon came to represent the art world's institutional preferences: the work of these artists is held in flagship collections, curated in major exhibitions and commands handsome prices on the art market.

Thus formlessness went from a bastion of political protest and an expression of deep sociopolitical anxiety to become recognizable, desirable, celebrated and fashionable, yet, ironically, within strict parameters. Postmodern anti-aesthetics preferred its critique served cold: art too closely aligned with grassroots political activism was suspect. It was ignored – rejected as a vestige of an outmoded strategy of cultural intervention, or its political project completely elided in interpretations that attempted to rescue it from theoretical irrelevance. Postmodern anti-aesthetics may have been avowedly 'sensitive to cultural forms engaged in a politic (e.g. feminism)',[26] but they ignored the fervent anti-aesthetics that characterized much of the 1970s feminist art, for example.[27] The art of 'formlessness' was warmly received by the institution in the 1990s, but the wet and messy feminist works of the 1970s remained repressed, as Australian art historian Catriona Moore argues:

> [N]o critic would dare to consider Hany Armanious' shitty offerings, Kathy Temin's Electra Complex or Mikala Dwyer's suburban neurosis as anything but arch aesthetic references. The paternal benevolence of art criticism blesses these museum refugees, while their wicked aunties and step-sisters remain in purgatory for sullying conceptualism with the grubby fingers of social realism.[28]

This feminist and social project blind spot is also apparent in an influential exhibition that sought to upend conventional understandings of modernist art history through invoking Bataille's *informe*. Rosalind Krauss and Yve-Alain Bois (the curators of *L'informe: Mode d'emploi*)[29] ignore the social projects at the core of the art of Cindy Sherman and Mike Kelley in their attempt to differentiate this work from the sticky protests of the abject and to affirm its art historical significance.[30] The exhibition is notable for its almost complete avoidance of feminist work – a curious omission given feminist art's assaults on modernist form, hierarchy and categories in the 1970s. Indeed, *l'informe*'s curatorial themes as drawn from the theoretical impulses of Bataille's notion – horizontality (over the erect subject), base materialism (anti-hierarchy), pulsation (libido over cognition) and entropy (chaos over order) – echo

[25]See Jane Rankin-Reid, 'Shirthead', *Art/Text*, Vol. 46, 1993, 78; Shaun Davies, 'Adams', *Agenda*, Vol. 32, July 1993, 8; Eve Sullivan, 'Hany Armanious', *Agenda*, Vol. 36, May 1994, 27; Robyn McKenzie, 'Kathy Temin: Infantile Terrible: Object Relations and the Problem Child', *Art + Text*, Vol. 45, 1993, 30.
[26]Foster, 'Postmodernism: A Preface', in *The Anti-aesthetic*, xv.
[27]See, for example, Catriona Moore, 'Museum Hygiene', *Photofile*, Vol. 41, March 1994, 8–14.
[28]Moore, 'Museum Hygiene', 12.
[29]Yve-Alain Bois and Rosalind Krauss, *L'informe: mode d'emploi*, Paris: Centre Georges Pompidou, 1996.
[30]See Hou Hanru, 'The Impossible Formulation of the Informe', *Third Text*, Vol. 10, No. 37, 1996, 91–3.

many of the radical strategies of early feminist art. Nonetheless, only four female artists were included in the exhibition, and these were interpreted through narrow theoretical ciphers.[31]

FIGURE 5.1 Cindy Sherman, *Untitled*, 1987. Courtesy of Cindy Sherman and Metro Pictures, New York.

This avoidance of feminist 'formlessness' speaks of a broader phenomenon, namely the privileging of art at a remove from authentic feeling and the social. This aversion to 'the grubby fingers of social realism' that marked postmodern anti-aesthetics – 'a ... *de rigueur* disdain for "message art", community art [and] artworkers' collectives'[32] – remains fashionable in contemporary art (despite various moves to re-conceptualize 'community art' as discussed in Chapter 6 on participatory art). Contemporary 'formless' artworks operate in a very different way from the provocative gestures of the historical avant-garde, gestures that were often motivated by passionate agendas, where the prevailing aesthetic order was perceived as directly associated with social and political repression. Instead, in contemporary anti-aesthetics there is a sense that there are no boundaries of taste to cross, which in turn means that engaging in anti-aesthetics loses its subversive impulse, and teeters on either the hedonistic or the cynical. Australian art theorist Rex Butler proposes that with kitsch art and Grunge, for example, 'everything is permitted in advance', so that the artist is freed from those very debates about aesthetic/anti-aesthetic, art/non-art and thus comes

[31]Joan Hugo, 'L'informe: mode d'emploi', *Frieze*, 11 November 1996.

[32]Adrian Martin, 'Before and After *Art & Text*', in Rex Butler (ed.), *What is Appropriation? An Anthology of Critical Writings on Australian Art in the '80s and '90s*, Brisbane and Sydney: IMA and Power Publications, 1996, 113.

to practise 'an empty virtuosity'.[33] The anti-aesthetic shock tactics of earlier avant-gardes, such as deskilled gestures, ready-mades and detritus, are redeployed, but in the knowledge of their ultimate powerlessness except as signs of the emptiness of art and the failure of art in its function as social critique. This risks jettisoning value per se – the value of art as object, the value of art as critique – and becoming nothing more than 'infantile silliness'.[34] In this vein we can also understand that the viewer is disposed to snigger at works like these and can feel comfortably superior. This is artwork of anti-awe; one is not in the presence of excellence, or rather it is excellence inverted to its obscene remainder.

Australian critic Jeff Gibson's description of Armanious' work captures this mode of art as puerile provocation perfectly: 'the transgressive character of this work has more to do with Bart Simpson than Marcel Duchamp', amounting to 'something of an aesthetic fart contest, an hilarious but by now generic affront to the standards of art world taste'.[35] Observations like these also raise another challenge to the critical value of formlessness: while it relied on critic baiting for its potency, the art world readily welcomed art that bit the hand that fed it in the hope of acquiring avant-garde legitimacy in a supposedly post-avant-garde, post-legitimacy (post-critical) age. Formless art, particularly as practised in lumpen mode, is very much aligned to the anti-skilling and outrage to taste and connoisseurship that has long roots in modernism but was most coherently articulated in conceptual and post-conceptual practices. Robert Hughes traces the anti-skill impulse in 'advanced' American art to the pronouncements of Clement Greenberg who regarded pictorial skill as 'a snare and delusion', deceptive and mind-fooling, 'a claim to importance by minor artists'.[36] However, such an impulse has a much longer tradition in European art with the romance of 'the primitive' and the 'unmediated' that began with the earliest twentieth-century avant-gardes (considered in Chapter 9). One important caveat: our observations so far do not discredit the deskilled, the immediate or the visceral in favour of the beauty and skill. For as we have argued, the objectives of Bataille's theories were tempered by his period, giving them their pungency. But there is something perverse about abject art at its most extreme.

When conceptual artists took up the anti-skill agenda in the 1960s and 1970s, it was as a challenge to the institution of art: to the narrow parameters within which value was awarded, to the elitist claim that artists had visionary powers and 'genius', to the so-called purity of art that did not countenance alternative modes of representing. Australian conceptual art pioneer Ian Burn asserted that traditional artistic skills such as rendering and figure drawing were 'not merely manual dexterity but forms of knowledge...Thus deskilling means a rupture within an historical body of

[33]Rex Butler, 'Introduction', in Rex Butler (ed.), *What Is Appropriation? An Anthology of Critical Writings on Australian Art in the '80s and '90s*, Brisbane and Sydney: IMA and Power Publications, 1996, 40.

[34]Jeff Nuttall's description of the work of certain young British artists (YBAs), 153.

[35]Gibson was specifically referring to Hany Armanious' exhibit *Abstract Pain Thang* and the exhibition Rad Scunge: Gibson Jeff, 'Avant-grunge', in Rex Butler (ed.), *What is Appropriation? An Anthology of Critical Writings on Australian Art in the '80s and '90s*, Brisbane and Sydney: IMA and Power Publications, 1996, 246–7.

[36]Robert Hughes, *American Visions: The Epic History of American Art*, London: Harvill Press, 1997, 613.

knowledge'.[37] Yet, as Hughes blusters, in the United States by the 1990s, anti-skill 'was so far internalised that it became simply a rationale for having little or no technique; and at this point it acquired political virtue by a semantic trick: the disparaging of the word "mastery"'. In other words, an artist could 'subvert' painting simply by being bad at it, as was claimed on behalf of American artist Sue Williams. Hughes cites the catalogue of the notorious 1993 Whitney Biennial that legitimized 'bad' art thus: bad art 'deliberately renounces success and power in favour of the degraded and the dysfunctional, transforming deficiencies into something positive in true Warholian fashion'.[38] This kind of anti-aesthetic arguably 'traps' criticality within the institution, affording 'the pleasure of striking more or less radical attitudes without the risk entailed in radical belief', an argument that undermines the critical value of formlessness and abjection.[39] Hence, not only was abject anti-aesthetics fuelled by a desire to 'challenge the social law'; it also found its *raison d'être* by seeking to outrage taste and test the institutional limits of the art world. As Hughes quips, 'nothing was more delicious to "advanced" taste than an enhanced sense of its own tolerance'.[40]

Anti-aesthetic art may have sought to resist all the demands of art history, style and aesthetics – through its 'banality', 'naivety', 'crudity' and 'artlessness'. However, instead of doing away with the authority of art, it replaced it with the authority of the work over the audience – in other words, with a kind of audience baiting – and ran the risk of falling into a sort of 'Grunge Romanticism'.[41] Indeed, the provocation of these anti-aesthetics rarely progressed beyond the relatively safe sport of institution baiting; it was intent on keeping alive the gap between art and life (rather than seeking to bridge it, as its conceptual antecedents had done), given that the work relied for its very *raison d'être* on the institutional setting of the art world. Its critic baiting and bad boy/girl taunting would have remained meaningless outside this context. As one critic asked, does one 'risk appearing aesthetically intransigent, uncool, non-cognisant of the subtlety of the work, or of … not getting the joke', or does one 'fall into the trap set by the artists of responding to their attention seeking in making any comment whatsoever'?[42]

The anti-aesthetics of the rough and ready, the lumpen, unrefined and deskilled, are now a style that is recognizably 'contemporary',[43] a brand even.[44] Attempting to capture the zeitgeist of millennial art, Australian curator Chris McAuliffe notes that the contemporary in art is marked by a 'refusal to stop', by the artist's 'stav[ing] off

[37]Ian Burn, 'The 1960s: Crisis and Aftermath', *Art & Text*, No. 1, 1981, republished in Ian Burn, *Dialogue: Writings in Art History*, Sydney: Allen & Unwin, 1991, 105.

[38]Hughes, *American Visions*, 614.

[39]Hughes, *American Visions*, 613.

[40]Hughes, *American Visions*, 605.

[41]Graham Forsythe, 'Monster Field', *Art/Text*, Vol. 46, 1993, 74.

[42]Davies, 'Adams', 9.

[43]Chris McAuliffe, 'Developmental Play: Deskilling and Deferral in Contemporary Art', *Avant-gardism for Children*, exh. cat. Brisbane: University Art Museum, University of Queensland, 1999, 15–20, 15.

[44]For example, Hany Armanious argued that there was no 'movement' of grunge in contemporary art, but that that brand had been conjured by a critic whose view misrepresented the artists' work: Hany Armanious, 'Artist's Statement' in 'The Hot Seat: The Artist and His Critic', ABC RN *Arts Today*, 10 November 2000: www.abc.net.au/rn/arts/atoday/ stories

the maturation of vision', by a 'general sense of the undisciplined'.[45] 'Contemporaneity', he argues, adopts childlike deskilling and deferral in aspiring to a 'rhetorical version' of modernist utopianism, enabling a version of institutional resistance – for example, a resistance of professionalism – that allows for material playfulness. Yet, McAuliffe acknowledges the problems inherent in this approach. For instance, lack of finish can edge into purposelessness and lack of discipline, so that the artist begins to provoke complaints of infantilism and accusations of historical redundancy through his or her churlish perpetuation of anti-bourgeois refusal: refusal of the work ethic, refusal to delay gratification, refusal of parent culture.[46] McAuliffe questions the continued relevance of such strategies outside the context of 1960s reactions against the art establishment, dominated as it was by formalism. He concludes, however, that such art persists because 'the child-like in its materiality draws together figures of resistance and resentment spawned over the intervening years', such as amateurism, do it yourself (DIY) and punk; 'through the boom years of 1980s, the informal and the unprofessional preserved the aura of marginality in the face of the seemingly irresistible juggernaut of market recuperation'.[47]

But how convincing is the 'resistance' and 'aura of marginality' of deskilled formlessness? Arguably, it remains a fashionable style that accrues counter-cultural cachet by dint of its opposition to the 'traditional aesthetics' of another, long redundant, era. Formless anti-aesthetics, in its aversion to authenticity and denial of the possibility of meaningful communication, in its attempt to abandon form and refusal to offer the possibility of pleasure-instigated thought, arguably defines itself by its opposition to beauty – distinguished as it is in conventional terms by completeness, coherence, formal balance, discipline and technical skill. In other words, to impugn beauty came to be the mark of 'advanced' or 'contemporary' art. As the new conformity, the anti-aesthetics of the 1990s carried forth the legacy of the early 1980s anti-aesthetic, which had asserted that its critical force lay in its attack on power relations, the hold of privilege, connoisseurship and 'quality'; this was despite the fact that these factors could hardly be seen to pertain to contemporary practice, particularly its market and institutional dimensions. The enemy that such anti-aesthetics railed against and invoked to justify their critical force was a paper tiger. And even if, as some have argued, that *was* the critical point of such art – to display its inability to stand outside the institution with indifference – once this was established, there was no future for such practice other than cynicism or nihilism, or infantile silliness.

Such tactics ebbed, paradoxically, into a loss of affect, or what Nuttall has called 'the degradation of awareness'. Writing of the yBa phenomenon, Nuttall observed:

> Outrage became difficult in the 1990s In the hands of people who are only outraged by a threat to their assumed right to self-appeasement, outrage has had most if not all its teeth drawn. Outrage in art needs anger, and anger needs love, the kind of anguished, yearning, caring, irresolvable involvement with others

[45] McAuliffe, 'Developmental Play', 18.
[46] McAuliffe, 'Developmental Play', 17.
[47] McAuliffe, 'Developmental Play', 18.

that has long ago been castigated …. The qualities of real shock and outrage have been disconnected. However dreadful the event, infantile silliness is all the artists can bring to it.[48]

Formless anti-aesthetics became a style without content, in a manner consonant with French philosopher Paul Virilio's analysis of contemporary art: it operated in a landscape without limits, without significance, without value, where the end result was the 'banalisation of excess'. Anti-aesthetic gestures – including attempts to outrage and shock which had clear antecedents in early modernism – persisted when not only had dominant social values and political realities radically changed, but when the whole idea of a transgressive avant-garde had been thoroughly problematized. These anti-aesthetics indeed smack of bad faith. Having undermined their own capability to perform a social function, eschewing all notions of utopianism, they merely go through the motions of 'transgression' without a rationale. Indeed they become part of a new conformism, the conformism of abjection, to use Virilio's phrase.[49] As Foster also suggests, if the symbolic order/ image screen is deemed to be torn, then to attack it 'might be beside the point'; even Foster's critical alternative, 'to expose [the order] in crisis, to register its points not only of breakdown but of breakthrough' does not appear convincing as a description of the 'shit movement' of abject art.[50] Moreover, if postmodern anti-aesthetics were a reaction to the stultifying dictates of formalism and high modernism, these were long dead and buried. Indeed, it could be argued that postmodern anti-aesthetics may well have misrecognized its enemy.

The art of abjection that aims to disgust presumably is only effective if its audience is still capable of this affect. As Danto argues, 'it would be of no value to such artists if a taste for the disgusting were normalised'; it is essential to the aims of such art 'that the disgusting remain disgusting, not that audiences learn to take pleasure in it',[51] or alternatively, become completely inured to or bored by it, as in the 'snickering, gum-chewing adolescents' and 'bored suits' British critic Rick Poynor spied among the audience of Jake and Dinos Chapman's *Hell*.[52] And yet, there is much to suggest that contemporary culture has indeed normalized disgust. One critic, the director of the Musée Picasso in Paris Jean Clair, has argued that the anti-aesthetics of 'repulsion, abjection, horror and disgust' form a 'new aesthetic category', whereby disgust now occupies the position previously held by taste.[53]

Another issue pertinent to the political value of the anti-aesthetic was its descent into inscrutability. One of the initial objectives of anti-aesthetics, for example as practised both by the Dadaists and certain postmodern artists influenced by

[48]Nuttall's description of the work of certain young British artists (yBas), 153.

[49]Paul Virilio, *Art and Fear*, London and New York: Continuum, 2003, 55.

[50]Foster, *The Return of the Real*, 157.

[51]Arthur C. Danto, *The Abuse of Beauty*, New York: Open Court Publishing, 2003, 53.

[52]Rick Poynor, *Obey the Giant: Life in the Image World*, London: August; Basel: Birkhauser, 2001, 67.

[53]Arthur C. Danto, 'Marcel Duchamp and the End of Taste: A Defence of Contemporary Art', *Tout-fait: The Marcel Duchamp Studies Online Journal*, Vol. 1, No. 3, December 2000. http://www.toutfait.com/issues/issue_3/News/Danto/danto.html

conceptualism and Minimalism, was to 'deflate' the art object by reducing it to a thing in the world, undifferentiated from other objects. However, all too often the result was that anti-aesthetic works were 'unreadable as art by any public other than that educated in advanced aesthetic theory'.[54] Indeed, the work, rather than become more accessible to the audience through its use of vernacular materials, intimidated the viewer in a similar, if distinct, manner to high modernism – a point American art critic Dave Hickey argues as one of the compelling reasons for the return of beauty. As British philosopher Paul Mattick surmises:

> While the anti-aesthetic has meant a repudiation of Greenberg's identification of modernism with non-linguistic visuality, language here still hovers outside the artwork (even when that work consists of text) as the explanation, external to it, necessary for its full functioning as art.[55]

The reactionary impulse of reproducing disgust and abjection in art has also been noted and analysed by Italian philosopher of aesthetics Mario Perniola. Citing Jacques Derrida and Kristeva, Perniola points out that not only can the negative pleasure of the sublime still be sublimated and overcome in art, but even the disgusting – the one dimension thought by Kant to be incapable of being absorbed by aesthetics, a dimension that seems to be irremediable and unmentionable, absolutely 'other' to the system – can be relieved by vomiting, by expulsion.[56] To Perniola, the aesthetics of difference would have yielded 'disappointing results' if the only options are disgust and abjection, for these remain as categories that *privilege* their opposite: 'the aesthetics of difference cannot be an aesthetics of disease, of trash, of abjection, because they are an indirect way of confirming identity and positivity'. In other words, 'transgression' has become a thoroughly culturally accommodated value. Moreover, Perniola adds, 'our research of an extreme negativity, the total abandonment of any criticism of the most brutal and disgusting reality, makes us fall victim to spiritualism, to fanaticism, to the most repressive tradition. The effort towards emancipation, the motive force of difference, is cruelly defeated'. Perniola warns that 'it is naïve to think that the negative owns a kind of integrity and autonomous splendour and to think evil as if it were good'.[57] Attempts to deploy anti-aesthetics, particularly those associated with abjection, as the exclusive means of forging a critical art, have backfired. Such anti-aesthetics run the risk of reinforcing existing power structures, of damning the lumpen and misshapen to its 'proper' place, of underlining rather than offering alternatives to the abject horror evinced by certain aspects of post-capitalist society.

[54]Paul Mattick, *Art in Its Time: Theories and Practices of Modern Aesthetics*, London and New York: Routledge, 2003, 128.
[55]Mattick, *Art in Its Time*, 128.
[56]Mario Perniola, 'Feeling the Difference', in James Swearingen and Joanne Cutting-Grey (eds.), *Extreme Beauty: Aesthetics, Politics, Death*, New York and London: Continuum, 2002, 11.
[57]Perniola, 'Feeling the Difference', 12.

This is a view shared by Virilio who proposes that abjection has become the new conformism, one that 'innovates an academicism of horror, an official art of macabre entertainment'. Virilio, like Foster and Perniola, traces the anti-aesthetics of contemporary art to its modernist forebears. In *Art and Fear*, Virilio writes that 'it was through the carnage of the First and Second World Wars that modern art from German Expressionism and Dada to Italian Futurism, French Surrealism and American Abstract Expressionism … developed first a reaction to alienation and second a taste for anti-human cruelty'. This observation prefaces his remarks about contemporary artists, who, 'spellbound by human violence', have 'abandoned their function of continually reassessing the creative practices and sensibilities, imagination and cultural meaning of advanced societies'.[58] Rather, such artists have 'murder[ed the] signs of artistic pity in the name of freedom of artistic expression', enforced 'the artistic suppression of sympathy' and sought to destroy 'careful viewer contemplation'.[59] It is a loss of compassion and pity Virilio attributes partly to art's loss of contact with nature, and its increasing identification with the values and aspirations of digitized post-capitalism. The modern and postmodern impulse to shatter the subject and evoke the sublime of abjection tragically coincided all too easily with the horror of contemporary social and political realities: 'You would think the drive to extinguish the suffocating culture of the bourgeoisie consisted specifically in exterminating oneself into the bargain, … thus giving ideas … to the great exterminators of the 20th century'.[60] Virilio adds that 'the verbal delirium' of modernism 'seems so oblivious to its own century and yet condescends to preach to the world in the name of freedom of expression … we are now supposed to *break the being*, the unicity of humankind'.[61] In reference to Adorno's powerful maxim that after Auschwitz to write lyric poetry is 'barbarism', Virilio surmises, 'Whether Adorno likes it or not, the spectacle of abjection remains the same, after as before Auschwitz. But it has become politically incorrect to say so. All in the name of freedom of expression, a freedom contemporary with the terrorist politics Joseph Goebbels described as 'the art of making possible what seemed impossible.'[62]

In the contemporary cultural climate, claims Virilio, an 'escalation in extremism' has brought with it a concomitant rise in insignificance, 'with significance going the way of the heroic nature of old-fashioned official art'.[63] This is a key point in the politics of late postmodern anti-aesthetics, which vaunts its insignificance and worthlessness as a perverse form of cultural capital. As Virilio observes, 'without limits, there is no value; without value there is no esteem, no respect and especially no pity … everywhere you turn, you hear the words that precede that fatal habituation to the banalisation of excess'.[64]

[58]Virilio, *Art and Fear*, 4.
[59]Virilio, *Art and Fear*, 5–7.
[60]Virilio, *Art and Fear*, 30–1.
[61]Virilio, *Art and Fear*, 32, 55.
[62]Virilio, *Art and Fear*, 57.
[63]Virilio, *Art and Fear*, 56.
[64]Virilio, *Art and Fear*, 63.

Late postmodern anti-aesthetics – the art of trash, shit, lumpen forms and abjection – continued to dominate advanced art practice well into the 1990s and beyond, even when its critical purchase was clearly exhausted. What had begun as attempts to access the elemental energy of 'the formless' as a way to generate alternate ways of being and to obliterate the notion of value ended in the precise opposite: the lumpen remained subjugated in its proper place and shit art was consecrated.

6 COME FLY WITH ME: PARTICIPATORY ART, INTERACTIVITY AND AUDIENCE INVOLVEMENT

Relational Aesthetics is also when a successful artist, um, who is too busy touring the globe going from biennial to biennial, and they have no time to make physical art objects any more, so the famous artist uses the attendees at the exhibition as the artwork in some way, you know what I'm saying, like to explore the social relationships between people and y'know this kind of practice is really good when you're already famous because, you know, you can bank on a couple of hundred people coming into your opening and y'know you know there's going to be mad motherfuckers around to do yer relational bidding. So it's good if you're famous, if you're not so famous, er, it might not work out for you, um, you might have to play, y'know, hide and seek or somethin', or peekaboo in the gallery, I don't know, um, but if you're famous, y'know, [click click], it's the way to go.

—HENNESSY YOUNGMAN[1]

Writing in 2008, art theorist *du jour* Boris Groys argued that a 'tendency toward collaborative, participatory practice is undeniably one of the main characteristics of contemporary art…. We are dealing with numerous attempts to question and transform the fundamental condition of how modern art functions, namely the

[1]Art Thoughtz, Hennessy Youngblood, 'Relational Aesthetics', https://www.youtube.com/watch?v=7yea4qSJMx4

radical separation of artists and their public.'[2] This is hardly a contentious argument. At least since the mid-1990s when French curator Nicolas Bourriaud coined the term 'relational aesthetics' to capture certain trends he observed in artistic practice at the time, 'participatory art' and its variants – including 'social practice', collective, networked and 'dialogic art' – have been fashionable. Of course, Bourriaud keyed in to long-standing ideas in the history of modernism around the political valency of seeking to reconcile art and life, an impulse that has always retained a certain critical appeal. And Bourriaud also invoked the enduring cachet of the Marxian cultural analysis of the Situationists, with their critique of the inauthentic experience ushered in by the 'Society of the Spectacle'.

At first, Bourriaud's catchy phrase was widely applied, by artists, critics and curators, in a rush that spoke not only of the zeal of early adopters but also of the relief that an easy-to-understand, apparently 'new', theoretical framework had emerged to 'explain' the contemporary scene and provide guidance to artists flailing in the wake of exhausted po-mo strategies. But like so many fashionable phrases, it has escaped a simple parsing. Aesthetics derives from the Greek 'aesthesis', which means what comes from the senses. Aesthetics is, therefore, relational from the very start, making the term tautologous but still rather serious-sounding. The insertion of 'relations' is a conveniently loaded term that fits tenuously into the 'everything and nothing' category. For after all everything is subject to relations with other 'others'; everything is relative, everything requires a context since nothing exists in a vacuum. But closer to home, the word also implies relations with people. In the age in which therapy has replaced religion and where it is more common to talk about community than to have one, any connotation of being together with fellow human beings has an emotive altruistic charge, and the 'joining-hands' mentality is ipso facto desirable and benign. In an era of social isolation, the best art is to afford inclusion, to give us the illusion that social alienation is easily surmountable, and that art still has a fair conscience to build community while the demographic, political and economic realities of the present are terrifyingly hopeless.

In effect, the term 'relational aesthetics' allowed artists to rally behind what appeared to be a new moral standard for art, but one that evaded the high moral ground of traditional avant-garde gestures with their assumptions about the potential of art to act 'outside' the dominant political system. Rather, this new standard operated in a strategic and 'feel good' way, working through 'provisional' gestures and producing 'social relations' as opposed to art objects, entirely contemporary in its taking account of the huge cultural changes wrought by developments in globalized capitalism that moved away from goods-based production and exchange, and towards the production and exchange of services and experiences. Bourriaud vaunted work that remained 'open-ended' and unresolved, that fit well within new curatorial approaches which privileged the 'laboratory' model, helping to make international stars of artists such as Rirkrit Tiravanija, Liam Gillick and Pierre Huyghe.

[2]Boris Groys, 'A Genealogy of Participatory Art', in Robert Atkins et al. (eds), *The Art of Participation, 1950 to Now*, exh. cat., London: Thames & Hudson and San Francisco, 2008, 19.

The zeal for new product, in particular one that filled a deeply felt gap, inflated the market appeal of 'relational aesthetics', but as sometimes happens with fashion sensations, the term soon encountered sceptics who sought to remind consumers of the product's shortcomings. Chief among the sceptics was British art historian and critic Claire Bishop, who arguably made her name by taking Bourriaud and the practice legitimized by his curatorial framework to task, in essence arguing that 'relational aesthetics' was neither new nor politically progressive. And yet, while as a result of these cogent assaults 'relational aesthetics' as such became a fashion crime in certain circles, the substantive practice it described retains its cachet to this day, if the number of artists working in this way that continue to feature in major exhibitions and publications that seek to define contemporary art is anything to go by.[3]

This chapter considers Bourriaud's opening gambit and its uptake, before analysing how the status of relational aesthetics as market leader was systematically undermined by a more discursive, open and historically contextualized approach to participatory practices. The current high fashion stakes of participatory art rely on a classic act of *détournement* that incorporates aspects of the critiques first levelled at relational aesthetics. Current participatory art seeks to address the 'quality' of the relations art practices create and the nature of the participants; it pays closer attention to the aesthetics of the artwork; it downplays both its historical novelty and its political efficacy and it does not resile from creating potentially confrontational situations that are not easily read as 'savvy' co-optations of commercial networks to create 'micro-utopias'.

Relational aesthetics

In *Esthétique relationnelle* (1998) (first published in English in 2002), French critic and curator Nicolas Bourriaud tapped into the frustration felt by many artists about art historical assertions that art was at an end, and that contemporary art lacked political engagement. Bourriaud sought to develop a different way of speaking about contemporary art, one that reduced art neither to 'a sum of judgments', nor to a movement.

He posed certain questions that went to the heart of the 'critical' aspirations of contemporary art: is it still possible to generate relationships with the world through artistic activity, rather than only represent the world? Can art function as a social

[3]Recent contemporary art blockbusters such as Documenta 2012 and The Biennale of Sydney 2012 (entitled All Our Relations) have featured a large number of participatory projects; recent devoted exhibitions and publications include Blake Stimson and Gregory Sholette (eds), *Collectivism after Modernism: The Art of Social Imagination after 1945*, Minneapolis and London: University of Minnesota Press, 2007; Robert Atkins et al., *The Art of Participation: 1950 to Now*, San Francisco, CA: Museum of Modern Art and London: Thames & Hudson, 2008; Nato Thompson, *Living as Form: Socially Engaged Art from 1991–2011*, Cambridge, MA: MIT Press, 2012, and of course Claire Bishop's many recent publications including *Artificial Hells: Participatory Art and the Politics of Spectatorship*, London: Verso, 2012.

experiment, a space protected from the uniformity of behavioural patterns, as an alternative to the mediation of human activity by commerce and spectacle? How can art be a 'hands on utopia'? Can it offer 'modest connections, open up obstructed passages, and connect levels of reality kept apart from each other'?[4] For much of the 1980s and 1990s – an age presided over by Jeff Koons and the yBas – these were not fashionable questions.

While a curator in the early 1990s, including for *Aperto* at the 1993 Venice Biennale, *Commerce* at Espace St Nicolas in Paris, 1994, and *Traffic* at CAPC Musée d'art contemporain de Bordeaux, 1996, Bourriaud tried to proffer possible answers to these questions, 'to find a point of contiguity' among the 'diverse practices' he observed around him. What he claimed to see was art that did not necessarily reiterate the avant-garde gestures of the past, but was doing something novel: putting the accent on sociability and interaction, on the relations between artists/public/work/ institutions, rather than making art objects. Bourriaud argued that contemporary art was 'carrying on the fight' begun by earlier avant-gardes to improve the world and to resist it being consumed by commercial interests, but with different strategies. It was no longer driven by the desire to change the world in a radical sense, but rather aimed to 'learn to inhabit the world better', and accordingly the strategies it employed were minor modifications, rather than overall reconstruction.

It is worth pausing to examine Bourriaud's statement, which reveals a great deal about the ideological agenda of relational aesthetics. For 'learning to inhabit the world better' is a notion that is not at all tinged with antagonism, rather the opposite. It implies appeasement, complicity, perhaps even complacency. We have to remember that relational aesthetics brought the often random practices of performance and happenings into the gallery, dusted them off and made them eminently more serviceable to a public, still thirsty for something smacking of 'the contemporary' but also with a taste for the consumable, the packaged. Thus Bourriaud's plea can easily be read as an aesthetic indoctrination. One cannot believe that an audience who is asked to participate in a work of art within the framework of the gallery will, as a result of this participation, be instilled with a deeper sense of community awareness and generosity. In fact, experience shows us that the opposite is more likely the case, in tight parallel with the negativity in charity: it is in participating in this limited, metaphoric, form of exchange that I relieve myself from the responsibility and the guilt of a much greater task. For curators, Bourriaud's programme was a treat, for the curator could now control and arbitrate over the performance, and it was also much easier to document, and place in lavish catalogues and artist monographs.

But Bourriaud's rhetoric holds fast: artists were working *within* rather than *outside* the broader social and political framework, in the manner of an *interstice* – what Karl Marx used to describe an alternative mode of exchange within capitalism. In the face of the endisms that had dominated the discourse of the 1980s, Bourriaud's curatorial gambit was that it was not modernity and the avant-garde that were dead, but rather the idealistic and teleological version of both: 'The role of artworks is no longer to

[4]Nicolas Bourriaud, *Relational Aesthetics*, trans. S. Pleasance and F. Woods, Paris: Les Presses du Reel, 2002, 8.

form imaginary and utopian realities, but to actually *be* ways of living and models of action within the existing real, whatever the scale chosen by the artist.' 'Any stance that is "directly" critical of society is futile, if based on the illusion of a marginality that is nowadays impossible, not to say regressive.'[5] Artists are 'tenants of culture', within it, not outside it (note again the choice of words, tenants are always financially beholden to their jobs from whose wages they pay a landlord). As such, Bourriaud discerned engagement with the minutiae of the everyday – 'a much more fertile terrain than pop culture' – rather than broad-brush political ideologies and movements, and critiques of globalization characterized by a playful and expansive, rather than didactic, tone.

As the Marxist reference underlines, these approaches to political action are not in themselves anything new. The re-interpretation of Michel Foucault's writings on power in the late 1980s to early 1990s (by such theorists as Antonio Negri) that reread biopower as the micro-politics of individual resistance, a revisiting of Michel de Certeau's theories of how the weak can 'inhabit' the strategies of the strong to pursue their own ends[6] and Louis Althusser's reviving of Antonio Gramsci's theories about the 'semi-autonomy' of the cultural superstructure from the economic base are just some examples of ideas that emerged to counter the disgruntlement of the Left after 1968. But, significantly, Bourriaud claimed them as new strategies in art. In doing so, we could say he was simply fulfilling his brief as a curator of a contemporary art space: he created a new fashion, but also set it up for a fall.

Drawing on earlier artistic manifestations of these approaches (albeit without acknowledgement, including Robert Morris' and Donald Judd's 'relational art' and Lygia Clark's 'relational objects' from the 1960s and 1970s), Bourriaud christened these purportedly new strategies 'relational aesthetics'. Contemporary art, he argued, is *relational*, corresponding to the worldwide spread of urban culture in the late twentieth century, such that we no longer walk through art, but we live through it. (But if that is the case, if contemporary art is relational, and contemporary art is aesthetic in some way, was he staking a claim for all of contemporary art?) Art does not simply hang within the walls of private collections and galleries, but enters into active relations with urban populations, functioning in the mode of 'an encounter', an 'unlimited discussion', rather than a work or object. This relational aspect that helps form a bond or linkage may have always been a part of the image, but it has intensified in the experience of contemporary art. For, Bourriaud argues, unlike most forms of image culture, art allows space for 'free' exchange and thought outside prescribed limits:

> [A] contemporary art exhibition ... creates free areas and time spans whose rhythm contrasts with those structuring everyday life and it encourages an interhuman commerce that differs from the communication zones that are imposed upon us Contemporary art is definitely developing a political project when it endeavours to move into the relational realm by turning it into an issue.[7]

[5]Bourriaud, *Relational Aesthetics*, 13.

[6]Brian Holmes comments on these developments as underpinning new cultural forms in the 1990s and beyond which he terms 'DIY Geopolitics': in Stimson and Sholette (eds), *Collectivism after Modernism: The Art of Social Imagination after 1945*, 273–294.

[7]Bourriaud, *Relational Aesthetics*, 16.

The key idea here is that this art is not about producing an object, but rather about producing – and not just *representing* – social relations. In relational art, the audience is envisaged as a community. Rather than the artwork being an encounter between a viewer and an object, relational art produces intersubjective encounters. Through these encounters, meaning is elaborated *collectively*, rather than in the space of individual consumption. One way that this idea has manifested itself is in artworks that strive for active participation from the audience and attempt to break down the distinction between the artist/producer and viewer/consumer. Bourriaud locates this tendency in art practice relative to critiques that emphasize the 'spectacular' quality of late capitalist societies and characterize their social spaces, such as the city, as alienating, inauthentic phenomena where consumerist fantasies created by capital are projected onto citizens, who in turn lose the capacity to define their own inner worlds. In particular, Bourriaud relies on Guy Debord's *Society of the Spectacle* (1967) to describe the state of alienation in which cultural producers find themselves in late capitalism.

In this now-canonical text, Debord proposes that in the age of advanced capitalism and mass media, authentic lived experience is supplanted by representation. Furthermore, passive identification with 'the spectacle' supplants genuine activity. The capacity for critical thought and resistance is undermined as 'the spectacle' manipulates the populace by unanchoring it from both personal and public histories and frames of reference. As Debord elaborates in *Comments on the Society of the Spectacle* (1988):

> [W]hen images chosen and constructed by someone else have everywhere become the individual's principal connection to the world he formerly observed for himself, these images can tolerate anything and everything.... Within the same image, all things can be juxtaposed without contradiction.... Spectacle isolates all it shows from its context, its past, its intentions and its consequences. It is thus completely illogical ... spectacular discourse leaves no room for any reply.... This absence of logic, this loss of the ability to perceive what is significant and what is not, has been intentionally injected into the population by the spectacle's anaesthetists/resuscitators.[8]

Debord thus characterizes the spectacle as a phenomenon that obliterates personal and collective memory, and casts the public into an eternal present where the past can only be accessed through pastiche. The spectacle renders the public passive, disconnected from authentic experience, the victims of mass deception and manipulation. Importantly for Bourriaud's argument, Debord asserts that 'The spectacle is not just a collection of images, *but a social relation among people, mediated by images*,'[9] and that 'the roles, ideas, and lifestyles possible within capitalist society are allowed to appear only to the extent that they appear as commodities'.[10]

[8]Guy Debord, *Comments on the Society of the Spectacle*, Paris: Editions Gerard Lebovici, 1988, reprinted online, n.d., http://www.notbored.org/commentaires.html, n.p.
[9]Guy Debord, *Society of the Spectacle*, Detroit, MI: Black and Red, 1983, 4.
[10]Sadie Plant, *The Most Radical Gesture. The Situationist International in a Postmodern Age*, London: Routledge, 1992, 24.

In the society of the spectacle, 'The social bond has been turned into a standardized artefact' and everyday life and relationships are experienced as products.[11]

Bourriaud concedes that the art world is implicated in a larger economic system, but that as a 'social interstice' it is a trading community that can elude the 'capitalist economic context'. This is because 'Art represents a barter activity that cannot be regulated by any currency, or any "common substance".'[12] Relational aesthetics, claims Bourriaud, is about relations between subjects, not between subjects and objects. It creates relations that are 'direct' not 'reified', 'micro-utopias and imitative strategies'.[13]

Bourriaud's poster boys and girls include Rirkrit Tiravanija, Philippe Parreno, Vanessa Beecroft, Liam Gillick and Felix Gonzales-Torres, with 'relational aesthetics' used to contextualize the work of a wide range of artists, from Gillian Wearing and Phil Collins, to Thomas Hirschhorn and Gabriel Orozco. Existing somewhere between a public installation, obscure performance and private archive, the artworks Bourriaud describes are, he argues, capable of creating ephemeral communities of viewers and/ or artists through offering a precarious gift, or initiating an informal probing into a specific figure or event in history, politics, fiction or philosophy, or engaging in a passionate pedagogy to distribute ideas, radiate energy and liberate activity. They create 'tiny revolutions in the common urban life' (Orozco's hammock installed at MoMA), or 'produc[e] in a split second a micro community' (Jens Haaning's *Turkish Jokes*, 1994). Bourriaud saw the artwork not as the object, but as the encounter that he compares – invoking the philosophical parlance of Emmanuel Levinas – with the acknowledgement and mutual respect of a subject facing the other:

form only exists in the encounter and in the dynamic relationship enjoyed by an artistic proposition with other formations, artistic or otherwise.... Producing a

FIGURE 6.1 A general view of the Pringle of Scotland pop-up store: Liam Gillick on 1 December 2011 in Miami, Florida. Photo by John Parra/Getty Images for DACRA.

[11]Bourriaud, *Relational Aesthetics*, 9.
[12]Bourriaud, *Relational Aesthetics*, 42.
[13]Bourriaud, *Relational Aesthetics*, 13.

form is to invent possible encounters; receiving a form is to create the conditions for an exchange ... an image points to a desired world which the beholder thus becomes capable of discussing, on which his/her own desire can rebound.[14]

FIGURE 6.2 Xxxora attends the private view for Damien Hirst and Feliz Gonzalez-Torres' *Candy* at Blain Southern on 15 October 2013 in London, England. Photo by Nick Harvey/WireImage.

Critiques of relational aesthetics

Bourriaud's curatorial premise and theorization of the new art of the period was quickly taken to task by a raft of critics, no doubt in part because of the smug neatness of the theory, its clearly defined terms and its popularity with artists. 'Relational aesthetics' was always going to be an easy target, the latest fad hard-pressed to survive the second outing on the runway. As noted earlier, the key grounds of attack were that contrary to its assertions, 'relational aesthetics' was neither new nor progressive. Critics pointed not only to the long lineage of modernist movements – including Fluxus, Arte Povera, site specificity, the readymade, installation – that placed social relations at the heart of their practice, but also to notions that the artwork itself, in whatever form, is about the interaction between viewers and work, each other and their various contexts. On the question of its political or critical efficacy, critics asked whether the constant opening out of works, the very indefiniteness that Bourriaud praised, would undermine any platform for action; whether such works expected too much of the viewer and, failing 'participation', remain merely inaccessible; whether interaction and 'discussions' were pursued for their own sake, irrespective of the quality and nature of the content;

[14]Bourriaud, *Relational Aesthetics*, 22–4.

whether such works addressed only art world insiders rather than the broader public sphere, instances of micro-politics that remained inured to macro-politics; and whether relational aesthetics was more like 'compensatory entertainment' than transformative experience.[15] While to some Bourriaud's dismissal of established Leftist politics was a breath of fresh air – he describes feminism, anti-racism and environmentalism as conservative movements that have a stake in maintaining the current structure of politics – to others his positing of the figure of the artist as not marked by class, race or gender was a fatal flaw.

Perhaps most damagingly, Bourriaud's proposition that these artists were forging a critical approach apposite to the organization of capital in the globalized world of the new millennium was derided as an excuse for artists' acceptance of capitalism as is, evident in the way their work adopted corporate production practices and 'aesthetis[ed] the nicer procedures of our service economy'.[16] The rhetoric accompanying these new neo-capitalist formations in fact denounced hierarchies and advocated autonomy in ways that co-opted the figure of the artist and the qualities of creative work:

> Autonomy, spontaneity, rhizomorphous capacity, multitasking (in contrast to the narrow specialization of the old division of labour), conviviality, openness to others and novelty, availability, creativity, visionary intuition, sensitivity to differences, listening to lived experience and receptiveness to a whole range of experiences, being attracted to informality and the search for interpersonal contacts.[17]

Could the argument that artists producing relations, not objects, evade capitalist logic be a plausible one? Is this applicable given that the art and theory that followed the so-called dematerialization of art engaged in issues of networking, travelling, and therefore always shifting sites and contexts? On the other hand, is not the 'remedial work in socialization' ('come talk, play, learn, with us') still necessary given the breakdown in community in Western world, and are not artists still in a privileged place to engender this process?

The most persistent and salient critic of relational aesthetics, Claire Bishop, approached the brief in a variety of ways. But, importantly, she went on to argue for a more nuanced and sophisticated approach to works that had this 'socialization' at their core. In one of her first essays on the subject, after dispatching relational aesthetics to the art critical bin reserved for the conciliatory and 'feel good', Bishop discloses her attraction to a 'tougher, more disruptive approach to "relations" than that proposed by Bourriaud'.[18] The choice of words is telling (as much as the choice of artists which we will consider shortly), not least because Bishop is deploying, consciously or not, the well-worn language of anti-aesthetic, masculinist critique – which we revisit later in the examination of Minimalist style art – that continues to

[15]Many of these critiques were developed in an early response by Claire Bishop, 'Antagonism and Relational Aesthetics', *October*, Vol. 110, Fall 2004.

[16]Hal Foster, Arty Party, *London Review of Books*, Vol 25, No. 23, 4 December 2003, pp. 21–2.

[17]Luc Boltanski and Eve Chiapello, *The New Spirit of Capitalism*, trans. Gregory Elliott, London: Verso, 2007, 97.

[18]Bishop, 'Antagonism and Relational Aesthetics', 77.

strike terror into the fashion watchers in the art world before they quickly fall into line. Here still is where the cultural capital resides, where the fashion buck stops, with Hal Foster and the gang (Bishop naturally published her essay in *October*) and their continuation of the tradition of negative critique and anti-aesthetics hailing from the nineteenth century. It is noteworthy that despite her consummate critique of Bourriaud, Bishop makes no mention of his blind spot on the contribution of feminist artists to social practice, an omission she repeats in her 2006 edited anthology on participatory art.[19]

In contrast to the artists who exemplify Bourriaud's 'compensatory entertainment' such as Gillick and Tiravanija, Bishop singles out two other artists who, she argues, work with 'relations' in a very different way. She praises Spaniard Santiago Sierra and Swiss Thomas Hirschhorn for their 'obstruction' and 'blockade',[20] for their refusal to seduce,[21] for treating visitors 'like hapless intruders', for 'acknowledging the impossibility of micro-utopias' and for not believing in the possibility of change.[22] There is something disturbingly consonant here with the fashionable 'viewer abuse' strategies of certain strains of Minimalism and other anti-aesthetic modern and postmodern art. Rather than act as instances for positive affectivity (a purportedly silly and misguided pursuit), claims Bishop, the work of these artists 'sustains tensions among viewers, participants and context' and 'provokes racial and economic disidentification', signalling not a return to modernist refusal as advocated by Adorno but rather expressing 'the boundaries of both the social and the aesthetic after a century of attempts to fuse them'.[23] Bishop applauds what she sees as these artists' attempts to reassert the autonomy of art: the ultimate fashion statement?

Bishop however has gone on to more substantial developments of her earlier ideas about participatory art, both reflecting and helping to create a more powerful and enduring fashion than Bourriaud's original teaser. She has nonetheless relied heavily on her whipping boy for the terms of her analysis, not least of which has been her compelling critical revision of one of the Left's sacred cows, Debord's *Society of the Spectacle*.

Bishop argues that Debord's concept of the spectacle (and the ensuing academic literature that draws on it) is underpinned by a particular set of binaries: illusory/authentic, complicit/critical, passive/active.[24] As such, Debord's notion of passive spectatorship in 'the society of the spectacle' is outmoded. Bishop points to many examples of 'spectacles' that genuinely engage the audience – cognitively, affectively and politically – and asserts that there is no privileged medium best able to ignite

[19]Helena Reckitt, 'Forgotten Relations: Feminist Artists and Relational Aesthetics', in Angela Dimitrakaki and Lara Perry (eds), *Politics in a Glass Case: Feminism, Exhibition Cultures and Curatorial Transgressions*, Liverpool: Liverpool University Press, 2013.

[20]Bishop, 'Antagonism and Relational Aesthetics', 78.

[21]Bishop, 'Antagonism and Relational Aesthetics', 75.

[22]Bishop, 'Antagonism and Relational Aesthetics', 70.

[23]Bishop, 'Antagonism and Relational Aesthetics', 78.

[24]Claire Bishop, introduction to 'Rethinking Spectacle', Forum at Tate Modern, 31 March 2007, available at http://channel.tate.org.uk/media/38061678001#media:/media/38061678001/2486933000 1&context:/channel/most-popular

agency and engagement.[25] In many cases, so-called participatory art projects that aim to overcome the pitfalls of 'spectacle' themselves become inauthentic and spectacular, more akin to public relations events than works of art. Critiquing the claims of relational aesthetics to provide a panacea against the 'inauthenticity' of spectacle, Bishop urges us to question the distinction between passively and actively engaging with art,[26] using the arguments developed by French post-Marxist scholar Jacques Rancière.[27]

Over the last ten or so years, Rancière has emerged (in the Anglosphere at least!) as an important figure in political science, philosophy and art, with one of his key points of inquiry being the relationship between politics and aesthetics. He asks us to rethink the notion that 'spectators' are passive, or that art has to move 'outside of itself' into the 'real world' to be effective as a conduit for social change: indeed he asks us to question the very distinctions between these terms. Rancière suggests that rather than seeking to overcome the distance inherent in the spectacle of performance – for example, between audience and actor, or teacher and pupil – we should recognize that distance is the precondition of any communication. Spectatorship is not passivity that has to be turned into activity: it is our normal condition.

In perhaps his most cited text, *Dissensus* (translated in 2010), Rancière argues that the causal logic underpinning contemporary political art is 'two centuries out of date': it is in essence the pedagogical model first proposed and critiqued by Jean-Jacques Rousseau that comprises either 'representational mediation' (which assumes that representation entails a separation between doing and seeing) or 'ethical immediacy' (i.e. 'framing the community as an art work'). Rancière proposes the 'aesthetic regime of art' as an alternative to both these outmoded terms. 'Aesthetic' designates the suspension of every determinate relation correlating the production of art forms and a special social function. What Rancière calls 'consensus' or the 'order of the police' (what we might think of as the safeguarded institution or 'the status quo') is contrasted with 'politics', namely the activity that breaks with the order of the police by inventing new subjects. Politics is what invents new forms of collective enunciation, what reframes the 'given' by inventing new ways of making sense of the sensible, new configurations between the visible and invisible, audible/inaudible, new distributions of space and time, new bodily capacities. Politics is when what *is invisible* – such as the suffering of specific bodies through discrimination and exploitation – is made visible. In its energy and rational alterity, politics thus creates a new form of 'dissensual' common sense.

According to Rancière, artworks can produce dissensus precisely because they neither give lessons nor have any destination. He writes:

> Within any given framework, artists are those whose strategies aim to change the frames, speeds and scales according to which we perceive the visible, and combine

[25]Claire Bishop, introduction to 'Rethinking Spectacle', Forum at Tate Modern, 31 March 2007, available at http://channel.tate.org.uk/media/38061678001#media:/media/38061678001/2486933000 1&context:/channel/most-popular

[26]Bishop, 'Antagonism and Relational Aesthetics' and Claire Bishop (ed.), *Participation*, London and Cambridge, MA: Whitechapel and MIT Press, 2006.

[27]Later republished as Jacques Rancière, 'The Emancipated Spectator', *Artforum International*, Vol 45, No. 7, March 2007, 271–80.

it with specific invisible elements and a specific meaning. Such strategies are intended to make the invisible visible, or to question the self evidence of the visible; to rupture given relations between things and meanings, and inversely, to invent novel relationships between things and meanings that were previously unrelated.[28]

As such, Rancière argues for a rethinking of the term 'fiction', which means not the creation of an imaginary world opposed to the real, so much as the *reframing* of the real, or the framing of a dissensus (as opposed to a consensus). 'Fiction is a way of changing existing modes of sensory presentations and forms of enunciation; of varying frames, scales and rhythms; and of building new relationships between reality and appearance, the individual and the collective.'[29] This should be the aim of critical art.

Rancière suggests that there is no straight path from the viewing of a spectacle to an understanding of the state of the world, and none from intellectual awareness to political action. Instead this shift implies a move from one given world to another in which capacities and incapacities, forms of tolerance and intolerance, are differently defined:

> What happens is a process of dissociation: a rupture in the relationship between sense and sense, between what is seen and what is thought, and between what is thought and what is felt. What comes to pass is a rupture in the specific configuration that allows us to stay in our 'assigned' places in a given state of things. These sorts of ruptures can happen anywhere and at any time, but they can never be calculated.[30]

But what happens to critical art in the context of the consensus of 'economic globalization'? Rancière claims the critical *dispositif*, or discursive apparatus, of art has not changed much since the 1970s: it still is based on the denunciation of the commodity, the society of the spectacle and the pornography of power. 'Critical' works invoke the same repertoire of denunciatory techniques, such as parodies of promotional films; Disney animals turned into polymorphous perverts; montages of petit bourgeois living rooms; overloaded supermarket trolleys; shit-making machines and so on. But since very few of us are ignorant of the insidious work of the commodity and the spectacle, 'political art' loses its efficacy.

This state of art in the age of consensus has brought about two responses, first, calls that art ought to help restore basic social functions threatened by the reign of the market, and emphasize the sense of taking part in a common world,[31] and second, the emergence of art as a space for dissensual practice, a 'place of refuge where the relations

[28]Jacques Rancière, *Dissensus: On Politics and Aesthetics*, trans. Steven Corcoran, New York and London: Continuum, 2010.

[29]Rancière, *Dissensus: On Politics and Aesthetics*, 141.

[30]Jacques Rancière, 'Aesthetic Separation, Aesthetic Community: Scenes from the Aesthetic Regime of Art', edited transcript of a plenary lecture delivered on 20 June 2006 to the symposium Aesthetics and Politics: With and Around Jacques Rancière co-organised by Sophie Berrebi and Marie-Aude Baronian at The University of Amsterdam, 20–21 June 2006, available at www.artandresearch.org.uk/v2n1/ranciere.html

[31]Rancière cites as examples Lucy Orta's transformable objects, Rene Fernandez's restoration of an old woman's house and Matthieu Laurette, literally living off the PR rhetoric of consumer culture.

between sense and sense continue to be questioned and reworked'.[32] Rancière maintains that art does not become more effective by moving beyond itself into the 'real world', for there is no such boundary, there is no 'real world'. Consensus means precisely that the sensory is given as univocal. 'Political and artistic fictions', therefore, 'introduce dissensus by hollowing out that "real" and multiplying it in a polemical way', and 'practices of art … contribute to the constitution of a form of common sense that is polemical, to a new landscape of the visible, the sayable, the doable'.[33] Rancière argues for critical art that accepts its insufficiency, that infiltrates the field of the market and social relations and then remains content to be 'mere images'.[34]

Broadening out participatory practices: Community

Rancière's ideas about what art might be like in 'the age of consensus' – via a disarming of Debord's influential reading of the late image-world – provided powerful tools for the expansion of theoretical and historical ways of understanding art that aims to activate viewers in ways we might call participatory. Bishop is a key figure in this rethinking. Like Groys, she holds that participatory practices have been one of the defining features of recent art. In the works that she focuses on, the accent is on the social dimension of participation, on collaboration and collective experience in contrast to 'interactive art' that is more narrowly (and pejoratively) conceived.[35] Citing significant forebears such as Gordon Matta-Clark and Carol Goodden's Food in NYC's SoHo district (1971) and Oiticica's samba-inspired parangolés, Bishop scopes her inquiry with clear stakes in community-building and community-based projects. From this historical grounding, Bishop categorizes participatory works into two trajectories, 'deauthored' practices that seek out collective creativity, and 'authored' practices that seek to provoke participants. One is grounded in the Brechtian tradition of critical thinking, the other in Artaud's theatre of cruelty that collapses the distance between spectator and audience in the belief that physical involvement is integral to social change. Both approaches are adaptive to the demands of a contemporary culture characterized by a more active subject, and both are evident in the contemporary practice of 'participatory art'.

The upshot is that Rancière's rethinking, helped along by Bourriaud's brave opening gambit and Bishop's proselytizing, has made community art fashionable: a remarkable turnaround, given its common associations of bad aesthetics mixed with

[32]Rancière, *Dissensus*, 145.

[33]Rancière, *Dissensus*, 149

[34]Examples include: Chantal Akerman's turning of geopolitical concerns on the Tex/Mex border into an aesthetic matter; Sophie Ristelhueber's photos of Israel/Palestine road blocks, that move the response from 'indignation to curiosity'; and Anri Sala's film *Give me the colours*, that portrays the council's painting of Tirana in swaths of bright colour.

[35]Claire Bishop, 'Introduction', in Clare Bishop (ed.), *Participation*, London and Cambridge, MA: Whitechapel and MIT Press, 2006.

good intentions. Community arts emerged in the 1970s in the tumult of the 'end of modernism' and the associated explosion of new art forms, and amid movements of social emancipation, exploring the potential for art to be genuinely empowering at a grass-roots level. However, as British author Justin Lewis surmises:

> [Community arts] has failed to make art and culture more accessible to most people. Far from challenging or storming the citadels, it has remained a harmless and irrelevant skirmishing on the sidelines..... Perhaps most importantly, the community arts movement has let the elitist aesthetics of the dominant subsidised culture off the hook. Most community artists were opposed to this cultural elitism, and yet, by forming a separate entity, 'the community arts', they allowed themselves to be appropriated by it.[36]

How to effectively reconcile so-called elitist aesthetics with authentic community engagement and participation has remained a challenge for many artists who position their practice as political and potentially transformative. A singular example of how a high-profile conceptual artist managed to pull this off is Martha Rosler's *If You Lived Here…* (1989).[37] Rosler's conceptual practice had long engaged with the way art institutions are integrally connected to the spaces they occupy. This project was in this continuum of inquiry, and responded very specifically to the politics of urban space and the relations between artists, art practice and gentrification in New York City in the 1980s.

If You Lived Here… had three exhibition elements, along with auxiliary events, like screenings and poetry readings, but the major non-exhibition events were four public, or Town Hall, meetings. Integral to the project was the cooperation of an array of activist and advocacy groups, two of which (Mad Housers and Homeward Bound) participated in substantive ways in planning, consultation and public presence. The three exhibition elements involved over 200 artists and activists invited by Rosler: Home Front focused on different forms of self-organized activism such as rent strikes or self-governing housing projects; Homeless: The Street and Other Venues addressed the visible and invisible homelessness of streets and metro stations, but also that of public housing and casual accommodation; and City: Visions and Revisions aimed at developing, with the aid of architects and planning groups as well as humorous and fanciful proposals, alternative urban planning strategies. The exhibition, just one of the project outcomes, featured a vast array of media and mixed up established artists such as Krzysztof Wodiczko, Dan Graham and Allan Sekula with lesser known and non-professionals, and also included homeless and squatter artists (some of whom were professional artists such as Andrew Castrucci and Thom Corn), begging the question about artistic value. As curator and critic Nina Möntmann noted more than two decades later,

[36]Justin Lewis, *Art, Culture and Enterprise: The Politics of Art and the Cultural Industries*, London: Routledge, 1990, 243.
[37]See Brian Wallis (ed.), *If You Lived Here: The City in Art, Theory and Social Activism: A Project by Martha Rosler*, Seattle, WA: Bay Press and Dia Art Foundation, 1991, 45–66.

The varying 'artistic professionalism' of exhibited works, the variety of media, … and the integrated discussion events resist classification and hierarchy, ultimately undermining aesthetic prejudices and broadening interpretative horizons.[38]

The project worked to form networks and relationships across layers of economic, social and cultural capital, from artists to local communities to town planners and official decision-makers. It supported homeless initiatives and by inviting activists to work within the art institution, introduced their concerns to a broad and diverse public. As art historian Rosalyn Deutsche argued at the time – in terms that prefigure some of Bourriaud's rhetoric – through the project's exploration of the production of space, Rosler sought to transform the conventional perceptions and uses of the site (namely the various places that made up this small section of SoHo) and produce an alternative social space. To include site as a requisite art issue is to render ambiguous the boundary between the art object and its context. Art is social in the first instance; it participates in the creation of social life, it actively constructs its audience, which is not a fixed, stable mass.[39]

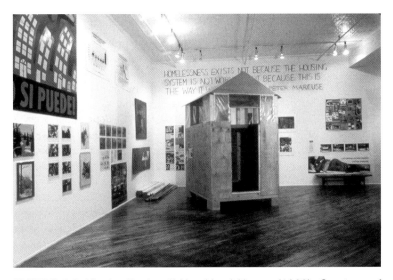

FIGURE 6.3 Martha Rosler, *If You Lived Here…* (1989). Courtesy of Martha Rosler.

Rosler's role was multivalent: project conceiver, manager and chief communications and negotiations officer. But it was her status as an artist, one with sufficient cultural capital, that allowed her to leverage the institution and render the project a success.

[38]Nina Möntmann, *(Under)Privileged Spaces: On Martha Rosler's 'If You Lived Here…'*, re-evaluating the exhibition in 2009, *e-flux journal*.
[39]Rosalyn Deutsche, 'Alternative Space', in Brian Wallis (ed.), *If You Lived Here: The City in Art, Theory and Social Activism: A Project by Martha Rosler*, Seattle, WA: Bay Press and Dia Art Foundation, 1991, 45–66.

Rosler's reputation brought the players together, and her approach permitted the project to run in a genuinely non-hierarchical way. As Möntmann argues, working across the actual exhibition space and its multilayered location allowed Rosler to strategically align the mainstream art system with sociopolitical activism that has limited institutional ties. Rosler's project,

> provokes the crossing of the boundaries between 'real world' and art world, by bringing together socially distinct areas: artist/exhibition maker, art-world artist/counterculture artist, interior/exterior, exhibiting institution/urban space, documentation/activism. The transgression of these boundaries opens up new communicative fields for the city, politics, and art.[40]

We could invoke Rancière, here, and suggest that perhaps a project such as this demonstrates 'there is no boundary'. Nonetheless, Rosler's position as an artist, and the institutional legitimacy that grants, is absolutely vital to the creation of potentially 'new' social spaces and experiences. As Pascale Jeanne, the late member of the Austria-based activist art collective WochenKlausur, eloquently puts it:

> Art is awarded its status through its recognition; such sanctioning comes about within institutional mechanisms. Art institutions can reaffirm a traditional, object-orientated understanding of practice or can participate in its transformation ... An understanding of what can constitute art changes when the term is used less to subsume fetishistic characteristics and mercantile aspects, and instead designates immaterial works that contribute to the transformation and improvement of ecological, political and social conditions. If WochenKlausur works at the invitation of art institutions, the institutions are acting to anchor activist art practice in human consciousness ... the art institutions' 'cultural capital' has been useful when seeking to circumvent bureaucratic hierarchies and mobilize decision-makers from politics, civil administration and the media.[41]

WochenKlausur has since 1993 'developed concrete proposals aimed at small, but nevertheless effective improvements to socio-political deficiencies', including building community centres, cinemas and language schools.[42] Engaging with institutions by participating in such civic renaissance projects does not necessarily disqualify the artist from 'the ecological analysis of the ... fissures in the urban network, of the role of microclimates, of distinct neighborhoods with no relation to administrative boundaries', as the Situationist International urged.[43] On the other hand, to acknowledge the artist's reliance on 'the institution' for their agency is also to

[40]Möntmann, *(Under)Privileged Spaces: On Martha Rosler's 'If You Lived Here ... '*, n.p.
[41]Interview published on Temporary Services website: http://www.temporaryservices.org/concrete_wochenklausur.pdf
[42]http://www.wochenklausur.at/
[43]Guy Debord, 'Theory of the Dérive', *Situationist International* No. 2, Paris 1958, Available at Situationists International Online: http://www.cddc.vt.edu/sionline/si/theory.html, last accessed 10 November 2014.

acknowledge their complicity, a stand that has informed the work of another pioneer of institutional critique, American conceptual artist Andrea Fraser:

> [T]he institution is us. Every time we speak of the 'institution' as other than 'us' we disavow our role in the creation and perpetuation of its conditions. We avoid responsibility for, or action against, the everyday complicities, compromises, and censorship … which are driven by our own interests in the field and the benefits we derive from it.[44]

New community arts?

Leveraging one's cultural capital as an artist in order to re-contextualize and thereby re-value the inherent creativity of existing communities is a powerful way of working that substantially addresses many of the shortcomings of 'relational aesthetics'. It also takes a very different tack to the 'tough' and 'obstructive' strategies that verge on 'viewer abuse' that Bishop offers as a credible alternative to Bourriaud's 'feel good' art.

Australian artist Angelica Mesiti has been developing this approach since 2010 when she undertook a project with the community of the southern Sydney suburb of Hurstville, auspiced by the local council and coordinated by Sydney's Museum of Contemporary Art. For *The Begin Again* (2010) Mesiti worked for several months with local residents, spending time with and eventually filming them as they partook of various community-based recreational activities, such as ballroom dancing, singing and car pimping. The final cuts – four videos and one kinetic installation – were then installed over two evenings in open spaces in the central shopping strip, from bus depot to civic plaza to rooftop car park. The public, a combination of art crowd and locals, including the protagonists featured in the various works, attended in droves: the Hurstville mall was abuzz not for the usual reason of consumption, but on account of more complex and less instrumental factors. Indeed, the effect of *The Begin Again* could well exemplify a more complex engagement with some of the key problematics raised by participatory art and 'relational aesthetics'. It demonstrates that artists may use the means of spectacle – such as grand scale, seductive effects, pleasure – in order to criticize its ends: the atomization of people and the substitution of authentic experience with artificially produced, capitalist-orchestrated media artefacts.[45] For, a project such as this could well offer a 'carnivalesque' experience within twenty-first-century image culture. As Mikhail Bakhtin proposed, carnival

> does not acknowledge any distinction between actors and spectators … . Carnival is not a spectacle seen by the people; they live in it, and everyone participates because

[44]Andrea Fraser, 'From Critique of Institutions to an Institution of Critique', in John C. Welchman (ed.), *Institutional Critique and After*, Vol. 2, Zurich: JRP Ringier, 2006, 133.
[45]Mark Godfrey in Bishop, 'Rethinking Spectacle'.

its very idea embraces all the people.... [In carnival], a special form of free and familiar contact reigned among people who were usually divided by the barriers of caste, property, profession, and age...such free, familiar contacts were deeply felt and formed an essential element of the carnival spirit. People were, so to speak, reborn for new, purely human relations.[46]

The Begin Again offers a compelling model of 'community art', a way of connecting art and community in generative ways. At one level, the work could be said to have many authors, everyday people performing their sometimes-extraordinary talents. But at another level, it is Mesiti's artistic agency – her formal manipulation of the 'readymade material' that she observes in the real world using high production cinematic aesthetics[47] and her 'good offices' as an artist that grant her access and funding – that actually realizes the project.

FIGURE 6.4 Angelica Mesiti *The Begin Again* (video still), 2011, four video works site-specifically projected and live performance. Vanessa Lloyd/Anna Schwartz gallery.

In *The Begin Again*, Mesiti developed a storytelling style that relies less on words than on sound and rhythm, less on image than on texture and movement, one that locates political agency less in the professional artist than in everyday creativity. This approach is also evident in her four-channel video installation *Citizens Band* (2012) where the artist captured the performance of four individual street performers from around the world in full, using minimal camerawork and editing in respectful

[46]Mikhail Bakhtin, *Rabelais and His World*, Bloomington: Indiana University Press, 1984, 7–10.

[47]Mesiti works with professional cinematographers and producers. In *The Begin Again* and *Citizen's Band*, this was Bonnie Elliott and Bridget Ikin.

deference to the music and musician. Old worlds, ancient traditions that pass from mouth to ear, from hand to hand, are woven into new realities, and both are rendered accessible to us, the viewers, by the artist's gentle touch. Such an approach evades some of the problems around cultural value that have dogged community arts while also facilitating a particular kind of cultural citizenship: participation together with self-styling and cultural capital.[48] Mesiti's work does not appear to fit neatly into either of Bishop's categories of participatory practice, for it is both highly authored – a beautifully shot and designed sound and image installation – and 'de-authored', in that so much of the creative endeavour that the work relies on is provided by others. And while Mesiti's 'intervention' itself did not prompt these other artists to action, it nonetheless hugely increased and diversified their audience while also enhancing their cultural capital.

Hand in hand with revised approaches to the position of the artist relative to 'community' have gone attempts to reconceive of the very notion of community. These attempts have a long history in the twentieth century, a key impetus being responses to the perceived links between idealized forms of community and totalitarianism.[49] However, their most recent incarnations have focused on the related phenomena of post-colonialism and globalization: how does community as an imaginary construction that is strongly utopian and idealized as limited, sovereign and fraternal (Benedict Anderson[50]), square with the reality of globalization? Among the many wranglings with this conundrum, anthropologist Mary Louise Pratt's 'contact zone' is particularly useful for those of us interested to theorize how art can facilitate complex forms of community:

Autoethnography, transculturation, critique, collaboration, bilingualism, mediation, parody, denunciation, imaginary dialogue, vernacular expressions – these are some of the literate acts of the contact zone. Miscomprehension, incomprehension, dead letters, unread masterpieces, absolute heterogeneity of meaning – these are some of the perils of writing in the contact zone. They all live amongst us today in the transnationalised metropolis … and are becoming more widely visible, more pressing … [and] more decipherable to those who would have ignored them in defence of a stable, centred sense of knowledge and reality.[51]

In the contact zone, no one is excluded, and no one is safe. The zone is marked by pain and incomprehension: discomfort, anxiety and confusion are necessary for learning about others. But the contact zone also promises wonder and revelation, mutual understanding and new wisdom. It harbours potential changes of mind

[48]See Rimi Khan, *Reconstructing Community-Based Arts: Cultural Value and the Neoliberal Citizen*, Unpublished PhD thesis, University of Melbourne, 2011, for an interesting discussion of different manifestations of community arts in contemporary Australia.

[49]Georges Bataille for example.

[50]Benedict Anderson, *Imagined Communities: Reflections on the Origin and Spread of Capitalism*, London: Verso, 2006.

[51]Mary Louise Pratt, 'Arts of the Contact Zone' (originally published in 1991), excerpted in David Bartholomae and Anthony Petroksky (eds), *Ways of Reading: An Anthology for Writers*, 4th edition, London: Bedford/St Martin's, 1996, 442–62.

and culture. It is interactive, improvisational and includes codes that both the ruler and the ruled share. What might happen in the contact zone of pedagogy, for example? Pratt suggests

> exercises in storytelling and in identifying with the ideas, interests, histories, and attitudes of others; experiments in transculturation and collaborative work and in the acts of critique, parody and comparison (including unseemly comparisons between elite and vernacular cultural forms); the redemption of the oral; ways for people to engage with suppressed aspects of history (including their own histories); ways to move into and out of rhetorics of authenticity: ground rules for communication across lines of difference and hierarchy that go beyond politeness but maintain mutual respect; a systematic approach to the all important concept of cultural mediation.[52]

The contact zone is a space of transculturation, whereby members of subordinated or marginal groups selectively use materials transmitted by a dominant or metropolitan culture to invent unique new forms. The contact zone is also a space of autoethnography, whereby people undertake to describe themselves in ways that engage with representations others have made of them. Autoethnography does not aim for an authentic, original voice, but entails a self-reflexive dialogue with the way the authors, as marginalized people, have been represented by and to the dominant culture – as Other, exotic or 'primitive', for instance. Such accounts are usually addressed both to the author's own community and to the metropolis, and commonly mirror back to the 'rulers' an image of themselves that they suppress. As both these strategies suggest, a contact zone treats relations among colonizers and colonized not in terms of separation, but rather emphasizes 'how subjects are constituted in and by their relationship to each other. It stresses co-presence, interaction, interlocking understandings and practices, often within radically asymmetrical relations of power'.[53]

The notion of the contact zone as developed by Pratt and James Clifford in the context of anthropology (and by extension, museology) and the complex approaches to community that underpins it, provide yet another means of broadening out our understanding of participatory art beyond the confines of the now devalued terms of 'relational aesthetics', and into what we might call the new community arts.

Tom Nicholson's practice could well be said to be tantamount to action as distinct from representation.[54] His installation *After Action for Another Library* 1999–2001/2006, a series of photographed books' title pages, was a relic of a long-term project in which the artist responded to human rights abuses in East Timor, specifically the systematic burning of libraries and schools by Indonesian forces in the wake of the 1999 UN ballot result for independence. The artist began a process of gathering books to replace those destroyed and donate them to the University

[52]Pratt, 'Arts of the Contact Zone', 442–62.

[53]Mary Louise Pratt, in *Imperial Eyes and Transculturation* (6–7), cited in James Clifford, *Routes: Travel and Translation in the Late Twentieth Century*, Cambridge: MA: Harvard University Press, 1997, 192.

[54]'The Practice of Action: An Exchange between Charles Merewether and Tom Nicholson, in *After Action for Another Library, Pier 2/3*, Biennale of Sydney, 2006.

Library in Dili. Specified by East Timorese Student Solidarity Council, the books included such titles as *My Place, The Second Sex, The Bell Jar, Man Alone, The Beauty Myth, The Third Way, Essay Writing for Students* and *The Human Condition.* Functioning as a community-building project in the contact zone between various cultures, *After Action for Another Library* set in motion not only the humanitarian action of donating the books, but all the relationships that that action mobilized: between the donors and donees; between the artist and both; between the donors and their books; between the donees and their books, lost and returned; between and within nation states and individuals; between the artist and his audience; between that audience and the people of East Timor; between that audience and their own passion for reading; between that audience and their national government and so on ad infinitum. Nicholson's action opened a space, provided a point of coalescence, where stakeholders in the recent events of East Timor could actively haggle over meaning, cultural significance and historical consequences.

FIGURE 6.5 Tom Nicholson, *After action for another library* (installation detail), 2004. Tom Nicholson. Photograph: Christian Capurro. Courtesy of the artist and Milani Gallery.

American philosopher Brian Holmes, in 'DIY Geopolitics', argues that tactical media that emerged in the late 1990s on account of the congruence of anti-globalization protest and social media technologies turns around the pessimism of *The Society of the Spectacle* by privileging the milieu of the event and positing the

possibility of alternative media content and ownership. Holmes sees these global social protests as alternative worlds for art, outside the constricted circuits of production and distribution:

> Something fundamental changes when artistic concepts are used within the context of massive appropriation amid a blurring of class distinctions. A territory of art appears within widening 'underground' circles, where the aesthetics of everyday practice is lived as a political creation.[55]

The potential of social media networks to provide avenues for new forms of participatory art has been explored and tested by the recent spate of 'democratic revolutionary' events, such as the Arab Spring and Occupy. American post-anarchist poet and darling of new breed anti-globalization protest Hakim Bey's injunction not to hate the media, but to instead become the media, has strong resonances with the impetus behind not only Bourriaud's 'relational aesthetics' but also its historical forebears in happenings, and later as instances of 'dissensus'.

While Bourriaud's original cachet faded some years ago, the impulse in contemporary art that he pinpointed has continued to enjoy fashionable status. Participatory practices are still the staple of contemporary art blockbusters as much as the modus operandi of networked artists.

[55]Brian Holmes, 'DIY Geopolitics', in Stimson, Blake and Gregory Sholette, (eds), *Collectivism after Modernism: The Art of Social Imagination after 1945*, Minneapolis and London: University of Minnesota Press, 2007, 274.

7 VIDEO ART AND VIDEOPHILIA

One of the great ironies about video is that it comes from the Latin 'I see', yet when it began to emerge into the contemporary art mainstream in the late 1980s, most people did not want to see it. Museum and gallery-goers, prepared for the static art object, were met with something that wasn't quite home movie and not exactly feature film. We must not forget also that that was the day of Betamax and VHS, so if you chanced upon a work of video art in the middle of its sequence, if you had the stomach and the gumption, you would need to see it out to the end, wait patiently until the tape re-winded, then watch it again from the beginning, only to decide that maybe it wasn't worth the effort. At least you could judge a painting in a few seconds. But today, the moving image has invaded the lives of just about everyone. With YouTube, Vimeo and hand-held cameras, it has become an inescapable part of life. But so pervasive is that it has invaded art practice in a way that is both salutary and parasitic. Video art is today not met with the same scepticism or antipathy: it is rather an expectation in an exhibition to certify its contemporariness. No large festival is without it. And even in solo shows it is common for artists who do not identify as video artists per se to insert a video to give their exhibitions a sort of 'contemporary boost', much like a nutritional supplement after a gym workout. Just as we saw in the previous chapter how participation is deemed an assurance of Leftist leanings, the video supplement in contemporary art as an expectation that leads to necessity, is what we call videophilia.

By the final decade of the twentieth century, video art appeared to have come a long way from its countercultural origins over two decades earlier to occupy a place at the very heart of the institution of contemporary art. Primarily in its digital manifestations, video came to replace photography as art's platform of convergence, bringing together television and cinema, sculpture and painting, performance and music; video became the 'postmedium'[1] best suited to an age in which the moving

[1] A description attributed to Rosalind Krauss, *A Voyage to the North Sea: Art in the Age of the Post-medium Condition*, London: Thames and Hudson, 1999.

image pervades every aspect of contemporary life and artists no longer observe disciplinary boundaries, balancing the aesthetics of painting with the impact of digital production and dissemination (including contemporary participatory practices with their increasing reliance on virtual networks). The discourse in which video art flowed broadened dramatically as the technology became cheaper and easier to use; practitioners who would not necessarily identify as 'video artists' began regularly to use the medium; and galleries, museums and collectors started to recognize the importance of video in their collections and exhibitions. There exist discernible continuities in some of the fundamental concerns of video art since the late 1960s and 1970s into the present including video as integral to the development of performance art with its surgical scrutiny of the self; video's 'deconstruction' of television and the electronic image; and video-makers with their alternative narratives performing the role of 'citizen-journalists' *avant la lettre*. Yet as these early concerns are revisited and replayed in the twenty-first century, they increasingly appear more as style than as substance.

In its earliest incarnations, video was enmeshed in conceptual art, performance art and social activism. Artists tended to use it in three main ways. For some, video offered a fast and loose means of documenting the everyday worlds they inhabited – at the time, in the West, worlds riven by widespread social unrest and civil disobedience. For others, video acted as a mirror to explore the inner world of personal identity and the shaping of the human subject by social forces. And for others still, video was the latest imaging technology that demanded to be pulled and pushed to discover what it was capable, and incapable, of representing. In each of these approaches, the images were necessarily banal or anti-aesthetic, as the artists sought to distinguish their newly discovered medium from both television and film, but also to integrate it as an extension of painting or drawing, photography or performance. In any event, these early experiments were limited to a small number of practitioners. Despite the user-friendliness and affordability of the game-changing Sony Portapak, video was often associated with a technophilic culture, certainly true of that practice which commandeered video to explore the making of synthetic images and sound, and its 1980s expression in full-throttle image appropriation. For several years after its pioneering use in conceptual and political inquiry, structuralist analysis, performance and documentary, video did not feature very often in the work of the highest profile contemporary artists of the day. The medium took some time to gain legitimacy in the museum and gallery circuit, and even longer among collectors. That was however to change, and change dramatically, in the early 1990s in a trajectory that has only continued to gather pace in the new millennium.

Why did video art become fashionable at this time? There are several, interrelated factors at play. First, there is the rise of installation art, which coincided with structural changes in the exhibition spaces and markets for contemporary art that saw huge growth in the demand for large-scale art that could travel easily across the globe. Second, digital moving image technologies, together with the integration of interactive media in everyday life and the rise of user-generated content, emerged as the defining media of our time. These technologies also had an impact on the development of new forms of post-globalization politics, facilitating transnational collectivity and grass-roots agitation. Third, video's medium-specific qualities

proved especially suitable to the demands of the time: what appealed was both its narrative potential as a time-based medium[2] and its capacity to undermine mimesis – the primary communicative means of traditional visual art – through its direct connection with the real.[3] And finally, video, having been born at the crux of the transition from modernism to postmodernism, in the thick of the massive ruptures with tradition undertaken by Minimalists and Conceptualists, was bound to always have a special anti-establishment cachet. Video was at one level a clean skin: as Czech-American video pioneer Woody Vasulka observes, its original attraction to artists lay in its having no canon, no tradition, no critical discourse.[4] But at another level, video carried the DNA of the two movements most determinant of contemporary art, Minimalism and conceptualism. This pedigree prompted many artists and curators mired in the increasing commercialization of art of the late 1980s and early 1990s to look to video to recuperate the social and political project of the historical avant-garde.[5]

This was, of course, bound to fail. Video did not become fashionable until after it was consecrated by the institution, when its decidedly unfashionable techie associations on the one hand and amateur community links on the other had been expunged. By then, it was too late. Video had become a major brand of contemporary art, both in its highly aestheticized versions that, despite Vasulka's claims, looked to the history of painting for formal and iconographic references and to cinema for production values, and in its low-tech manifestations that traded on the authenticity of DIY and underground cultures. From the haute couture of Bill Viola and Rodney Graham, to the improvised street wear of Vito Acconci and Joan Jonas, video had the fashion market sewn up. So let us consider the transformation of video from gauche anti-establishment nerd to glamorous catwalk model.

Activism and self: The 1970s and its fashion legacy

From the beginning, video art was understood as anti-establishment. It can lay claim to a unique origin: unlike other visual arts media, it was forged in the crucible of contemporary, rather than modern, classical or ancient, art. It had no tradition so was not beholden to it. It had no canon so could start from scratch in response to its immediate circumstances. It had no critical discourse so was not accountable to it. It promised to democratize the production of images. Video art emerged at that point when modernism was short circuited by Minimalism and conceptual art – the critical approaches that have paved the way for the art of today – and as such was perfectly placed to carry the mantle of the moment, the dematerialization of art, a

[2]Hopkins, *Art after Modern Art 1945–2000*, 240.
[3]Kristine Stiles, 'I/Eye/Oculus', in Gill Perry and Paul Wood (eds), *Themes in Contemporary Art*, New Haven, CT, and London: Yale University Press with The Open University, 2004, 183.
[4]Stiles, 'I/Eye/Oculus', 213.
[5]Stiles, 'I/Eye/Oculus', 183.

radical response to art's commodification. Together with performance, video had a privileged relationship with real-time events and experience, what American art historian Kristine Stiles argues allows them to 'augment metaphor with metonymy', that is, to move art from representations that rely on 'is not' but 'is like', to 'is like' and 'is directly connected'. Metonymy undermines the traditional separation of the artwork from what it represents, such that the mundane and the personal can be re-imagined in very direct ways through video.[6]

As pioneering American video artist Hermine Freed once observed, the portable video camera arrived (in the late 1960s) just when artists needed it most: to release them from the *cul de sac* of formalism and studio-bound practice; to provide a solution to the ephemerality of performance and inaccessibility of land art; and to offer a means to confront the inescapable ascendancy of TV in the popular consciousness.[7] The key attractions of the medium were its aesthetics of realism, together with its capacity for instantaneous recording and transmission, easy reproducibility and relative cheapness and ease of use that distinguished it from TV and film. These attributes lent themselves readily to the aspirations of social transformation through activist and community-based art that marked the period, while also facilitating self-reflexive experimental work, meshing with explorations in performance, sound and visual effects.

The emergent video practice of the late 1960s and early 1970s reflected these two broad approaches. Video artists concerned with documenting communities and social issues were often associated with grass-roots organizations and events, including countercultural music festivals[8] and video access centres. Video access centres, perhaps ironically, were state funded: in Australia, for example, the reformist Labor government in 1973 set up thirteen free such centres around the country, modelled on the Canadian Challenge for Change project in which video was used for community negotiation and dispute resolution. The video access network provided video facilities and production personnel to encourage communities to turn the camera on their own lives, demystify the medium and tape their own news. Most of the material produced in such settings has not survived and has certainly not crossed the institutional boundary into museum collections, although there are exceptions, and interestingly enough these tend to be the work of those collectives that went beyond 'handing back the medium' to communities and instead also engaged in formal experiments. An example is Sydney-based video collective and studio Bush Video that became the focus of innovation not only in activist video but also in electronic image experimentation, including the possibilities of feedback.[9] Members included founder Mick Glasheen, credited with

[6]Stiles, 'I/Eye/Oculus',185.

[7]Hermine Freed, 'Where Do We Come from? Where Are We? Where Are We Going?', in Ira Schneider and Beryl Korot (eds), *Video Art: An Anthology*, New York: Harcourt Brace Jovanovich, 1976.

[8]For example, the Odyssey Rock Festival (Wallacia, 1971) and the Aquarius Arts Festival (Nimbin, 1973).

[9]See Stephen Jones, 'Some Notes on the Early History of the Independent Video Scene in Australia', in Jill Scott and Sally Couacaud (eds), *The Australian Video Festival 1986*, exh. cat., Sydney: Australian Video Festival, 1986, 88–94.

supposedly producing the first work of Australian video art, *Teleological telecast from spaceship Earth: on board with Buckminster Fuller* (1970); Jeune Pritchard, whose collaboration with Luce Pellissier, *Queensland Dossier* (1977), examined civil rights abuses in that state during the 1970s; and Stephen Jones, who went on to play an important role in the music/video/performance innovations of the 1980s, including with the group Severed Heads.[10] Along with video access centres, much early video art was concerned with taking on TV and the mass media – examples include the guerilla programming of German video practitioner Gerry Shum – although even back then the art credentials of this work was suspect to some. Richard Serra, for instance, expressed the view that art was not suitable for mass communication.[11]

Dismissed by many, including even some video art practitioners, as 'realist agitprop',[12] these early uses of the medium in the context of down-home community activism were ultimately not fashionable: it is rather the associated whiff of political radicality that survives to be used as a fashion label. As American media theorist Marita Sturken argues, the early work by video collectives is often overlooked by art history, critics and curators, 'fixated on form', as 'political' or not art at all: 'The marginal way in which the collectives are treated in video history is indicative of the way in which socially concerned work was simply written out of the art historical agenda for video set forth in its museification.'[13] The rhetoric of the early video collectives is remarkably similar to that of the new millennial 'citizen-journalist' and user-generated content that have accompanied emergent forms of collective activism in the age of the internet and social media, often pinpointed as beginning with the wave of anti-globalization protests set off in Seattle in 1999. The origin of these phenomena in the video collectives of the 1960s and 1970s is sometimes acknowledged, although the art institution has had little interest in them other than to vaunt the radical essence of video. Some critics have confronted this reality by arguing for the uncoupling of video from the art world whose fashion criteria have always marginalized grass-roots politics:

> It's turned out that the fate and destiny of video art is much larger than the art world. Independent video penetration into the public sphere has become paramount, and public interventions such as peer-to-peer file sharing, blogging, streaming, and even the lowered cost of video projectors have become important means allowing artists to reclaim public space. Through this process, video work enters into the culture, not just the rarefied art world of the museums and galleries.[14]

[10]Other members of Bush Video included Ariel, Philipa Cullen, Joseph El Khourey, John Kirk, Jon Lewis and Ann Kelly.

[11]Stiles, 'I/Eye/Oculus', 217.

[12]Peter Callas, 'Australian Video Art and Australian Identity: A Personal View', in The 1st Exhibition of Australian Contemporary Art in Japan (Catalogue), *Continuum '83*, exh. cat., Tokyo: Japan–Australia Cultural & Arts Exchange Committee, 1983, unpaginated.

[13]Marita Sturken cited in Jesse Drew, 'The Collective Camcorder in Art and Activism', in Blake Stimson and Gregory Sholette (eds), *Collectivism after Modernism: The Art of Social Imagination after 1945*, Minneapolis: University of Minnesota Press, 2007, 97.

[14]Drew, 'The Collective Camcorder in Art and Activism', 111.

The other approach that emerged in the early days of video was more personal, what some have termed 'apolitical'.[15] Some of these artists self-reflexively explored video image processing and synthesizing, or engaged in conceptual and emerging installation art, using video as an analogue or extension of performance. In Australia, for example, 'pure uses of the medium's reflexiveness and realtime'[16] included works such as David Perry's *Interior with views* (1976), and early experiments with the synthesized image by Ariel, Warren Burt and Stephen Jones. Some artists used video experimentally with music and dance, and explored the medium's potential to facilitate human and technological feedback. Philip Brophy's performance group Tsk Tsk Tsk foregrounded the aural capacities of video in their proto-multimedia performances, while Tim Burns' literally titled *Change of Plan-2 people in a room-closed circuit TV lent by Sony* (1973) – later described as 'Australia's first closed-circuit video installation'[17] – featured the real-time display of the everyday activities of a pair of naked actors, the monitor mounted outside the closed room in which they were living.

But most significant in terms of the legacy for contemporary art were those artists who co-opted video for conceptual purposes and integrated the two nascent forms of video and performance art. The list here is long and illustrious, easily recognizable to any undergraduate Bachelor of Fine Arts: Vito Acconci, Bruce Nauman, Chris Burden, (and perhaps less so) Joan Jonas, Hannah Wilke and Ana Mendieta. In Australia, for example, 'the first use, in Australia, of video in a conceptual art context'[18] took place at Ihibodress, an artist run space in Sydney established by Mike Parr, Peter Kennedy and Tim Johnson: it was Kennedy and Parr's video recordings of the performance of particular instructions, made in 1971 on an Akai ¼ inch Portapak and later shown as *Idea Demonstrations* (1972). Here the artists aimed to render the viewer complicit in the often confronting physical ordeals of the artist, an aspiration which reached its apogee in *Cathartic action/ social gestus No. 5* (1977), during which Parr chopped off a life-like prosthetic arm with a tomahawk and proceeded to explain the theoretical and ideological roots of his cathartic act to an audience reeling in shock.

This strain of personal experimentation and the focus on self and body in video has carried through strongly into contemporary practice. Artists today frequently use video to explore the relationship between the personal body and the body politic or public space, or the construction of identity through the gaze. Mike Parr himself still uses video not only to document performances but also to heighten their effect and focus the viewers' attention on the ethics of watching; contemporary works where the artist subjects himself to privation and pain include *Water from the Mouth 1,2 & 3*

[15]Peter Callas, 'Peter Callas Interviewed by Nicholas Zurbrugg', Nicholas Zurbrugg (ed.), *Electronic Arts in Australia: Continuum*, Vol. 8, No. 1, 1994, 94.

[16]Bernice Murphy, 'Towards a History of Australian Video', in Jill Scott and Sally Couacaud (eds), *The Australian Video Festival 1986*, exh. cat., Sydney: Australian Video Festival, 1986.

[17]Jones, 'Some Notes on the Early History of the Independent Video', 2008, 94.

[18]Jones, 'Some Notes on the Early History of the Independent Video Scene in Australia', 93.

(1999) and *Kingdom Come and/or Punch Holes in the Body Politic* (2005). Artists of a later generation continue to mix video and performance to scrutinize the body of the artist, including another Australian artist, Tony Schwensen. Schwensen's videos feature documentation of himself following his own injunctions, which appear banal at first but grow monumental in their repetition and duration; an example is *Weighty weight wait* (2006) where the corpulent artist sat for eleven hours on the scales of Sydney's Art Gallery of NSW's loading bay while his ordeal was streamed live to the public gallery. The artist claimed to be testing the proposition that 'Doing nothing makes you fat', which he managed to disprove, losing weight through his endurance performance.

Schwensen's self-scrutinizing videos foreground their low production values. New media critic Michael Rush noted the return of low-tech performative style video in the 1990s in the work of artists such as Sadie Benning, Pipilotti Rist, Cheryl Donegan, Gillian Wearing, George Barber and Nelson Hendricks,[19] and we could add others such as Peter Land whose works 'conjure up a condition of self exposure and failure'.[20] It is a style of video that harks back to the form's inception, when degraded aesthetics corresponded with the accessible and affordable technologies of the day, including still-expensive editing suites. Some pioneering artists, such as Nauman, let their tapes simply run to the end unedited, largely because of the cost and expertise editing demanded. This 'artlessness', that also included scratches and dirt, over- or underexposed images and corrupted sound, was born of necessity then. By the 1990s, however, it had become a fashion, one that could either be reproduced through deliberately bad technique or through sophisticated digital effects that mimicked the limitations of analogue. The aim was the golden touch of authenticity, along with the political cachet of early video art.

Early video's explorations of self proved to be a good fit with contemporary narcissistic culture. As Jesse Drew laments,

> With the slow decay of the heady, idealistic 1960s, much of the video art world developed into bland narcissism, wrapped up in the solitary gesture.... Provoked by a culture of ironic detachment, video artists mushed around with the form, experimenting with the equipment while sidestepping its roots in television. In the depoliticized climate, becoming void of social consciousness made for better response from gallery patrons, and what was good for the patrons was good for the galleries.[21]

By the 1980s, video had entered 'the palaces of art' to live 'happily ever after in the glow of a Bill Viola installation'.[22]

[19]Michael Rush, *New Media in Late 20th-Century Art*, London: Thames and Hudson, 1999, 109.
[20]Uta Grosenick and Burkhard Riemschneider (eds), *Art at the Turn of the Millennium*, Cologne: Taschen, 1999, 294.
[21]Drew, 'The Collective Camcorder in Art and Activism', 100.
[22]Drew, 'The Collective Camcorder in Art and Activism', 100.

The language of video, the found image and appropriation: The fashion legacy of the 1980s

The self-reflexivity of video in the 1970s, with its structural analysis and unpacking of the mass media, developed further in the 1980s under the influence of postmodern critiques of the role of electronic media in constructing 'reality' in late capitalism.[23] The 1980s also saw the emergence of domestic VHS, video libraries and novel music and image synthesizer technologies which, together with the impact of MTV music video and the fresh legacy of punk DIY aesthetics, created the perfect conditions for the development of early re-mix culture.[24] Video proved particularly well-suited to considering the creation of meaning and the positioning of the self in a media-saturated world, in works concerned with foregrounding the possibilities of what could be said via the electronic image, or exploring the relationship between the camera and the spectator. A key exponent of this approach was Australian group Severed Heads, electronic music and video pioneers who generated images through drum machines and bass synthesizers, and mounted interactive audio and video installations where audience movement triggered the production of images and sound, such as *Chasing Skirt* (1988).

Parody, pastiche, de-historicization and irony, quintessential to 'the allegorical impulse' of postmodern art, were strategies that came naturally to those video artists mining the archives of the moving image, particularly TV, the medium that had closely accompanied them since childhood. Video meshed easily with some of the core ideas of postmodern thought, including the critique of originality and authenticity and Baudrillard's simulation. An artist who well exemplifies this approach is Australian Peter Callas, who pioneered an image synthesizer (the Fairlight Computer Video Instrument) and developed an innovative jump-cut technique able to compress a multitude of cultural signifiers, generating videos now iconic of the image-overload of super-capitalism; works like *If Pigs could Fly (The Media Machine)* (1987) powerfully foreground the role images play in constructing national identity. Randelli (Robert Randall and Frank Bendinelli) in works such as *A taxi to temptation* (1985) created overtly staged videos that appropriated the clichéd signifiers of commercial imagery to critique their vacuity. The artists associated with Sydney's Super8 Film Group and Metaphysical TV, including Mark Titmarsh and Gary Warner, like many of their international counterparts, explored the nature of TV as a medium, making much of their work by 'pulverising and reconstructing fragments from broadcast TV'.[25] Stephen Harrop's *Square Bashing* (1982), that blended motifs from Hollywood movies to create an eerie mediation on how such images structure our own psyches, remains a classic of this genre.

[23]Key theorists include Jean Baudrillard, Paul Virilio and Fredric Jameson.

[24]Ian Haig, 'Australian video in the 1980s', unpublished paper presented at Video Void symposium, Contemporary Centre for Photography, Melbourne, November 2010.

[25]As described by fellow Super 8 member Mark Titmarsh in *SynCity* exh. catalogue, Sydney: d/Lux/MediaArts, 2006, 11.

FIGURE 7.1 Tracey Moffatt, *Love* (still), 2001. Courtesy of Tracey Moffatt and Roslyn Oxley 9 Gallery, Sydney.

Appropriation of found imagery as a process for video creation continued into the 1990s and beyond. However, that the image was 'stolen', its source, and the form of the electronic language, became less important. Rather, due to video's ubiquity, the emphasis shifted to the video's content,[26] and increasingly to narrative. Australian artist Tracey Moffatt's videos made in collaboration with film editor Gary Hillberg exemplify this trend. Beginning with *Lip* (1999), and going on to *Artist* (2000), *Love* (2003), *Doomed* (2007) and *Other* (2009), each video is a tightly edited series of scenes from mainstream films, set to a soundtrack and sequenced in a broad narrative arc. The result is a vivid enactment of how cinema creates cultural stereotypes – such as the black servant, romantic love, the exotic other – although the videos are also a fan's tribute. The compilation of personal favourite screen moments plundered from the near infinite video archive has reached its apogee in the age of YouTube, vidding and mashups. Soda_Jerk (Dan and Dominique Angeloro) in works such as *Pixel Pirate II: Attack of the Astro Elvis Video Clone* (2007) edit renowned film and TV characters into absurd narratives, challenging anachronistic copyright regimes but also having fun with the medium. Not even private archives are off-limits to the video pirate: Ms & Mr (Richard and Stephanie Nova-Milne), for example, draw on their own recorded family memories to fictionalize their pasts, providing a powerful metaphor of the contemporary self as mediated by electronic and digital media.

[26]Stuart Koop and Max Delany, *Screen Life: Videos from Australia*, exh. cat., Madrid: Reina Sofia Museum, 2002.

Given the redeployment of well-loved and recognizable footage that taps into viewers' nostalgia for the enjoyment of popular culture, and the relative ease with which such mashups can now be made, this type of video work remains fashionable. However, some works manage to distinguish themselves from the fashionable pack through their erudition, insight and technical innovation. The more recent works of Soda_Jerk are a case in point. Rather than an easy ride through the clichéd tropes of mainstream and B-grade movies, the later elements of the duo's *Dark Trilogy* use appropriated film to probe deep psychological territory, in particular the experience of aging from a female perspective. *After the Rainbow* has the innocent Judy Garland of *The Wizard of Oz* confronting her washed-up alcoholic self in later life, while in the final video of the trilogy the two stars of *Whatever happened to Baby Jane?* dream of their younger, beautiful selves and appear to rue how their Hollywood careers have been shaped by their aging.

FIGURE 7.2 Soda_Jerk, *The Time That Remains*, 2012, two-channel projection on screens back-lit with fluorescents. UTS Gallery, Sydney, 2013 Photo by David Lawrey, Courtesy of the artists.

Installation and alternative spatial experiences: The 1990s and their fashion legacy

Before the recuperation of early video performance and the emergence of vidding that retrospectively valorized aspects of 1980s image appropriation, video's fashion stakes received their definitive fillip when in the 1990s installation became the default setting for art practice. During this period, contemporary art accelerated its rapid growth and diffusion through the networks of globalization, including

the new art fairs and biennales that proliferated throughout the developing world. Video was integral to installation's success, while installation, given its relationship with traditional forms such as sculpture, facilitated video's consecration by the institution in a way denied to single-channel video.[27] Installation, with its embrace of the ready-made, both image and object, and its accent on the spatial properties of the exhibition site, was well disposed to video. Video's flexibility of scale and immateriality, together with its ease and economy of production, meant that it could easily fill or transform a previously daunting or mediocre space through enlargement provided by data projectors. It proved to be the perfect medium to meet the voracious demands of the new mass museum for monumental scale, spectacle and simultaneous worldwide exhibition.[28] As the museum moved from elite to mass phenomenon, becoming 'a site of *mise en scene* and operatic exuberance' – as cultural critic Andreas Huyssen describes it[29] – and as the private collector's desire to flaunt the social and cultural capital exchanged for economic capital brought with it the desire for scale – as Hal Foster puts it – so did video's fortunes rise.[30]

Video could achieve the effects of a wall-sized history painting (an irony for us is that in their time these paintings were called *machines*), create an immersive environment through the theatrical effects of darkness and privacy or simulate interactivity through laser triggers and feedback loops. Artists designed innovative and diverse physical spaces for the audience to encounter video imagery, such as multi-screen, immersive or VR-like environments, to disrupt conventional viewing conditions and heighten affective responses. Patricia Piccinini's *Plasticology* (1997) augments the effect of the computer-generated eco-system represented on the screen by dispersing monitors throughout the space (*à la* Nam Jun Paik), while her *Breathing Room* (2000) integrates video of digitally constructed skin into a self-contained cubicle with a vibrating floor, which rumbles in sync with the skin's dilating orifices to create a stultifying simulation of a panic attack. Daniel von Sturmer enlists video installation to playfully dismantle the conventions of viewing art in works such as *The Truth Effect* (2003), while the fractured narratives of David Rosetzky, including *Untouchable* (2003), rely on the physical platforms and layout of video images to drive home the deadening lack of intimacy among his contemporary cast of characters.

British philosopher Peter Osborne ventures that the rise in video's fashion stakes (or as he phrases it, 'the renewed interest in film and video in art spaces') is on account of the intensification of distraction in which art is received today. Large-scale video installation, a staple of contemporary art, provides a form of distraction that acknowledges its spatial conditions as part of the viewing experience, enacting

[27]Rush, *New Media in late 20th-Century Art*, 116.

[28]Karen van den Berg and Ursula Pasero, 'Large Scale Fabrication and the Currency of Attention' [2012], in Natasha Degen (ed), *The Market*, Cambridge, MA: MIT Press and London: Whitechapel Gallery, 2013, 126.

[29]Andreas Huyssen cited in van den Berg, 'Large Scale Fabrication and the Currency of Attention', 26.

[30]Hal Foster, 'The Medium Is the Market' [2008], in Natasha Degen (ed.), *The Market*, Cambridge, MA: MIT Press and London: Whitechapel Gallery, 2013, 200.

a deepening of distracted perception as a condition of reception.[31] Distraction, Osborne argues, is built into the gallery experience to alleviate the anxiety created by the expectation for contemplative immersion.[32] A good example of this might be the mesmerizing wraparound video installations of Russian collaborative artists AES+F that fill every nook and cranny of the gallery space with 'perfect' digitally generated worlds, such as in *The Feast of Trimalchio* (2009).

FIGURE 7.3 AES+F, *The Feast of Trimalchio* (still). © AES+F/ARS. Licensed by Viscopy, 2014.

Video and the return of narrative

As evidenced by more recent work made by appropriating images, video art revised its earlier strategy of rejecting narrative altogether so as to craft an alternative visual language to TV and film. Less concerned with its distinctive technical and formal aspects, in the 1990s video art embraced its ability to tell stories; this coincided with the turn away from appropriation in the visual arts in general,[33] and the emergence of identity politics. Yet video art did not abandon its quest to construct alternative ways of viewing the moving image: its narratives were often fractured through

[31]Peter Osborne, *Anywhere or Not at All: The Philosophy of Contemporary Art*, London and New York: Verso, 2013, 189.

[32]Osborne, *Anywhere or Not at All: The Philosophy of Contemporary Art*, 186.

[33]What American art theorist Hal Foster termed 'the return of the real': *The Return of the Real: Art and Theory at the End of the Century*, Cambridge, MA: MIT Press, 1996.

temporal and spatial disruptions in innovative explorations of installation. At the same time, the 1990s witnessed the 'arrival' of 'new media', with its signature concepts of interaction, interface and immersion, concepts whose articulation, as Australian media theorist Darren Tofts argues, had already begun in the early phase of video art.[34] Video in the 1990s was 'reframed' by digital technologies, and modulated into 'hybrid' works (another buzzword of the period).[35]

In the 1990s, artists used video to explore traumatic historical and personal events, deploying narrative in different ways. Practice ranged from the low-tech personal stories of resistance in the satirical works of Destiny Deacon[36] such as *I Don't Want to be a Bludger* (1999) where the artist takes a humorous sledgehammer to stereotypes of Aboriginal identity, to the lugubrious imagery of Dennis del Favero's video testimonies of victims of war atrocities, such as *Motel Vilina Vlas* (1996). While the former work is an effective use of DIY personal confessional, the latter typifies the bad faith of certain video artists who deploy the medium to aestheticize suffering and feign concern in an avowed attempt to engage in diverse and fractured storytelling and underline the problematic nature of documentary and the elusive nature of truth. A counterexample might be the work of Canadian Jayce Salloum. His video installation *everything and nothing* from the ongoing project, *untitled* (1988–2006), is a multi-monitor work that plays out hundreds of hours of interviews the artist did with survivors of political detention and civil war. The artist does represent himself, off camera, asking questions in halting French and often leaving himself open to be patronized by the real storytellers. These engage in incisive political and cultural analysis, but one always grounded in personal reflection and feeling. This personal, individualized tragedy invites empathy in a way that a national or cultural tragedy finds far more difficult. We may mis-encounter this analysis cum testimony, find ourselves unable to comprehend what this people experienced. Or we may be reminded of our complicity in this system of value in our inter- as much as intra-national relations. We may even be confronted with how we too, like these survivors, are regularly cast as shit in the global value system, how our cultural specificity has been increasingly compromised. This work exemplifies video's capacity for metonymy at its most powerful, where the medium's tendency to venal use is undercut by the strength and significance of its content and its ethical handling.

The postmedium condition: Aesthetics and participation

A sure sign of the postmedium condition is the recent embrace by certain video artists of the aesthetics of painting, given video's beginnings as an anti-establishment riposte to the commodity form *par excellence*, and its self-reflexive tradition whereby works

[34]Darren Tofts, *Interzone: Media Arts in Australia*, Melbourne: Craftsman House, 2005, 33.
[35]Darren Tofts, 'Australian Video in the 1990s', unpublished paper presented at Video Void symposium, Contemporary Centre for Photography, Melbourne, November 2010.
[36]Deacon worked collaboratively with Michael Riley and Virginia Fraser.

consistently called attention to the conditions of their own making. Even when relying on digital effects, some artists mask over their works' technical underpinnings for aesthetic effect. In the fashionable tradition established by Bill Viola, Australian artists such as Shaun Gladwell in *Storm Sequence* (2000) and Susan Norrie in *Undertow* (2002) use a single large-scale projection and radically slowed footage to represent the forces of nature in the manner of the sublime landscapes of the Romantics. It is now something of an in-joke that all that is needed to create a significant video work is to slow down the image to infinitesimal, turn down the volume to spiritual silence, use lush (or historically faded) colour and recognizable art historical aesthetics (a Caravaggesque dramatic chiaroscuro is a Viola favourite, but Rococo and Romantic will also do). There is no doubt that this formula for instant fashion has made many careers. It rivals the other instant fashion, this time in the tradition of Vito Acconci, where anti-aesthetics rule: tape yourself in poor quality doing something intimate and embarrassing and don't just post it on YouTube but project it on a gallery wall.

Along with its embrace of traditional aesthetics in recent years, another aspect of video's postmedium condition, as well as its fashionability, was its suitability as a point for the convergence for a wide spectrum of other media. With the rise of digital media, video proliferated in contemporary art circles. At one end of the production spectrum, video by the new millennium had, in the work of certain practitioners, become almost indistinguishable from film: mural scale, shown in dedicated theatre-like spaces if not cinemas themselves, and often shot on lush cinema stock or cinema-quality high-definition camera. The archetypal example here is of course Matthew Barney, whom we discussed in detail in Chapter 2, but there are now countless examples of fashionable video auteurs, including Isaac Julien and Steve McQueen. At the other end of the production spectrum is that video art that brought the products of computer manipulations and hand-held device image capture to the gallery and museum. Video was able to entrench its ascendancy as a contemporary art medium by seamlessly transmitting the effects of social media technologies, and hence able to claim to embody the most current means of human relations, the building blocks of the politics and interactions of today. The Perth-based 'tactical arts group' PVI (led by Kelli McCluskey, Steve Bull and Ofa Fotu), for example, blends video, mobile communications technologies and performance to engage communities in public interventions. Works include *Reform* (2007), 'a radical vision of community-watch gone awry',[37] where performers in the guise of local concerned citizens patrol a city precinct for anti-social behaviour, and *transumer* (2010), 'a site-specific intervention that encourages audiences to clandestinely take over their city in preparation for an anti-consumerist uprising'.[38] Video-hosting networking sites provide the means to realize global participatory projects of unprecedented scale, such as Australian artist Deborah Kelly's *Tank Man Tango* (2009), a synchronized dance performance that paid tribute to the humble figure who, shopping bags in hand, stood his ground against the tanks in Tiananmen

[37]PVI artist statement: http://www.pvicollective.com/, last accessed 25 October 2013.
[38]Biennale of Sydney 2010 website: http://www.biennaleofsydney.com.au/, last accessed 25 October 2013.

Square twenty years earlier, on 5 June 1989. While on the one hand this use of video can be seen as a way to remind audiences of historical events that have ongoing political ramifications and create a sense of shared concern, on the other it typifies the co-optation of video for what some may see as opportunistic 'activism'.

Video can claim to be of its time and to remain of our time, given the full integration of the moving image in the everyday life of the twenty-first century. In this, ironically, it has a long pedigree: video pioneer Frank Gillette stated back in the 1960s that 'you are as much a piece of information as tomorrow morning's headlines'.[39] Many early video works – including classics like Les Levine's *Slipcover* (1966) and Nauman's *Video Corridor* (1968) – focused on the very issue of interactivity and audience participation, experimenting with viewer feedback and self-surveillance.

Despite the immense innovation in its early years – its critical role in community activism, performance and electronic and interactive image generation – video did not become fashionable until it was institutionally consecrated and its more radical and less art-bound origins domesticated. Had it remained techie and grass roots, fashion would have continued to snub it: it is highly unlikely that The Metropolitan Museum, New York, would have purchased a video access centre tape, whereas it did acquire its first video work in Viola's *The Quintet of Remembrance* (2000) in 2000. The institutional imprimatur required that video relinquish all but the sign of its early radicality.

Nonetheless, against the contrary claims of theorists like Fredric Jameson, cultural historian Nicholas Zurbrugg passionately argued for video art's criticality: video art, he claimed, allows for self-analysis and for the critical examination of culture, disorienting viewers and compelling them to think about their own processes of perception and cognition.[40] It is true that for part of its history even to this day, video's explorations of performance and the body, the language of film, TV and digital media, and the implications of spatial disruptions to the viewing experience, have lived up to Zurbrugg's expectations. But for a great deal of this century so far, video has readily served its purpose as fashionable art world fodder. Videophilia in artists and art consumers alike has met the voracious demands for large-scale, travel-friendly art, meshing with the celebrity machine that promotes international art stars ready for market, and mostly trading on its (long faded) anti-establishment roots.

[39]Rush, *New Media in Late 20th-Century Art*, 125.

[40]Nicholas Zurbrugg, 'Jameson's Complaint: Video Art and the Intertextual Time-Wall', *Screen*, Vol. 32, Spring 1991.

8 MINIMALISM: DONALD JUDD OR IKEA?

In some ways, Minimalism has never gone out of style since it first emerged as a vortex of silence in the midst of the cacophony of protest – the loud rhetoric of liberation mixed with the strains of psychedelic rock – which marked the 'end' of many 'modernist myths', social, political and artistic in the 1960s. Silence, the essence of cool, has remained a powerful symbol of art that refuses to be domesticated by discourse, or anything else for that matter. Radicalizing art by foregrounding the relationship between the viewer and the object, Minimalism provoked the ire of establishment critics – pre-eminently the then disciple of Greenberg, Michael Fried – who were angered by the way it undermined the autonomy of the art object and crudely reduced it to bald industrial materials. Before long, however, Minimalism had effectively displaced its very *bête noire*, Abstract Expressionism, at the tip of the avant-garde tree, to be sanctified and canonized as the official style. By the end of the 1970s, true enough, Minimalism was in certain circles of 'advanced art' rejected as hard-line and authoritarian (in part as a result of cogent feminist critiques about some of its gendered assumptions). Yet, despite its integration as convention, Minimalism as a problem never said die. Its imperatives faded in and out of view, but they remained, still sufficiently unresolved to provoke many a contemporary artist – whether they be termed 'post-Minimalist' or not. Writing a eulogy for Donald Judd, and citing artists from Hesse through to Warhol, Steinbach, Gober and Koons, Richard Serra observed that 'individually and collectively, we all put our heads in Judd's box'.[1]

As Foster notes in *The Return of the Real* (1996), Minimalism occupies an ambivalent position vis-à-vis modernism; arguably it is both the last modernist style and a crucial step towards the loosening of conventions and myths such as originality and authorship, the watershed to postmodernism. Minimalist works' apparent dumbness begged the spectator to speak; as monumental steel jutted into their stomachs or

[1]Richard Serra, 'Donald Judd' [1994], in James Meyer (ed.), *Minimalism*, London: Phaidon, 2000, 289.

threatened to crush them from overhead, these works made viewers acutely aware of their incarnated presence. Minimalism activated the viewer in such a way as to mobilize ongoing debates about the nature of perception and the power of the viewer to interpret a work according to his or her own desire alone. The fecundity of ideas thrown up by Minimalism goes to underline that 'There is nothing minimal about the "art" in Minimal art. If anything, in the best works, it is maximal. What is Minimal is the means, not the ends.'[2] On the other hand, Minimalism was, and still is, frequently accused of being 'boring', of depriving viewers of the interesting content and complex composition they come to expect from innovative art which, to that point, had been recognizable on account of its formal experiments. Some artists and critics attempted to reclaim the positive value of boredom – conventionally a pejorative associated with triviality and irrelevance – a gambit that was developed with some gusto in postmodern anti-aesthetics.

In the twenty-first century, (post-post) Minimalist sculpture is decidedly fashionable: it is still admired and respected, and art and non-art audiences alike are bound to stumble upon it: in malls, foyers, specialist doctors' waiting rooms, as public sculptures and so on. It has entered the mass consciousness in a host of ways but, by virtue of its heroic muteness, retains its mystique; its visual language is familiar and has to a greater degree entered the common vernacular, but we still defer to the experts for guidance. One form of Minimalist sculpture that is particularly fashionable in global surveys of contemporary art is that which melds art and interior design, and has even prompted the emergence of an internet meme: 'Is it Donald Judd or IKEA?' As Martin Braathen reminds us, 'Both the museum and the department store display precious objects, and more importantly, both institutions engage in two prominent features of bourgeois public culture: the refined leisure of connoisseurship and the entertaining consumption of shopping.'[3] In this strain of Minimalist contemporary art that has softened the corners of Judd's boxes, silence – narrative shutdown, cool, 'boredom' – is pervasive. As we have suggested already, because of its use of industrial materials (it is durable and these echo the architectural structure) and its crisp geometric angularity (it works with modernist furniture, or can sympathetically be married to another artwork that is not Minimalist), Minimalist sculpture is a fashionable, popular addition to public spaces, museum architecture and 'experience design', which could well prompt its own internet meme: is it Richard Serra or the City of Sydney? (It is interesting that Judd back in the early days pushed for permanent installation of his work, at the same time as he disavowed the term 'Minimalist'.)

This impulse in Minimalism is what some years ago Rosalind Krauss identified with 'the cultural logic of the late capitalist museum'; she proposed that on account of Minimalism now shaping how we look at art, the 'industrialised museum will have much more in common with other industrialised areas of leisure – Disneyland, say [or we could add IKEA] – than it will with the older pre-industrial museum. Thus it will be dealing with mass markets, rather than art markets, and with simulacral experience,

[2]John Perrault, 1967, cited in Hartmut Obendorf, *Minimalism: Designing Simplicity*, London: Springer Verlag, 2009, 52.

[3]Martin Braathen, 'The Commercial Significance of the Exhibition Space' [2007], in Natasha Degen (ed.), *The Market*, Cambridge, MA: MIT Press and London: Whitechapel Gallery, 2013, 113.

rather than aesthetic immediacy.[4] This point has been brought home more recently by critics who identify large-scale fabrication (and its regular sidekick 'spectacle') as the predominant organization of contemporary art. The disconnect between the parlour-scale of traditional art (think, say, a still life by Chardin or a gathering of card players by Cézanne) and the industrial phenomenon of the city prompted artistic methodologies to align with the monumental new dimensions of the urban everyday: enter Minimalism.[5] The public's embrace in the last two decades of large-scale public art – reflected for instance in the changing fortunes of Richard Serra from *Tilted Arc* (Federal Plaza NYC) loser in 1981 to *Clara-Clara* (Jardin des Tuileries, Paris) winner in 2008 – and large-scale public (and private!) destination architecture museums, has ensured the fashionability of Minimalism.

FIGURE 8.1 Richard Serra, *Clara-Clara*, 2008. Boris Horvat/AFP/ Getty Images.

Forms of what we might call 'soft Minimalism' – springing in part from Robert Morris' 'anti-form' reaction to the movement's hard-edged doctrines – or Minimalism inflected with psychological references – associated in part with the 'feminization' of Minimalism's 'rhetoric of power' together with the longing to recapture one of Minimalism's original concerns, 'embodied immediacy'[6] – are less pervasive, and less fashionable. It would take some substantial alteration for these two arguably more complex impulses inherent in Minimalism to become fashionable, one as 'formlessness', the other as 'participation', aspects of fashionable art discussed in other chapters of this book.

[4]Rosalind Krauss, 'The Cultural Logic of the Late Capitalist Museum', 1990, in James Meyer (ed.), *Minimalism*, London: Phaidon, 2000, 288.
[5]van den Berg and Pasero, 'Large Scale Fabrication and the Currency of Attention', 128–9.
[6]See Alex Potts, *The Sculptural Imagination*, New Haven, CT, and London: Yale University Press, 2000.

But now let us consider, how and why has Minimalism retained its fashion kudos, at least in certain forms? What remains of Minimalism's original paradigm-shifting imperatives in its currently fashionable incarnations?

Classic Minimalism and its early critiques

Minimalist artists constructed simple, monochromatic, geometric objects of formal symmetry, characterized by an absence of traditional composition. Minimalism was an extreme abstract art, not imitative but solipsistic, self-referential: it was unto itself, harking back to the idea of truth to materials whose lineage can be located in the Russian Constructivists (particularly Rodchenko and El Lissitzky) through to Moore, Hepworth, Gabo, Pevsner and Caro, the latter often mistaken, in the broader sense, for a Minimalist artist. Its style was an aloof, decisive and rational reaction to the existential angst of Abstract Expressionism and its myth of individual creativity. It was also Greenberg's call for formal values – in painting the paint-ness of the paint and recognizing the flatness of the picture plane – taken to the nth degree; here was form and material in all its brute presence but lacking the appeal to the numinous or tragic that we associate with artists like Rothko or Newman (who nonetheless opened many doors for the Minimalist project). In its impatience with the spiritual and the sentimentally contemplative, Minimalism marked a return to a more intellectual, detached sensibility, and also a move to annex criticism from the critic to the artist. (For instance, Judd himself was a prolific critic and it is instructive to compare the tenor of his writings with other artist-writers such as Motherwell or Newman.) Yet, it was, not surprisingly, a critic's pejorative assessment that gave rise to the term: Richard Wollheim's description of practice, such as Ad Reinhardt's paintings and Marcel Duchamp's readymades, distinguished by what he thought of as 'low art content' (a claim we will return to later when we consider the pros and cons of boredom). How off beam could a critic be? After all, one of the most influential poets of the previous century on artists had been Mallarmé, the great poet of nothingness. Nonetheless, the term soon came to describe the outcomes of artists working with large-scale geometric shapes that shared the qualities of total abstraction, order, simplicity, clarity, factory fabrication, a high degree of finish and anti-illusionism or literalness.

In his influential 'Notes on Sculpture' (1966), Robert Morris noted the distinction between the tactile nature of sculpture and the optical qualities of painting. Training his attention on the qualities of very simple gestalts or wholes, Morris argued that the intensification of the simplest shapes and the elimination of all non-essential sculptural attributes establish a new limit and freedom for sculpture, especially in that it drew the spectator into sharp relief. Morris proposed key characteristics for advanced sculpture: that the ground should be the base; that colour is inconsistent with sculpture; that simplicity of shape does not necessarily equate with simplicity of experience; that large scale is necessary for sculpture to take the viewing experience beyond the internal relationship with formal elements into a consideration of the external elements that sculpture unfolds in time, and needs to be walked around rather than grasped in one visual glance (as Greenberg said about ideal painting). Morris sought to remove the maker of the work – the artist – from the dialogue

between audience and work. With Minimalism, he said, 'the little visual appeal shifts our attention to external relations', that is, to our relation as viewers to the work, to the art object as it occupies the space, to its relation to us and to its setting. (Examples of Morris' early work to which these thoughts relate include *Corner piece* 1964, *Ring with light* 1965 and *Untitled* (mirrored cubes), 1965.)

In related ways, Carl André's Minimalism sought to reduce the language of sculpture to basic phonemes and modular units, such as squares, cubes, lines and diagrams. His work pushed against from, towards structure and space, consistently searching for the simplest, most rational model. That search for an underlying rational simplicity also informed Sol LeWitt, who took the grid as a starting point for his exploration of the paradox of simple logic producing perpetual complexity. Donald Judd was particularly driven to overcome the problems of illusionism in art that he identified at the heart of Greenberg's dominant but narrowly conceived ideas of modern art. According to Judd, sculpture should not represent anything: it should stand for itself, against illusion and falsity. In his essay 'Specific objects' (1965) Judd stated that to avoid the problems of illusionism, he took his work into 'real space'. He used modern machined materials to undermine the notion of art as handcrafted, and serial representation that is endlessly additive to question the completeness of work, compelling viewers to look *through* as well as at the work. Examples of his work that reflect these ideas include *Untitled* (1966–8), *Untitled* (1969/82) and *Untitled* (1975).

Incidentally, the title *Untitled* was so ubiquitous to Minimalism that it became synonymous with it, such that in contemporary art it now takes its status as historicized meta-title. In other words, a work entitled thus directly cites Minimalism, taking the Minimalist ethos into its embrace as it were. But whereas Minimalism advanced the idea that one requires something to express nothing, now the title of nothing means something, an especially postmodern irony. The working alternative is 'no title', which works for English but not in other languages since *sans titre* in the French and *ohne Titel* in German carry both meanings, consigning an artist's attempts at neutrality to the semantic onus of historical allusion. The shadow of Minimalism weighs upon us.

Some early critiques of Minimalism, once it had settled into 'top spot' of official art discourse, objected to a quality that underpins its current fashionability: Minimalist works were said to resemble modular furniture and corporate design, to be consonant with the 'tidiness and security' of middle-class values. Some later critiques, Anna Chave's for instance, affirmed this view, arguing that Minimalist forms were of a piece with commercial objects, and that Minimalism's 'rhetoric of power' underlined rather than challenged the language of social authority, being aggressively and unreflexively masculinist, phallic even.[7] Minimalism's monumentality, heavy industrial materials, 'tough-mindedness' and a downright loathing of any 'extraneous' decoration affirmed its (stereotypical) gendered stakes. Chave maintained that Minimalists sought to impose their forms and arguments – citing Serra's infamous *Tilted Arc* as just one example – and that they perpetrated violence through their work: even literally at times! (Serra's

[7]Anna Chave, 'Minimalism and the Rhetoric of Power', [1990], in James Meyer (ed.), *Minimalism*, London: Phaidon, 2000, 275.

work once fell on a viewer.) According to Chave, despite Minimalism's purported neutrality, Minimalist artists were never so radical as to question authorship or authenticity with any real seriousness. Even Judd's inversion of the Expressionist mark (the irreducibility of the manual index), by not touching his work and having it fabricated by the hands of others, still began and ended with Judd the artist, the name, the brand. They equated expression with power, not with feeling or communication. Unlike many historical avant-gardes, Minimalists did not propose any utopian alternative, despite their overt identification as 'Leftists' and the counterargument, per Adorno, that 'authentic art is familiar with expressionless expression'.[8] Yet, there's something inexorable about Minimalism's alignment with power that makes it cool and, ultimately, fashionable. And we know that fine lines and simplicity in the fashion world (e.g. Armani, Sander) immediately confer on the garment the status of 'classic'.

Even certain Minimalists themselves questioned the muteness and reductionism of Minimalist forms, leading some, most notably Eva Hesse and Robert Morris, to develop what became known as 'post-Minimalism'. In his essay 'Anti-form' (1968),[9] Morris critiqued his initial approach, saying it had relied on exactly the same principles as traditional sculpture, namely subjective decisions, and had resulted in icons. In signalling a move to 'anti-form', Morris argued for the absence of determinable shape, durability and outline, principles he applied in his felt works where the materials responded to simple actions such as cutting and dropping: 'random piling, loose stacking, hanging, giv[e] passing form to the material. Chance is accepted and indeterminacy is implied since replacing will result in another configuration ... the work refuses to continue the aesthetics of form.'[10] Works such as *Untitled (Pink Felt)* (1970) allude to the body, to skin, to gravity, but they refuse the unitary profile of Minimalist sculpture, pointing instead to process and 'anti-form', as did the work of Eva Hesse. Hesse developed Minimalist forms from geometric to organic works with a series of oppositions: industrial order versus bodily chaos, heavy/rigid versus light/flexible, careful calibration and grading of colour versus disorder and disarray, evident in works such as *Accession II* (1967). Hesse used materials for their irregularity and translucency, including resin, latex (to the frustration of curators and collectors since it degrades) and fibreglass, invoking bodies and skin, containers, clothing, coating, protecting, containing, hiding. Yet, despite these narrative inferences, Hesse said she wanted to make 'nothings', like the piece of broken pipe she might find in the street. 'Nothings', it would appear, implied the absence of aesthetic value, which would immediately transform the 'nothing' into art. Hesse recounts in relation to *Right after* (1969), that 'it left the ugly zone and went into the beauty zone. I didn't mean it to do that', so she made another, 'ugly version' (*Untitled*, 1969).[11]. It is clear that post-Minimalist anti-form in the vein of Hesse and Morris is intimately related to

[8]Theodor Adorno, *Aesthetic Theory*, cited in Chave, 'Minimalism and the Rhetoric of Power', 275.
[9]Robert Morris, 'Anti-form', *Artforum*, Vol. 6 No. 4, 1968, 33–35.
[10]Morris, 'Anti-form', 34.
[11]Eva Hesse, cited in Alex Potts, 'The Sculptural Imagination: Figurative, Modernist, Minimalist', New Haven and London: Yale University Press, 2000, 355.

the anti-aesthetics of postmodernism, but in a distinct way to the impulses of what we might call 'classic' Minimalism. Whereas anti-form leaks into the discourses of formlessness and ugliness, signalling affective saturation and the bodily rumblings of abjection and disgust, classic Minimalism is rather related to the anti-aesthetics of affectlessness, boredom and cool, where the body is expunged – analogous to the public face that covers up the private life of *American Psycho*'s Patrick Bateman.

FIGURE 8.2 Eva Hesse (1936–70) works on a sculpture composed of rubber-dipped string and rope in her studio, New York City, New York, 1969. Photo by Henry Groskinsky/The LIFE Picture Collection/ Getty Images.

From Minimalism to anti-aesthetics

The aesthetic is best defined by its enemies – not conception and concern, but boredom, indifference, worry, confusion, and past a certain point, pain.

—HENRY DAVID AIKEN[12]

As we saw in Morris' 'Notes on Sculpture', 'classic' Minimalism's strategy of intensifying minimal stimulation sought to revitalize the relationship between 'viewer' and work such that the former would become ever more conscious of their embodied subjectivity and their role in creating the meaning of the artwork. However, Minimalism also invites 'an anti-aesthetics of the unpresentable' that marks the turn to the postmodern through a divergence in the role of aesthetics: whereas certain forms of modernism relied on understanding, which aims to make sense of the work, postmodernism sought rather to confound meaning, to prevent the viewer from 'mastering' the work through understanding.[13] Increasingly, 'minimal stimulation' and 'anti-illusionism' tipped over into utter affectlessness and the purposeful evocation of boredom, no longer informed by modernist aspirations to reconnect viewer and object, but on the contrary, numbing the viewer entirely. In this regard, the Minimalism of contemporary art lives up to the psychological cliché of male emotivity: reticent and aloof. It is better to show no emotion and no vulnerability. And in this regard Minimalism's horror of affect is a striking, if negative, reflection of the times. It is the art of corporate psychopaths ('disassociation of affect' is the clinical phrase), or of those who wish to shy away from the real issues of our 'end' times. After all, Minimalism offers us safe refuge from such ghastly ever-encroaching realities such as global warming, natural catastrophe, depletion of resources, mass poverty, ghetto culture and overpopulation.

The current fashionability of Minimalist art is in part a result of the legacy of this anti-aesthetic impulse, and its powerful endorsement by what American critic Dave Hickey calls 'the therapeutic institution'.[14] The coup de grâce of contemporary Minimalism is its ability to maintain its anti-aesthetic cool, its disdain of the viewer and hence its institutional insider favour, while at the same time offer the sleek surfaces and imposing scale that speak with the assurance and mastery of lifestyle products and advertising. It evacuates the experience of the specific, embodied subject, but substitutes the generalized experience of the ideal post-industrial consumer, re-calibrating postmodern 'wane of affect' with gestures towards individual (consumer) creativity – Minimalism as interior design – and community affectivity – Minimalism as public experience design.

[12]Henry David Aiken, 'Some Notes Concerning the Aesthetic and the Cognitive', in Morris Phillipson (ed.), *Aesthetics Today*, Clinton: Meridien, 1961, 265.

[13]Peter Williams, 'When Less Is More, More or Less: Subtraction and Addition in (Post)modernist Poetics', in James Swearingen and Joanne Cutting-Grey (eds), *Extreme Beauty: Aesthetics, Politics, Death*, New York and London: Continuum, 2002, 40.

[14]See Dave Hickey, *The Invisible Dragon: Four Essays on Beauty*, Los Angeles: Art Issues Press, 1993, 53–68.

The 'therapeutic institution' of art is that 'loose confederation of museums, universities, bureaus, foundations, publications, endowments'[15] that usurped the traditional function of aesthetics in the last sixty years. Hickey argues that this institution set itself up as exceptionally well positioned to guarantee the criticality of art, given its avowed inviolability to the 'corruption of the market' and cast out aesthetics as irrevocably identified with that corrupt force. Robert Morgan holds the American art education system fed on *Artforum* and *October* responsible for perpetrating a particularly narrow interpretation of worthwhile art practice – denoted by the rubric of the anti-aesthetic – that denigrated the idea that art can be made with relation to feeling and imagination.[16] And Hickey too places the critical establishment, which had emerged as the custodian of postmodern theory and powerful arbiter of advanced art given its enormous contribution in legitimizing such practice, at the heart of 'the therapeutic institution'. A key player in this critical establishment was Hal Foster – then professor of art history at Cornell University and one of *October*'s co-editors – who as early as 1983 had proposed that aesthetics were inimical to critical practice. In that year, Foster published an edited anthology that was to become a touchstone for postmodern art theory and practice. Entitled *The Anti-aesthetic*, it contained now-classic essays including 'Sculpture in the Expanded Field' by Rosalind Krauss, 'Critical Regionalism' by Kenneth Frampton and 'On the Museum's Ruins' by Douglas Crimp. The title itself revealed a great deal about the place aesthetics occupied in the new postmodern landscape. Aesthetics had come to be equated with 'official representations', and Foster deployed the term 'anti-aesthetic' as a 'rubric' that encapsulated a variety of postmodern concerns, 'in short, a will to grasp the present nexus of culture and politics and to affirm a practice resistant both to academic modernism and political reaction'.[17]

How ironic, if not entirely unpredictable, that within a decade it would be Foster and his cohort who had become the new academy of advanced art theory with its exclusive criteria of entry (and that within two decades that same cohort would be scratching their heads as to why artists increasingly looked elsewhere for critical dialogue).[18] In any event, Foster's 'anti-aesthetic' became shorthand for advanced art of the 1980s and early 1990s. Aesthetics came to be associated with a whole raft of misdemeanours: suspect 'official representations' that were used to legitimize existing power relationships and repress difference; the claim that art could exist outside of and untainted by politics; the privileged position of the artist/author who professed originality and autonomy; the belief in a unified subject capable of a meaningful aesthetic experience; faith in the ability of language to express feeling and communicate effectively; the interpretation of artworks according to their internal, formal properties rather than by reference to a cultural context; *and* art that

[15]Dave Hickey, 'After the Great Tsunami', in Dave Hickey (ed.), *The Invisible Dragon: Four Essays on Beauty*, Los Angeles, CA: Art Issues Press, 1993, 53.

[16]Robert Morgan, *The End of the Art World*, New York: Allworth Press, 1998, 205.

[17]Foster, *The Anti-Aesthetic*, 1983, xv.

[18]This is the central question preoccupying the editors of *October* in a round-table on the perceived current crisis in art criticism and theory: See 'Round Table: The Present Conditions of Art Criticism', *October*, Spring 2002, No. 100, 200–28.

pandered to the market. As art struggled to define its role vis-à-vis popular culture, and as discourse-based art strove to distinguish itself from the market-bolstering 'hot' painting of the trans-avant-garde, aesthetics increasingly came to be associated with tainted, uncritical commercial interests.

Foster asserted that 'the very notion of aesthetics, its network of ideas is in question here', that is, the traditional Romantic/modernist association of aesthetics with disinterest, autonomy, universality and the idea that art can effect a 'symbolic totality'. Foster even had the temerity to jettison Adorno's notion of aesthetics as a 'critique of the world as it is', that is, as 'subversive, a critical interstice in an otherwise instrumental world'. For, to Foster this criticality was now 'largely illusory'. What remained was rather 'a new strategy of interference', one allegedly driven by neither modernist utopianism nor modernist negation, a strategy that became manifest in early postmodern art: art concerned with the critique of the subject and focused on the image screen to illustrate that the subject was dictated by the symbolic order; art that was either anti-illusionistic and hence anti-visual or which vaunted the simulacral status of the image to the point of affectlessness; and art that sought to break the repressive economy of the gaze (and which ultimately granted artist and viewer little agency).[19]

Foster was at pains to distinguish the *postmodern* anti-aesthetic from 'modernist nihilism', marked as it was by 'negation' or 'espoused in the anarchic hope of an "emancipatory effect"'; his brand of anti-aesthetic was not 'utopian' but 'rather a critique which restructures the order of representations in order to reinscribe them'.[20] That is, according to Foster, modernism with its investment in the autonomy of aesthetics had failed in its attempt to subvert existing power regimes, instead eventually becoming the official culture; postmodern art must therefore do the opposite, abandon autonomy, thereby abandon aesthetics and engage directly with the vernacular. The distinction Foster seeks to assert proved to be hardly clear-cut, however. Early postmodern anti-aesthetic works, with their critique of representation, traditional modes of viewing and aesthetic response, were most certainly associated with political projects, notably feminism, and critically contextualized in terms of their 'resistant' or 'transgressive' qualities. It may be true that the radically changed sociopolitical context for such artistic responses inevitably altered their meaning and effect, and that with faith in grand narratives thoroughly shaken, any notion of utopia became problematic. However it is also true that a kindred avant-garde impulse to challenge the perceived forces of conformity – by demonstrating what they repressed in order to function – was nonetheless operative in much early postmodern art. Despite claims to the contrary, postmodernism arguably failed to undermine the avant-garde's self-conscious mission to compel the 'bourgeois public' into an acknowledgement of the ills and hypocrisies of its society and the art world as its microcosm.[21] Moreover, as Paul Mattick points out, Foster's strategic distinction evaporated as quickly as postmodern art became the new official culture.[22]

[19] Foster describes this phenomenon in *The Return of the Real*, 146.

[20] Foster, *The Anti-Aesthetic*, 1983, xv.

[21] Rosalind Krauss, *The Originality of the Avant-Garde and Other Modernist Myths*, Cambridge, MA: MIT Press, 1986.

[22] Paul Mattick, *Art in Its Time: Theories and Practices of Modern Aesthetics*, London and New York: Routledge, 2003, 127.

Robert Morgan notes that 'the anti-aesthetic, frequently associated with postmodernism in visual arts, [was] not so much a style as a method of critique', characterized by the rejection of quality and originality.[23] To Morgan, the wane of aesthetics in postmodernism was a result of the waging of intellectual war on Eurocentric art that was cast as merely a representation of a much broader yet concealed history of colonialism and expansion: 'In such a climate, aesthetics was no longer useful … what replaced aesthetics was a sort of applied theory.'[24] Morgan goes on to argue that for postmodern criticism and the art it favoured, aesthetics as such, the visual rhetoric of the work, interfered with the theoretical arguments about the work that, in accordance with the legacy of Minimalism and conceptualism, had come to be privileged.[25] Postmodern criticism also recoiled from the phenomenon of experience in relation to a work of art; experience was nearly relinquished or usurped in favour of theory, so that criticism became more a philosophical or sociological inquiry with little to do with aesthetics.[26] The discursive method was essentially a cynical one – Morgan cites the criticism of Benjamin Buchloh as an example – a method not unrelated to hyperrationality, which entailed the denial of the subject's experience as a pre-eminent concern in critical writing.[27] This position emanated from one of the central thrusts of postmodern philosophy, the critique of the subject and the feeling of subjectivity, both of which are predicates for the traditional understanding of the aesthetic experience.[28] As a consequence of this lack of desire for aesthetics, Morgan claims that criticism lost its contact with the object, and experience no longer had a language. 'Experience of the work of art is the fundamental ingredient in one's critical response, the foundation of any authentic interpretation' and entails both thought and feeling (the allusion here is to phenomenology). Without experience, there is no possibility for taking a position: semiotics, formalism or deconstruction are theoretical positions that if used in relation to one's experience may be useful instruments of interpretation, but if uncoupled from experience, become vacuous and dangerously abstracted. The current art world begs for the wilful absence of experience on the part of critics.[29]

The critique of the subject was central to the postmodern abandonment of aesthetics, as encapsulated in another key text of the postmodern condition, Fredric Jameson's *Postmodernism or the Logic of Late Capitalism*. As is well known, here Jameson identified the postmodern condition with the 'wane of affect'. As the subject of modernism is eclipsed, so too is the possibility of the aesthetic experience, which relies on feeling:

The end of the bourgeois ego, or monad, no doubt brings with it the end of the psychopathologies of that ego – what I have been calling the wane of affect…. As

[23]Morgan, *The End of the Art World*, 203.
[24]Morgan, *The End of the Art World*, 5.
[25]Akin perhaps to Danto's postulation that with postmodernism came the end of art in that art now amounted to arguments about it, to the discourse of art.
[26]Morgan, *The End of the Art World*, 35.
[27]Morgan, *The End of the Art World*, 36.
[28]See Perniola, 'Feeling the Difference'.
[29]Morgan, *The End of the Art World*, 27–30.

for the expression of feelings and emotions, the liberation, in contemporary society, from the older anomie of the centred subject may also mean not merely a liberation from anxiety but a liberation from every other kind of feeling as well, since there is no longer a self present to do the feeling. This is not to say that the cultural products of the postmodern era are utterly devoid of feeling, but rather that such feelings – which may be better and more accurately following Jean-François Lyotard, to call intensities – are now free-floating and impersonal and tend to be dominated by a peculiar kind of euphoria.[30]

That wane of affect, to the point of affectlessness, is of course already evident in one of the key reference points of early postmodern practice, the work of Andy Warhol. Although there has been much debate as to whether Warhol's affectlessness does not disguise some engaged, critical quality,[31] it is generally agreed, by critics across the ideological spectrum, that Warhol's art represents an effacement of the self, disconnection from feeling, a simulacral deployment of the image that undermines its referential power.[32] Integral to a traditional understanding of aesthetics is the emotional register of the aesthetic experience. American philosopher of aesthetics Henry David Aiken wrote in the 1950s that it is 'undeniable' that the quality and value of works of art are in part determined by 'the richness and depth of their emotional expressiveness'; but the representation of that expression must be understood as such, for without such understanding any emotion the observer feels would remain the 'private, dumb, inexpressive importation of the observer himself'.[33] In direct contrast to this conception of aesthetics, the postmodern anti-aesthetic was characterized by a critique if not outright rejection of expression, and a loss of faith in the reliability of representation. Indeed, the postmodern anti-aesthetic was concerned to underline the failure of communication, to render both the work and the observer 'dumb', to undermine the observer's expectation of a 'meaningful dialogue' with the artist or the artwork. The point was to promote a critical relationship with all representations and a consequent impulse to alter reality through altering representation, although it is also the case that many artists during this time relinquished pretensions to any political efficacy at all.

Minimalism's 'boring' nature can be seen as integral to these postmodern strategies, deliberately depriving the viewer of visual interest and placing the

[30]Fredric Jameson, 'Postmodernism or the Cultural Logic of Late Capitalism', in Joseph Natoli and Linda Hutcheon (eds), *A Postmodern Reader*, Stony Brook: SUNY Press, 1993, 319.

[31]For example, in the writings of Thomas Crow, 'Saturday Disasters: Trace and Reference in Early Warhol', in Serge Guibault (ed.), *Reconstructing Modernism*, Cambridge: MIT Press, 1990.

[32]Hal Foster refers to this view of Warhol in *The Return of the Real*, 127–30, while in *American Visions*, Robert Hughes comments that Warhol's importance stems from one central insight that he embodied, that there is a role for affectless art, that '[y]ou no longer need to be hot and full of feeling'. Hughes goes on to associate that loss of affect with death, remarking that 'somewhere near the heart of Pop morbidity lurked', and with the rejection of nature that Pop and Minimalism shared: *American Visions: The Epic History of Art in America*, London: Harvill Press, 1997, 539, 541, 563.

[33]Henry David Aiken, 'Some Notes Concerning the Aesthetic and the Cognitive', in Morris Phillipson (ed.), *Aesthetics Today*, Clinton: Meridien, 1961, 254–74.

responsibility on the audience 'to acquit itself of indifference'.[34] Yet, interestingly given the desire of postmodern anti-aesthetics to free itself from modernist utopianism, boredom as a state has strong links to utopianism. Invoking some of the most influential thinkers of the twentieth century, including Walter Benjamin and Martin Heidegger, Peter Osborne suggests that there is a utopian function to boredom in modernity derived from its distinctive relations to possibility. Benjamin, for instance, describes boredom as 'the dream-bird that hatches the egg of experience' and, more resonantly for our purposes, asserts that boredom is 'the other side of fashion', 'the dialectical counterpart and existential background to the libidinal discharge associated with the object of fashion, an integral part of the complex and paradoxical temporality of the new'.[35] Osborne argues that boredom is part of a 'constellation of terms' – including attention, curiosity, distraction, fascination, indifference and reverie – that characterize the phenomenology of modernity as one of utopian longing. Citing the positive value of boredom in the art of Fluxus, happenings and Warhol, Osborne comments that 'The production of boredom has become ever more important within art since the Second World War, as a defensive reaction against the expansion of the culture industry into its field of operations.'[36] In this schema, boredom is associated with contentlessness in the positive sense of providing the tabula rasa – literally, the blank canvas of modernism – for alternative ways of being and thinking. Osborne quotes Marx's observation that boredom is 'the mystical feeling which drives the philosopher from abstract thinking to intuition'.[37] He concludes that in the age of late capitalism, where more than ever art is 'received in distraction' – its sites of distraction having moved from architecture to film, TV and the interactive digital screen – that boredom intensifies the demand that art function politically. Boredom he sees as the antithesis of distraction, and art that evokes that state performing its role through its very emptiness, its 'negation of use value'.

However, do Osborne's dichotomies hold any longer? Could it be that, in the age of ubiquitous digital connectivity, boredom and distraction are less in opposition than one and the same, that the quintessential contemporary experience is of being bored *while* interacting: the endless phone scrolling and posting while socializing or watching television, the restless gaze of the consumer who visits IKEA seeking stimulation and distraction but ends up as bored as ever? If this is indeed the nature of the contemporary subject, how effective is the boredom – the intensification of blankness – that is arguably at the heart of Minimalism's utopian qualities in mobilizing 'the possibility of the possible'?[38] And how relevant and convincing are the claims made on behalf of the postmodern affectless anti-aesthetic?

[34]Hilton Kramer commenting on Barbara Rose's assessment that Minimalism 'tests the viewer's commitment', in Frances Colpitt, *Minimal Art: The Critical Perspective*, Seattle: University of Washington Press, 1990, 119.
[35]Osborne, *Anywhere or Not at All: Philosophy of Contemporary Art*, 178.
[36]Osborne, *Anywhere or Not at All: Philosophy of Contemporary Art*, 179.
[37]Osborne, *Anywhere or Not at All: Philosophy of Contemporary Art*, 183.
[38]Osborne citing Theodor Adorno.

Contemporary Minimalism as IKEA art

The IKEA phenomenon is the iconic example of how the logic of Minimalism has pervaded culture. In 2012, IKEA stores attracted 776 million customer visits, and the company produced more than 212 million copies of its 2013 catalogue.[39] By any stretch of the imagination, IKEA is a fashion sensation: huge market uptake, huge market share, huge impact on everyday aesthetics, such that it has become the twenty-first-century global embodiment of Warhol's 'a Coke is a Coke' mantra. As curator Daniel Birnbaum observed in an early article on IKEA's cultural effect,

> While it may appear less philosophical, the IKEA catalogue is perhaps a more efficient guide [than Heidegger's *Being and Time*] to the structures of everyday life in the West. It is the anonymous agency which Heidegger designated 'das Man' (usually translated as 'the they' or 'the one'), setting the standards for everyday existence. IKEA's declared ambition to 'furnish the world' is not just a throwaway advertising copyline.[40]

IKEA's philosophy of 'levelling' (what we might also take for standardization) is proselytized through its Minimalist aesthetics – clean lines, geometric patterns

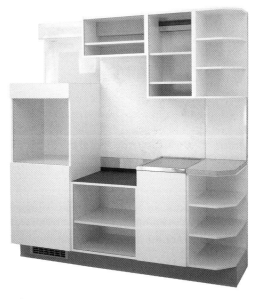

FIGURE 8.3 Clay Ketter, *Surface Habitat for Appliance* (1997). Clay Ketter/Sonnabend Gallery, New York/Bildkonst Upphovsrätt i Sverige. Licensed by Viscopy, 2014.

[39]Emma Allen, 'From Showroom to Studio: Artists Repurpose IKEA Products', *New Yorker*, June 2013.

[40]Daniel Birnbaum, 'IKEA at the End of Metaphysics', *Frieze*, Issue 36, November–December 1996, 34.

and modular structures – that have become equivalent to 'good taste'. Under the guise of modernist utopian thinking – as exemplified in the Bauhaus tradition of democratizing the best design and seeking to improve social conditions through aestheticizing everyday domestic environments – affordable Minimalist design would have us partake of 'a form of DIY existential individualism'.[41] We are promised agency, belonging, self-expression and a moral code for living by partaking of the consumerist ritual. But as we saw with postmodern anti-aesthetics, (post-post) Minimalism has become tantamount less to good taste, than to *no* taste, that is, the eradication of expression and feeling – the ultimate cool ('no commitment'). The difficult viewing experiences, including boredom, once imposed by classic Minimalism have been entirely domesticated. Boredom is no longer a space for utopian imaginings, but the default condition of a culture without content.

The fashion for domesticated Minimalism is consistently on display across biennales and contemporary art fairs. Clay Ketter uses IKEA products as structural elements in his installations that resile from any aesthetic intervention to suggest that art is 'already consummated in the world around him'.[42] Andrea Zittel's *Living Units* embody 'the luxury of minimalisation', according to the artist. The works of Imi Knoebel, John Armleder, Darren Almond, Richard Venlet, Geoff Kleem, Stephen Little, Thomas Locher, Nathan Coley and Julian Opie, among many others, deploy similar aesthetics. The very fashionability of Minimalist aesthetics, together with a growing recognition of IKEA's cultural iconicity, has given rise to its own genre, IKEA art, some of which is inspired more by satire than conformity. Elmgreen and Dragset for instance aim to make overt IKEA's repression of the chaotic diversity of human experience by embedding Nordic design into situations and environments that talk about identity issues, desire and the body.[43] Helmut Smits provides a tutorial on how to start a fire using eight standard IKEA products, while Joe Scanlan offers a cheap coffin for sale online made entirely from IKEA shelving. Anders Widoff and Stig Sjölund, Jason Rhoades, Jason Salavon, Nathan Baker, Jeff Carter, Koya Obe, Adriana Valdez Young, Andres Jaque Arquitectos, Claire Healy and Sean Cordeiro: these are all artists who in recent years have engaged with IKEA's mass manufacture of Minimalist aesthetics in different ways. The fashion for domesticated Minimalism could suggest that the reality that boredom is the signature mood of the times is disavowed, or that, like Ingvar Kamprad, some artists, curators, dealers and critics cynically manipulate our desire to belong to the community of good taste and human perfection but deliver us self-abjection instead – fear of our messy bodies and emotions, fear of diversity and individuality.

[41]Birnbaum, 'IKEA at the End of Metaphysics'.

[42]Ketter quoted in Birnbaum 'Before and After Painting', pub. Galleri Andreas Brändström, Stockholm, 1995, cited in Birnbaum, 'IKEA at the End of Metaphysics'.

[43]Emma Allen, 'From Showroom to Studio: Artists Repurpose IKEA Products', *The New Yorker*, June 2013.

Contemporary Minimalism as experience design

Just as one could imagine a continuous line from an IKEA showroom to the Basel Art Fair, one can also imagine Tony Smith's turnpike seamlessly curving into a Serra sculpture as the elegant trajectory then takes in the shimmering surface of The Guggenheim Bilbao and the vaulting walls of Tate Modern's Turbine Hall. Minimalism is the logic of the contemporary hyper-museum, as Rosalind Krauss so presciently pointed out in her personal observations of the newly installed Dan Flavin exhibition curated by Suzanne Pagé at the Musée d'art moderne de la ville de Paris in 1990. What struck Krauss was that standing at best vantage point, she and the curator were not looking at the works but at the exhibition spaces as illuminated by the overflow of Flavin's sculptures: 'the museum is somehow the object'. Krauss continued:

> Within this experience it is the museum that emerges as powerful presence and yet as properly empty, the museum as a space from which the collection has withdrawn. For indeed, the effect of this experience is to render it impossible to look at those few galleries still displaying the permanent collection. Compared to the scale of the Minimalist works, the earlier paintings and sculpture look impossibly tiny and inconsequential, like postcards, and the [permanent] galleries take on a fussy, crowded, culturally irrelevant look, like so many curio shops.[44]

Krauss argues that Minimalism is the model for the shift in contemporary museum concept and design away from the narration of the story of art, and towards focusing on the cumulative effect of the work of a select few artists to create an 'intensity of experience, an aesthetic charge that is not so much temporal as it is now radically spatial'. The revision of the effects of Minimalism and its role in producing the postmodern subject in the 1990s happen at the same time as major revisions in the museum. It is Minimalism, Krauss writes, citing the founder of mega-museum MassMOCA Tom Krens, 'that has shaped the way we … look at art: the demands we now put on it; our need to experience it along with its interaction with the space in which it exists; our need to have a cumulative, serial, crescendo towards the intensity of this experience; our need to have more and at a larger scale'.[45] How analogous this is to the developments in consumer display, in particular the giant, spectacular showrooms of lifestyle design, is striking. Like the museum, the showroom sets up a series of tableaux that purportedly fire up the imagination of the viewer to create their own scenarios, an idea pointedly delivered in Guy Ben-Ner's video *Stealing Beauty*, 2007, which depicts the artist and his family acting out their very own sitcom in an IKEA showroom.

[44]Krauss, 'The Cultural Logic of the Late Capitalist Museum', 285.

[45]Krauss, 'The Cultural Logic of the Late Capitalist Museum', 286.

Karen van den Berg and Ursula Pasero have recently reiterated Krauss' insights in the aftermath of the massive expansion in the art market and the exhibition of contemporary art around the world over the last two decades. In seeking to explain the supersizing of artwork during this time, with the corollaries of supersized museums and supersized prices, the authors identify a complex of factors. The museum as a mass institution has brought a global and hence ever-expanding attention to art, partly facilitated through digital communications. This increased attention has boosted the demand for bigger work (that compete with each other for attention), larger showrooms and simultaneously operating multiple sites, which in turn has led to the development of large-scale fabrication art studios – such as those run by Hirst, Koons, Barney, Murakami and Ai Wei Wei – where artistic production and other creative industries (notably product design) converge. The supersized work requires supersized spaces, hence the knock-on effect to spectacularly scaled museums, and the phenomenon whereby works are made for specific exhibitions, where the space of exhibition is now also the site of production.[46] This is a curious turn on Minimalism's site specificity: rather than operate as a strategy of institutional critique, it operates as a means of institutional affirmation. This phenomenon is also of a piece with the burgeoning of destination museums during the same period: monumental and original, buildings like the Guggenheim Bilbao are artworks in their own right, and often critiqued for interfering with the exhibitions they host.

This confluence of consumerism, spectacular architecture and museum spectatorship facilitated by Minimalism runs counter to some of Minimalism's original concerns. Krauss reminds us that early Minimalism sought to offer a kind of reparation 'to the subject whose everyday experience is one of increasing isolation, reification, specialization, a subject who lives under the conditions of advanced industrial culture as an increasingly instrumentalised being'. Minimalism, 'in an act of resistance to the serializing, stereotyping and banalising of commodity production', holds out to this subject 'a promise of some kind of bodily plenitude in a gesture of compensation that we recognize as deeply aesthetic'.[47] Yet Minimalism's materials, forms and seriality were 'at the very heart of commodity culture of mass production'. This paradox, whereby a phenomenon carries within it the codes of the very conditions (of commodification and technologicalization) that it sets itself against, Krauss accepts as inherent to the relationship of modernist art and capital. She cites Le Corbusier's designs for better living that ushered in the anonymous culture of suburban sprawl they were intended to counter as a classic instance, but we could as easily point to the example of fashion: aspiring to novelty and differentiation, it ushers in mass conformity. Aspiring to deliver bodily immediacy, Minimalism instead laid the groundwork for the fragmented postmodern subject of contemporary mass culture.

[46]Karen van den Berg and Ursula Pasero, 'Large Scale Fabrication and the Currency of Attention' [2012], in Natasha Degen (ed.), *The Market*, Cambridge, MA: MIT Press and London: Whitechapel Gallery, 2013, 126–31.

[47]Krauss, 'The Cultural Logic of the Late Capitalist Museum', 286–7.

Not so fashionable? Feminizing Minimalism, formlessness and embodied immediacy

One of the Unilever-sponsored series at Tate Modern's Turbine Hall was Doris Salcedo's tectonic crack across the full surface of the hall's massive floor ('more than five football fields in length').[48] Supersized in every respect, *Shibboleth* (2007) was a hugely expensive feat of design and engineering, taking many months to complete and many weeks to dismantle after its half year long outing that drew 'platoons' of visitors.[49] In many respects, and despite the artist's claims about its darkly critical connotations, this work would appear to exemplify the confluence of Minimalism, spectacular public space and museum design we have been considering as both cause and effect of Minimalism's fashion kudos. It stands in contrast to Salcedo's earlier work, such as *UnLand* (1995–8), where the artist inflected the language of Minimalism with a disturbing psychological charge by focusing on domestic spaces and objects, particularly furniture, in a manner evident also in works by Louise Bourgeois and Rachel Whiteread. In the work of these artists, art historian Alex Potts identifies 'the most striking recent shift' in sculpture, namely, 'the regendering of the persona of the sculptor', which he argues has moved Minimalist sculpture away from the 'formal articulation of viewing' towards an encounter 'that foregrounds the psychic dimension of a viewer's engagement with the work'.[50] This development in contemporary Minimalist sculpture that links domestic/private space, psychic unease and female practitioners has been commented on by several critics.[51] It is arguably quite distinct from the fashionable strain of Minimalism that has been this chapter's central concern, one that links public space, psychic indifference (boredom) and predominantly male artists. These latter works still manage to exude a kind of cool detachment, aspiring less to the embodied specificity and psychic charge of feminist-informed work that engages with the domestic sphere and notions of home, than to public status, more 'universal' ground. Compare for example the treatment of Minimalist form in works by Clay Ketter and those by pre-monumental Salcedo. In *Untitled* (1995), wooden drawers, cupboards and shelves are filled with cement, their structures conjoined in awkward but still formally restrained ways, their surfaces smoothed or scraped by hand: the effect is profoundly disturbing. In Ketter's, by contrast, the sleek, mass-produced aesthetics and anodyne configuration meld effortlessly into the design experience of the museum and its related cultural industries.

Fashionable Minimalism is that which follows in Ketter's mode, whereas feminist-infused Minimalism arguably finds its 'fashion' home in the context of the formless.

[48]Jean Robertson and Craig McDaniel, *Themes in Contemporary Art*, Oxford: Oxford Univerisity Press, 2012, 186.

[49]Jean Robertson and Craig McDaniel, *Themes in Contemporary Art*, op.cit., 186.

[50]Alex Potts, *The Sculptural Imagination*, New Haven and London: Yale University Press, 2000, 358.

[51]For example, Julian Stallabrass in *High Art Lite* (1999) and Gill Perry, 'Dream Houses: Installations and the Home', in Gill Perry and Paul Wood (eds), *Themes in Contemporary Art*, New Haven, CT, and London: Yale University Press in association with The Open University, 2004, 231–276.

Perry emphasizes the abject remnants that stick to the Minimalist objects created by Salcedo and Whiteread, suggesting that

> in the case of both of these artists it is precisely these complex sculptural processes, revealed in tactile form, that give their worlds some of their most haunting qualities. Traces and marks of their casts and their structures, bits of hair, dust, clothing, or wallpaper that got caught up in the making process, the strange textures and tones left by the concrete, cement or rubber mix, help to construct the evocative 'subject object'[52]

The formless is where the messy, rubbish-filled insides of Bourgeois' Minimalist cells set the scene, and where ironically the disruptive elements of the feminine can be appropriately binned. The fashionable strain of Minimalism also manages to abject embodied immediacy to protect its detached elegance, another potentially disruptive quality that this time finds expression in the so-called participatory art. As we have observed, both of these modes of practice have developed distinct values of fashionability.

[52]Perry, 'Dream Houses: Installations and the Home', 269.

9 INSIDE-OUT: OUTSIDER ARTISTS GO INSIDE

In a garden, growth has its season. First comes spring and summer but then we have fall and winter. And then we get spring and summer again.
Spring and summer?
Yes.
And fall and winter?
I think what our insightful young friend is saying is that we welcome the inevitable seasons of nature but we're upset by the seasons of our economy.
Yes. There will be growth in the spring.
Mmm
Mmm
Well Mr Gardiner I must admit, that is one of the most refreshing and optimistic statements I've heard in a very, very long time.
(Applause)
I admire your good solid sense. That's precisely what we lack on Capitol Hill.
—HAL ASHBY[1]

In September 2012, after over two decades of architectural wrangling and eight years of building, the museum for contemporary art in Amsterdam, the Stedelijk, opened its new wing designed by Alvaro Siza Vieira. Together with all the luminaries of art since the 1960s, alive and dead, is preserved a room painted by Karel Apel. Like a latter-day pagan shrine, visitors can enter it in small groups to pay homage. It is a spirited work in the artist's uncompromisingly harsh style. The outsider has made his way to the inside, forever sanctified.

[1]Hal Ashby, *Being There*, Lorimar Film Entertainment, 1979.

The reasons for the rise in popularity of Outsider Art in the last two decades are not too hard to cite. Outsider Art's emergence as an 'acceptable' and 'coherent' art form, or movement or style, runs parallel with the broadening and emergence of many other tendencies in this book, such as video, which, as we saw, went from alternative to normative in the late 1990s. Outsider Art appeared as a healthy, sobering, 'honest' foil to the way that art had become mediated with and by technology. The need to look at, recognize, accept and understand Outsider Art can be seen as part of a much broader range of cultural symptoms over the anxiety of an eschatological world. In a place where avarice reigns, where technology is central to all forms of life, where the environment is being devastated such that many sense their impending doom, where food is processed and plastics abound, the response is to go for organic and sustainable foods, to ensure your children play with wooden toys, and to take care that the tea you drink is fair trade. Outsider Art is to art what homemade is to the commodity, the small locus of wholesome authenticity in a world of artificiality and complications leading to imminent ruin.

From a philosophical standpoint, Outsider Art is the antidote to the threat of the 'post-human'. While priests, soothsayers and quacks have long warned of the end of the world, the notions of the end of history and the ends of man began to be aired by philosophers and cultural critics in the late 1970s when Jean-François Lyotard published *The Postmodern Condition: A Report on Knowledge,* with the now famous statement that postmodernism marks the end of the 'grand narratives' of modernism. A little more than a decade later appeared the bestseller, *The End of History and the Last Man* (1992) by American political scientist Francis Fukuyama. The title is provocative enough. Fukuyama proposed that following the end of the Cold War, free market capitalism and liberal democracy emerged as the denominators of the end point of human evolution. While his thesis came up for criticism, there was truth in the perception that the end of the millennium was characterized by a new concept of change. The subject as conceived within this complex was something very different from the modern subject who was invested with the potential for genius, invention and agency. The outsider in Outsider Art was a pleasant reminder that this may be wrong, that there just may be the possibility of an independent mind. Less pleasant was the way the outsider had been so poorly treated by the forces of social rationalization. But he or she was an avatar of human truth in a lamentable world that had broken its pact with humanism.

Artistically speaking, Outsider Art salvages what had been discredited in Abstract Expressionism, Transavantgardism and Neo-expressionism. As is well known, 'Abstract Expressionism' is an umbrella term for the group of artists who in New York were conjoined by friendship, by their championing by major critics Clement Greenberg and Harold Rosenberg and by a common belief in the ability of non-objective abstraction and the artist's gesture to portend truths transcending words or pictures. Revisionist art theorists (Rosalind Krauss for instance) explained that Greenberg had chosen only to examine one aspect of their art at the expense of the performative element, which places their work in different interpretative territory. More glaringly, with the exception of Helen Frankenthaler and Lee Krasner, the movement was predominantly male, and thus a particularly male expression. Finally Abstract Expression, for all its stormy 'truth', was beautifully suited to the

FIGURE 9.1 José dos Santos, Installation detail, 2014. Courtesy Self-Taught and Outsider Art Collection, The University of Sydney.

commodity market: it was painting, it was about uniqueness, but at the same time, being abstract, it could also say nothing, not interfere in a conversation and be readily coordinated with an interior decor scheme. The successive movements occur with these misgivings in mind; it was expressionist work in awareness that the myth of unmediated, pure expression had been discredited. So the postmodern expressionists like Julian Schnabel, George Baselitz and Enzo Cucchi could have it both ways: they could appear to be posing a commentary on the *possibility* of true expression (in true postmodern style), while always being able to be taken up by collectors who liked gestural art and believed in it. But Outsider Art avails itself of none of this worldliness. Because it is self-taught (the phrase is sometimes an alternative epithet) and is made by people who have been sequestered in some way – by dint of choice, mishap or mental illness – it comes with the absence of pretention and therefore the embodiment of earnest genuineness. Expressionism *can* live untainted.

The fraud of Outsider Art

The term 'Outsider Art' was coined in 1972 (a year after the 'birth' of Contemporary Aboriginal art) by the English art critic Roger Cardinal as an umbrella term to describe the art produced by those not associated with, admitted to or educated by the art scene, denoting usually the insane, but also the parochial *ingenue*. 'Outsider Art' also incorporates the 'Art Brut' of French postwar artist Jean Dubuffet, and folk art as part of its lineage. By and large this kind of art is characterized by a rawness in both conception and design which assumes a deeper plenitude of psychic penetration, a child-like honesty made possible only from the lack of inhibitions of either the censoring superego or the arbitrary rules of mainstream culture. It is the perception

FIGURE 9.2 Georg Baselitz's exhibit at the Frac Picardie in Amiens, France, in February 2004. Photo by Raphael Gaillarde/ Gamma-Rapho via Getty Images.

that art from so-called outsiders comes to us uncivilized and unalloyed that gives it its allure, a negative cachet that is caught up, we would argue, with a diagnostic voyeurism. This is far from the only thing that makes Outsider Art a challenging concept. It is an ostensibly innocent descriptor that masks a deep problem: its insulation from the discourse of 'high' art. It presumes a set of alternative ('outside') criteria proper to it,

which, by implication, 'normal' art discourse is ill-equipped to accommodate. Now that Outsider Art is a largely accepted genre of art and art market, rather than an innocent epithet made in passing, its premise of inside vs outside, its claim to rules beyond the ken of those possessed of reason, accountable knowledge and history, is cause for scepticism. For it enframes a manner of thinking with recourse to an exclusive mysticism that is conservative by manner of its exclusionism, its clubbiness and for the way it spurns a normative level of accountability to which 'insider' art is generally answerable.

Let's begin with the presumption that Cardinal's term implies. Much like Alloway's coinage of Pop, Cardinal may have begun with a throwaway term; and while the coinage may belong to such people, they are less responsible for the acceptance, continuing theorization and relative hardening of the term. Its scattered acceptance is problematic. To begin with it is a notion based on principles that are philosophically woolly. If there is an outside to art, there must be an inside. The rejoinder is easy to anticipate: the inside represents the art schools and academies, the galleries and museums, the critics and the connoisseurs, the educated amateurs and the enthusiasts, that fête, recognize and patronize the artists themselves. But this is just all gloss and rhetoric. The 'art world' is too much of a disordered, discordant mass to have an inside let alone an outside. Since at least the Middle Ages, art has always had its share of outsides. From the Renaissance at least, art's life and development is firmly based in a dialectic between what it wants to be and what it isn't; what it ought and ought not to be. This of course reaches a head in Modernism – active in the key terms avant-garde and vanguard – in which the dialectic between belief and apocrypha finds its point of contestation in form and style. If we look at the different movements burgeoning in the early twentieth century, we would have to say that this institution was multiple, a heterogeneous pool. The possibility of defining an inside to an outside is more than a little simplistic.

It is with Modernism that an inside–outside dynamic, constructed as it may have been, becomes most visible. For the avant-gardes were highly critical of institutions. Despite the institutions they made of themselves or that were made of them in the dialectical passage from radicality to acceptance, the avant-garde at its youthful peak was ipso facto of the institution, namely the academy, which they saw as the guardianship of habitual, stereotypical modes of artistic production. Broadly speaking, the dissatisfaction with art schools and their accompanying salons was twofold. The first was the repetitiveness that they perpetuated, and second, that they were inadequate microcosms of the kinds of freedoms to which the radical artists wished to aspire. While the avant-garde defined themselves as against the establishment, they needed that institution against which to fight their battles. The spontaneity and energy perceptible within avant-garde works still derive from the energy of heterodox resistance.

Therefore for the notion of Outsider Art to be tenable it must ignore the very binary on which Modernism, and to some extent Postmodernism, is built, of spontaneous luminaries fighting their battles of truth against the sclerotic lethargy of the art establishment. Over and above the debate of what constituted admissible art or inadmissible art – whether that be what satisfied public

propriety or what was appropriate for the salon or equivalent academic showing – the presiding debate was what was good and bad art. This still sits within the claims made by the institution of art: what enshrines the institutions, the beliefs and the knowledge systems that allow for the consensus of the value of objects as symbolically invested, that is, imbued with the quality of artness. A large portion of the activity of artists and those comprising their 'world' is to separate the good from the bad.

What constitutes good art and bad art is of course a relative and vexed question, and highly variable. At one extreme it can be read ideologically (e.g. *Entartete Kunst* or 'Degenerate Art') or, on the other, in the way we prefer to see it here, as understood in the Kantian sense of the distilling process that occurs all the time with moral beings for whom almost every moment of the waking day is spent in making choices, hence the right and good passage as opposed to the less favourable. If the difference between good and bad is seen in terms of inside and outside then so be it, but this is not what the proponents of Outsider Art mean.

Thus one way of looking at the so-called art world is as a system of fluid and constantly redefining demarcations. This is especially present and apposite to the age of 'contemporaneity', the wobbly term that has snuck in past postmodernism as the prevailing rubric for the times. Its looseness can be attributed to the sheer abundance of different styles and attitudes caused by digitization and globalization. There is also a subtle implication within the term that not all art produced now is necessarily contemporary. Rather, contemporary art is defined according to what most sums up the spirit of the times: its discontents, its contradictions. What makes the notion of the contemporary so challenging is that it follows a dialectical model whose terms of reference are shifting. The profusion of Biennales throughout the world, what many would agree as endemic of the globalized and diffuse nature of the contemporary within art, is critical to the manner in which the contemporary is trying to instate and constantly to redefine itself. We might do well to remember the famous discourse of marginality that is still a driver and an inhibiter for postcolonial nations such as Australia, whose remoteness from the more febrile and lucrative art markets makes some forms of ambitious art making and art marketing unjustifiable. And within the so-called centres themselves – be they London or New York – there are hundreds of galleries that complain of not being satisfactorily accepted within so-called mainstream markets and opportunities. The art market is always winnowing out its own. In short, there have always been outsides to art, and these outsides are multiple and exist according to many categories; so to stake a claim for a principal outside is simplistic. There is a substantial amount of art which is called Outsider by some – and which shares the traits typical to *tâchisme* or other more 'insider' terms – which is well worth looking at and which garners as much attention as other 'mainstream' art. The *brutiste* tendency is very much part of that composite which many recognize as what makes up contemporary art. So if we were to use the simplistic dialectic of Outsider Art against itself, we might well say that the simplistic, binaristic contrariness is merely a posturing that is always already subsumed by the difference inherent within 'the contemporary' within art. However, the discourse surrounding Outsider Art suggests otherwise.

True nature, but packaged

What we today accept as Modernist art owes a substantial debt to the kinds of tendencies that Outsider Art wishes to own for itself. We can go further than that and look at concepts of freedom and liberalism inherited from the eighteenth century, and in particular the thought of Jean-Jacques Rousseau. Extraordinarily Rousseau – particularly in the works *Émile* and *The New Héloïse* – is credited with having overhauled the way in which children were treated and represented. The way he shaped our idea of childish innocence and the alacrity with which his thought was adopted is well known. More extraordinary still is the degree to which his ideas still have purchase today, extending to those who neither know nor care about the Enlightenment *philosophe*. Rousseauian notions of untutored energies allowed free reign, the voice of childish innocence was to be preserved at all costs, as it bespoke of a quality uninhibited by the false consciousness of cultured society. Rousseau's concept of society is a tissue of laws that have lost their moral substance for having severed themselves from the constituents that gave birth to them. The culture–nature opposition was sadly endemic of this, since it suggested that humanity had lost its fundamental bond to what was natural, hence true and free. For Rousseau humans could never be free so long as they invested too much in social standards at the expense of those taught by nature.

In effect, Rousseau constructed an idea of nature that had never existed before. Philosophy had always spoken of natural laws, but these were seen as extensions of God, irrespective of whether one was Cartesian or Spinozist. But Rousseau's importance lay in the way he crystallized the Enlightenment and pre-Romantic notions of independent agency through absorbing them into a concept of Nature. As opposed to viewing Nature as an extension of God's will and his abounding substance, Nature now belonged to Man. It became the object of human striving. Whereas nature was part of God, man, and his relationship to nature, had effectively replaced God. With this came a series of potent myths of non-mediation whose ramifications Rousseau could barely have imagined. A wild fruit, a fruit that has not been tampered with, is immeasurably better than one that has come from a farm; so too, a gesture that comes to us without premeditation or forethought is truer than one that shows the characteristics of culture and tutelage. In short, it gives us a more accurate snapshot of Nature and is closer to who we really are.

Together with the increasing attention given to children at the end of the eighteenth century came a fascination with the insane. The Romantic identity is tightly woven within the growing valorization of untutored, non-rulebound, forms of expression. Michel Foucault's groundbreaking studies in the 1960s and 1970s in this regard are well known: the growth of the discourse of reason after the Renaissance witnessed a parallel growth of that of unreason. The implication of this was that reason could not subsist without a culture of diagnosis and sequestration. This binarization of society also created a countermovement among artists in particular. Thus the interest in children, the insane and the primitive from poets to doctors comes as a result of increasing consensus in certain circles, pre-eminently artistic but also philosophical, that their expressions yielded a more poignant

truth than could be gained from due tutelage and reflection. Géricault's portraits of the insane are part of this trend, as are Goya's etchings and paintings of lunatic asylums and black masses. Rimbaud's *dérèglement des sens* (disorder of the senses) becomes a catchcry for successive generations of artists and climaxes in Abstract Expressionism. With Pollock in particular, art met its inevitable dead end, that is, according to the narrative of unfettered expression.

When we look back on figures like Rimbaud or Pollock, and others like van Gogh, Artaud, Klee or the German Expressionist artists of 'Die Brücke', it is hard to gauge the limits of outsiderness, let alone what characterizes its style. All of these artists are definitely 'in' the art world. They are cardinal members of the history and language of art. There are numerous others who fit the bill as well, such as Gauguin, but for the sake of conciseness allow us to concentrate on those few we have mentioned. Pollock always played the outsider and his marketing was reliant on that. By no wish of his own, van Gogh is the same. Pollock was a student of Hans Hoffman, and van Gogh was largely self-taught, but constantly sought out the advice of his peers, who were some of the most brilliant artists of his time. He had worked at the art dealers Goupils and Cie, had attended classes in Paris of the famous academician Cormon and was in contact all his life with his brother Theo who was the manager of Goupils in Paris. To name him naïve is tendentious and of benefit only to the commercial market. Klee can be singled out not only because of his famous dictum of 'taking a line for a walk', obeying chance over conscious design, but because of the uncanny regularity with which the so-called Outsider Art looks like bad imitations of him. All the artists who formed the 'Die Brücke' group in 1905 were architecture students with no art school training. They attempted to crystallize the still developing interest of the avant-garde in African sculpture, with the Fauvist revolution of Matisse, Derain and Vlaminck, as well as an ebulliently pantheistic body culture imbued with vitalist narratives of complete freedom.

Rimbaud deserves special mention as he is the archetype of the artist-outsider and visionary *ingenue*. Beginning writing seriously at thirteen, and abandoning it when he was twenty, he epitomizes the youthful, impatient flourishing of raw emotion and explosive intelligence that youths and die-hard Romantics think art should be. His *Saison en Enfer* (Season in Hell), which he composed aged nineteen, is not only astonishing for being written in the still nascent genre of the prose poem, but ranks with any visionary tract from St Augustine or Hildegard von Bingen. Its third line reads, 'Un soir, j'ai assis la Beauté sur mes genoux. – Et je l'ai trouvée amère. – Et je l'ai injuriée.' ('One evening, I sat Beauty on my knee. And I found her bitter. And I insulted her.') It is a refrain that endears itself to anyone who wills an alternative, antinomian vision. Rimbaud is held up as the success that can possibly be achieved when an artist is left to his or her own devices freed from the false expectations of social conformity.

Artaud is another priestly figure within art whose madness has often led to gross misinterpretation. For like van Gogh, he had his bouts of sanity, and much of his art represents an effort to negotiate the two poles of mental activity. While his fellow Surrealists were busy holding up Artaud up as the token madman, Artaud was desperate for recognition within their coterie, not as an outsider who was both idolized and vilified. Like van Gogh, his work is an intricate odyssey into self-analysis, since he

found the diagnosis and forced empathy of doctors and artists deficient. Artaud wrote a vertiginous text on van Gogh in which he declared that he had been victimized by a society who had failed him and driven him to suicide, 'suicided by society'. Both Artaud and van Gogh were social beings whose efforts at clear and unduped expression are too easily seen as a symptom of madness as opposed to their effort to escape it. In the words of Louis Sass from *Madness and Modernism*,

> It in no way diminishes the unique and uncanny brilliance of his writings to suggest that the sensual excesses of his 'theatre of cruelty' may be better understood not as expressions of a naturally overflowing vitality but as defenses *against* the devitalisation and derealisation that pervaded his being.[2]

Sass goes on to articulate that the main source of Artaud's agony lay in the constant loss of self brought about from his collapse into psychotic states, and the powerlessness that came with it. The 'magic' that he sought in life and art was both bereft in the bourgeois mind *and* in danger of being unreachable as a result of his own mental failure.

We do not take issue with the equations of art and madness, except when it is simplistic and when madness, just as childlikeness or the noble savage, is made into a fetish that debilitates other narratives of art production. In his book on Outsider Art, British art historian Colin Rhodes describes artist-outsiders as

> by definition, fundamentally different to their audience, often thought of as being extremely dysfunctional in respect of the parameters for normality set by the dominant culture. What this means specifically, of course, is subject to changes dictated by history and geographical location. Thus, the emergence of a heterogeneous group has been made possible which includes those labeled as dysfunctional through pathology (usually, though not always, in terms of psychological illness), or criminality (often in tandem with the first), or because of their gender or sexuality, or because they appear in some way to be anachronistic, or are seen as un(der)developed, or often simply because of a cultural identity and religious belief that is perceived as significantly different.[3]

This description is notable for its open-endedness, numerous qualifiers (often, usually, often) and odd co-option of gender and queer. Rhodes glances on a Foucauldian revisionist reading of madness, namely that it is a necessary condition, or type, that is brought about as an opposite pole to the rational subject. But, with all credence to Foucault's classic theory, it is a category error to say that people with chemical imbalances in the brain are symptoms of rationalist ideology. This is why persons with such disturbances are no longer called mad but mentally ill. It is worth questioning the uncertain truth that images of Outsider Art offer since they are from people at the threshold of their faculties, or beyond. If we claim to be sane, then we

[2]Louis Sass, *Madness and Modernism*, Cambridge, MA: Harvard University Press, 1992, 238.
[3]Colin Rhodes, *Outsider Art*, London: Thames and Hudson, 2000, 7–8.

must ask what is it that we derive from the imagery of those of the clinically insane. By parallel, this concern brings us back to the hoary issue of what we see when we look at artworks by cultures of completely different customs and languages from ours. We see what we want to see; we see in terms of our own standpoint; we think we get it but we as likely don't. In the case of the latter (whose best analogy is Aboriginal art) we might know we are satisfying our primitivist nostalgia; what are we aiming for with the art of the insane and the misfit?

Like the art of 'primitives', there is also a grim disparity between the conditions of making and the resultant artwork. As we saw in the chapter dealing with Aboriginal art, what we call the work of art is but one integer in a manifold complex of activity. Siting, the spirituality of place, also plays a central role. When transported to the museum, the best word for such work is deracinated – literally to have the tree wrenched from its roots. To some extent also, the material conditions of someone clinically insane who purports to produce 'art' are also important; certainly knowing the 'artist's' story adds to the fascination of the work. However the truth of the matter is that those who are apt to collect a work of art by an Aboriginal artist – who has laboured over the work in dust, heat and warding off flies – is unlikely to have him or her over for dinner. The same applies to the so-called outsider.

Say nothing, say everything

To paraphrase Nelson Rockefeller, abstract art can mean anything you want it to mean. Art that readily avails itself of discourses that too easily lapse into regions of pure abstraction, pre-articulacy, is by implication immune from 'conventional', 'reasonable' discourses and their constrictive power relationships. By contrast, there are contemporary artists such as Yayoi Kusama and Louise Bourgeois who are remarkable for the way irrationality is a talismanic standard which threatens to explode the work of art, and the individual, at any moment, but is also kept in check with ironic reflection.

One category that has been omitted is that of the other kind of child artist, the artist in the state of mental decline. There is a narrative of development that persists since the Renaissance that artists begin as tempestuous revolutionaries and end as heroes at peace with the world, finally after a long life of apprenticeship to art, plumbing the secrets of childish immediacy. An artist like Matisse is a model in this regard. Apart from the way in which this myth came to eclipse other forms of development and became a kind of mandate for artistic success in old age, like all myths, there is a sizeable grain of truth. There is a serenity that can creep into the art of old and experienced artists that strikes us with its untrammelled honesty. But this obsession with honesty can be taken too far. The madness of mental decrepitude is as seductive to some of art's audiences as the mental weaknesses that give vent to the questionable truths of outsider artists. To quote Martin Filler, 'one man's serenity is another's senility'. The late works of Titian, venerated as a watershed in his career for their freedom, were executed while the artist was not in full possession of his faculties and physically ill. Willem de Kooning's last paintings are celebrated as feats of freedom yet they were made while the artist was in an advanced state of Alzheimer's disease

such that his assistants had to hand the paint to him, effectively choosing the colours themselves. The last paintings of Picasso, before his death in 1973 at the age of ninety-one, have also been subject to steady criticism, even as early as on the occasion of the exhibitions in Avignon's Palais des Papes in 1971, 1972 and 1973. Critical responses were lukewarm, and many commented on the mad jumble of paintings whose evident haste was either the product of a man who had taken leave of his senses or had become governed by the idea of his inviolable genius, or both. These are instances of what the literary critic Barbara Herrnstein Smith has called the 'senile sublime' or better, 'the dross of dementia'.[4] What is to be noticed is the manner in which these examples are still fervently defended, and the eagerness with which some people respond to the work of artists which manifest a *loss of agency*, as if that lack of intent, will and knowledge provides an easier access to primal truth, whatever that is, or whether not really knowing what you are doing can make challenging art.

What this short list of artists aims to underscore is that the history of art is so populated with artists with mental disorders (salient, repressed, hidden, manifest or diagnosed; we are now led to believe that most artists show symptoms of the latest mutation of Asperger's syndrome, itself a construction by a Viennese doctor) that it is impossible to make any disassociation. Nor is there sufficient evidence that any similar line can be drawn between artists with formal training and those without. Well before the avant-garde, art has always had an agonistic, and indeed parasitic relationship to the outsider – the heathen, the heteroclite, the healer. The narrative of the avant-garde exposes a cycle within art that is recurrent within many other endeavours as well, from science to politics: discourses refresh themselves with others from the outside; assimilate and develop, then fall into stagnation and disrepute (take Thomas Kuhn's theory of the scientific revolutions for example). In short, there are always already outsides within art. And as the example of Artaud has shown, these outsides multiply, and are often inadvertent, still less desirable to those who inhabit them. Even were 'Outsider Art' to call itself a rhetorical title – like Vauxcelles' phrase that gave way to Fauvism – then this would necessitate a rhetorical twin of 'Inside'. In short, the semantics of 'Outsider Art' are binaristic, yet once this binary is scrutinized, the logic is found wanting. To lay a term like 'Outsider Art' at art's door is about as presumptuous as sending an outdated manual on motor mechanics to Daimler-Benz.

Before concluding, a note on the relationship between Aboriginal art and the notion of Outsider Art. Contemporary Aboriginal art belongs to a marginal community whose political, spiritual and intellectual needs have been inadequately met. Most of its artists – and certainly all of those who come under the indeterminate banner of 'traditional' – have not had formal art training in the sense of what is offered by Federal and State institutions. And yet, in the main Indigenous artists have always campaigned for parity with the other arts. Aboriginal art has come up for its fair share of criticism for the desire to be equal to non-indigenous arts (while at the same time being commercially and internationally more successful), while yet protesting that non-indigenous eyes have a limited access and comprehension of the sacred,

[4] Cit. Martin Filler, 'The Late Show', *New York Review of Books*, 11 June 2009, 28.

secret nature of their art. The issue of a right of admission to a particular discourse is prevalent among colonized peoples, however, since it maintains the right of difference.

Problematically, but without the specific cultural harness, 'Outsider Art' seeks the same indulgence. By definition, it asks to be judged by criteria 'outside' that of art while wanting to be positioned as art. 'Outsider Art' places itself within its own special quarantine, insulated from 'mainstream' criticism. This alternative discourse that it claims for itself is permanently hidden since it belongs to the regions of the inarticulateness – as we have seen, either childlike, psychotic or 'primitive'. Yet it wishes to claim for itself something more nuanced than a symptomatology. 'Outsider Art' is also ahistorical; the phenomenon of 'outsiderness' can be located in time but it does not follow the same kind of development as the history of style within conventional art, be it Western or Eastern (especially Chinese, Japanese and Korean). But the call for different criteria from those of 'conventional' art discourse could be mistaken for the desire to escape criticism. And this kind of sequestration may well lead to indifference. The proponents of 'Outsider Art' are mostly well-versed art historians or critics who have offered an alternative discourse. How many 'Outsider Artists' so-named really would have wished to have been called as such? The example of Artaud is well taken. Would Adolf Wölfli have wanted such encouragement? Colin McCahon's work in a series of sallies into the dark is the desire to be heard, to be accepted and embraced and to belong.

The principal problem with Outsider Art is the most obvious: it is so often so bad. The good artists that have been claimed within 'Outsider Art's' pantheon are few: Wölfli, Wols and Jean Dubuffet number among them. The latter's membership is always provisional since his *brutisme* is a developed style and strategy, not to mention that he is a darling of the French establishment who is treasured for having managed to divert attention, ever so briefly, away from the art world of the United States with an approach that was less derivative of Abstract Expressionism than *tâchisme*. For all its alternative self-styling, the newness delivered to us from the eyes untrammelled by 'reasonable' culture is often monotonous: there is a now familiar litany of iconographic and formal elements. Is there an Outsider Philosophy? Perhaps the closest would be Epicurus, Spinoza or Nietzsche. But they are not insane, except Nietzsche at his last, but we don't value his last works more because they are infected by a syphilis-addled mind.

So we ask again, why the recent surge in Outsider Art – despite that insanity is as old as the common cold – and its continuing interest, and finally the veneration it appears to garner in some circles? In addition to the reasons we have already cited, we might also point to the need for redemption in 'end times' (as per the title of Slavoj Žižek's book on the subject), with its histrionic environmentalism. It is the need of members of the developed world – whose development depends on the exploitation of two-thirds of the rest of the world's population and at the cost of environmental devastation – to harp on about recycling, organic food and sustainable farming. The fascination with Outsider Art could be seen as part of the guilty hankering for wholesomeness.

Or, in answer to the question about the fashion for Outsider Art, we could have dispensed with this chapter altogether and stopped at the epigraph from the film adaptation of Jerzy Kosinski's novel *Being There* (1971). Peter Sellers plays a

gardener called Chauncy Gardiner, a simpleton who is let loose on the world after his employer dies, having lived an insulated life tantamount to voluntary house arrest. The world is agog at Gardiner who soon becomes a celebrity, his banalities taken for prophetic axioms. Gardner wasn't to blame, all he wanted to do was to garden. But what does it say of the gullibility of others, looking for authenticity in their lives?

CONCLUSION: FASHIONABLE ART

Art has always capitalized on suffering: the suffering artist is one of the most pervasive and tenacious figures in the collision between art and popular culture. When art took flight from the hold of religion in the Renaissance it was able to express the grandeur and terror of religious experience with memorable urgency. But it also always required a tender and tragic soul to be able to divine the sublime urgencies of the soul. To quote the neon work by Bruce Nauman, 'the true artist helps the world by revealing mystic truths'. This can only be leveraged by the artist as someone with a heightened conscience and who is, to some extent, a social pariah. But in the last twenty or more years, mass culture has not mined art and artists so much as subcultures in order to maintain its edge and its currency. And the tormented artist has been replaced by former models, ex-stockbrokers and entrepreneurs whose studios and workshops resemble boutique factories that produce products for the resourced and well-connected institutional machinery of the high-end gallery. The artist as martyr to his or her art is very much a thing of the past. Now the artist is someone who must function well in society across a wide variety of platforms and professionals who help to keep his or her work shown, circulated and desirable.

After Perestroika, the fall of the Berlin Wall and the dismantling of Communism, the world was left without a common enemy. This liberation was for some a curse since it meant that political causes were more diffuse, unlocatable. It became increasingly uncertain to whom, and for whom, the artist was speaking. The final collapse of the old binary world order was just as confusing for curators who were expected to have the gift of manufacturing a concern, a topic, that made sense of the art world for the public by defining some kind of common trajectory. But as the 1990s unfolded, and as art through digitization became more globally mobile, it became more evident that the definitions of what was contemporary art, and limiting the sets of concerns of artists to a few ideas, were futile. The hold of the critic was also loosening. But art, like any industry, must have a set of standards that can justify choices of inclusion in an exhibition, or choices for acquisition. Unlike any industry, however, art's units of

measure are abstract and fluid. They have to do with mood, taste, circumstance, luck and coercion – in no particular order.

Once art was no longer restricted by rules or ritual, it entered into the open market. We must remember that the Medicis of Florence were bankers who made themselves into a glorious dynasty of rulers thanks largely to art. Art has always had trends and patterns, which in many senses can be related to fashion insofar as desire is conjoined with expectation. And each era had its fashions to some degree, a citable example being painterliness by the end of the nineteenth century, where some faint whiff of Impressionism was insurance that an artist had the imprint of being 'de son temps', of his time.

But alas the secure age of 'isms' is beyond us. It is unthinkable for an artist or poet like Marinetti to publish a manifesto and a new art movement (as he did in *The Figaro* in 1909) without courting the possibility of being diagnosed with some form of psychosis. It has also become harder to generalize about contemporary art. In the 1930s artists who wanted to look modern cubified their paintings to some degree, now they insert a bit of performance, or a video or make sure that their cultural difference is somehow anecdotally preserved. A small list of artists, mostly still men, have been anointed with celebrity status, like supermodels or A-list actors, which assures that whatever they do is also sanctified (and also in the interests of those who collect them).

But within the Milky Way, or noxious miasma, depending on your viewpoint of global artistic production, there are patterns and groupings that mark out works of art as 'contemporary'. To be sure, if only painting were curated into a contemporary biennale, the show would immediately be condemned as not of its time. Curators are charged with the task of making an exhibition look representative of the present mood and moment. Like fashion it must look like a familiar grouping, but must also somehow look different; Simmel's insightful paradox. The rise of the global celebrity curator, from Hans-Ulrich Obrist to Carolyn Christov-Bagarkiev, has occurred in lock-step with rationalization, privatization and the need for corporate sponsorship. They are regularly faced with a pressing dilemma: to present something edgy and challenging while also creating accessible pageants to ensure that the turnstiles keep turning, since the success of large exhibitions is increasingly measured according to visitation numbers. Nonetheless, curators of this calibre are often capable of reconciling this problem. They provide artists from less privileged countries, from Africa to the impoverished Eastern Bloc countries, an international forum. And it is with such exposure that artists feel empowered to undertake projects, which stretch their careers and provide fertile ground for debate about what art should be, and what it should say in the present era.

This book has been an effort to clarify this dynamic through a variety of examples. Since Postmodernism art has died a hundred deaths, only to revive. But the pathos of art that was so resonant in modernism has somehow dissipated. This is not however the cause for yet more mourning, since art inhabits more than one space, and the separation between art and popular culture has been dismantled. This is also not to say that art has lost its clout, but we vouch for a critical stance that is rich with scepticism and irony. Sometimes you can see substance behind the fashion,

sometimes art is just going through its regular motions and playing at being art. Artists have always lapsed into being stage designers (Leonardo designed stage sets for François I), but it is also through the recognizability of certain patterns and trends that art can reach a wider audience, and maintain a dialogue with a contemporary community, and with the past, since the quintessence of fashion is a melding of time past and time future.

BIBLIOGRAPHY

Adorno, Theodor W., *Ästhetische Theorie*, Frankfurt am Main: Suhrkamp, 1970.
———, 'Commitment', in Fredric Jameson (ed.), *Aesthetics and Politics* (1977), New York and London: Verso, (1980)1995.
Aiken, Henry David, 'Some Notes Concerning the Aesthetic and the Cognitive', in Morris Phillipson (ed.), *Aesthetics Today*, Clinton: Meridien, 1961, 254–74.
Allen, Emma, 'From Showroom to Studio: Artists Repurpose IKEA Products', *The New Yorker*, June 2013.
Antliff, Mark and Patricia Leighton (eds), *A Cubism Reader. Documents and Criticism 1906–1914*, trans. Jane Todd, Chicago and London: Chicago University Press, 2008.
———, *Cubism and Culture*, London: Thames and Hudson, 2001.
Athanassoglou-Kallmyer, Nina, 'Ugliness', in Robert Nelson and Richard Shiff (eds), *Critical Terms for Art History*, 2nd edition, Chicago: University of Chicago Press, 2003281–95.
Bakhtin, Mikhail, *Rabelais and His World*, Bloomington: Indiana University Press, 1984.
Barthes, Roland, *The Fashion System*, University of California Press, 1983, 8.
Bataille, Georges, *Visions of Excess. Selected Writings, 1927–1939*, Minneapolis: University of Minnesota Press, 1985.
———, et al., 'Critical Dictionary', *October*, Vol. 60, Spring, 1992), 25–31.
Baudelaire, Charles, *Œuvres complètes*, Paris: Pléiade, 1954.
Baumé, Geremie, 'Reformist Baroqie: Liu Dahong and the Chinese Fine-de-Millennium', in Geremie Barmé (ed.), *Liu Da Hong: Paintings 1986–92*, exh. cat., Hong Kong: Schoeni Fine Oriental Art, 1992, 6–9.
Besnier, Jean Michel, 'Georges Bataille in the 1930s: A Politics of the Impossible', trans. Amy Reid, *Yale French Studies*, No. 78, On Bataille, 1990, 66–89.
Birnbaum, Daniel, 'IKEA at the End of Metaphysics', *Frieze*, No. 31, November–December 1996, 33–6.
Bishop, Claire, 'Antagonism and Relational Aesthetics', *October*, Vol. 110, Fall 2004, 51–79.
——— (ed.), *Participation*, London and Cambridge, MA: Whitechapel and MIT Press, 2006.
———, *Artificial Hells: Participatory Art and the Politics of Spectatorship*, London: Verso, 2012.
Boltanski, Luc and Eve Chiapello, *The New Spirit of Capitalism*, trans. Gregory Elliott, London: Verso, 2005.
Bois Yve-Alain and Rosalind Krauss, *L'informe: mode d'emploi*, Paris: Centre Georges Pompidou, 1996.
Bonyhady, Tim, *Images in Opposition. Australian Landscape Painting 1801–1890*, Oxford: Oxford University Press, 1985.
Bourdieu, Pierre, *Les règles de l'art*, Paris: Seuil, 1992.

Bourriaud, Nicholas, *Relational Aesthetics*, trans. S. Pleasance and F. Woods, Paris: Les Presses du Reel, 2002.

Braathen, Martin, 'The Commercial Significance of the Exhibition Space' [2007], in Natasha Degen (ed.), *The Market*, Cambridge, MA: MIT Press and London: Whitechapel Gallery, 2013, 113–18.

Burn, Gordon, 'Damian Hirst', in *Sex & Violence, Death & Silence*, London: Faber and Faber, 2009.

Burn, Ian, 'The 1960s: Crisis and Aftermath', *Art & Text*, No. 1 1981, republished in Ian Burn, *Dialogue: Writings in Art History*, Sydney: Allen & Unwin, 1991.

Butler, Rex, (ed.), *What Is Appropriation? An Anthology of Critical Writings on Australian Art in the '80s and '90s*, Brisbane and Sydney: IMA and Power Publications, 1996.

Callas, Peter, 'Australian Video Art and Australian Identity: A Personal View', *Continuum '83*, exh. cat., Tokyo, 1983.

———, 'Peter Callas Interviewed by Nicholas Zurbrugg', in Nicholas Zurbrugg (ed.), *Electronic Arts in Australia*, Vol 8 No 1, Murdoch: Continuum, 1994, 94.

Carter, Michael, *Fashion Classics from Carlyle to Barthes*, Oxford and New York: Berg, 2003.

Cellini, Benvenuto, *My Life*, trans. Julia Conaway Bondanella, ed. Peter Bondanella, Oxford: Oxford University Press, 2002.

Chave, Anna, 'Minimalism and the Rhetoric of Power' [1990], in James Meyer, (ed.), *Minimalism*, London: Phaidon, 2000, 275.

Cheetham, Mark A., *Kant, Art and Art History*, Cambridge: Cambridge University Press, 2001.

Chiu, Melissa, *Breakout: Chinese Art Outside China*, Milan and New York: Charta, 2006.

Chiu, Melissa and Benjamin Genocchio (eds), *Contemporary Art in Asia: A Critical Reader*, Cambridge, MA: MIT Press, 2011.

Clark, T.J., *The Painting of Modern Life. Paris in the Art of Manet and His Followers*, London: Thames and Hudson, 1984, revised ed., 1999.

Clarke, David, 'Contemporary Asian Art and Its Western Reception' [2002], in Melissa Chiu and Benjamin Genocchio (eds), *Contemporary Art in Asia: A Critical Reader*, Cambridge, MA: MIT Press, 2011.

Cole, C.L. and David Andrews, 'America's New Son: Tiger Woods and America's Multiculturalism', in P. David Marshall (ed.), *The Celebrity Culture Reader*, New York and London: Routledge, 2006, 345.

Colpitt, Frances, *Minimal Art: The Critical Perspective*, Seattle: University of Washington Press, 1990.

Crow, Thomas, 'Saturday Disasters: Trace and Reference in Early Warhol', in Serge Guibault (ed.), *Reconstructing Modernism: Art in New York, Paris, and Montreal 1945–1984*, Cambridge: MIT Press, 1990, 311–31.

Danto, Arthur C., 'Marcel Duchamp and the End of Taste: A Defense of Contemporary Art', *Tout-fait: The Marcel Duchamp Studies* Online Journal, Vol. 1, No. 3, December 2000, Unpaginated, accessed at: http://www.toutfait.com/issues/issue_3/News/Danto/danto.html

———, *The Abuse of Beauty*, New York: Open Court Publishing, 2003.

Davies, Norman, *Vanished Kingdoms*, London: Viking, 2011.

Davies, Shaun, 'Adams', *Agenda*, Vol. 32, July 1993, 8

Dawei, Fei, 'The Problems of Chinese Artists Working Overseas', in *China's New Art, Post-1989*, exh. cat., Hong Kong: Hanart TZ Gallery, 1993, 41.

Debord, Guy, *Society of the Spectacle*, Detroit: Black and Red, 1983.

———, *Comments on the Society of the Spectacle*, Paris: Editions Gerard Lebovici, 1988.

De Nora, Tia, *Beethoven and the Construction of Genius. Musical Politics in Vienna, 1792–1803*, Berkeley and London: California University Press, 1995.

Deutsche, Rosalyn, 'Alternative Space', in Brian Wallis (ed.), *If You Lived Here: The City in Art, Theory and Social Activism: A Project by Martha Rosler*, Seattle: Bay Press and Dia Art Foundation, 1991.

Drew, Jesse, 'The Collective Camcorder in Art and Activism', in Blake Stimson and Gregory Sholette (eds), *Collectivism after Modernism: The Art of Social Imagination after 1945*, Minneapolis: University of Minnesota Press, 2007, 95–114.

Eagleton, Terry, *Figures of Dissent: Critical Essays on Fish, Spivak, Žižek and Others*. London and New York: Verso, 2003.

Filler, Martin, 'The Late Show', *New York Review of Books*, 11 June 2009, 27–9.

Foley, Fiona, 'When the Circus Came to Town', *Art Monthly Australia*, #245, November 2011, 5–7.

Forsythe, Graham, 'Monster Field', *Art/Text*, Vol. 46, 1993, 74.

Foster, Hal (ed.), *The Anti-aesthetic: Essays on Postmodern Culture*, Port Townsend: Bay Press, 1983.

———, *Compulsive Beauty*, Cambridge, MA: MIT Press, 1993.

———, *The Return of the Real: The Avant Garde at the End of the Century*, Cambridge, MA and London: MIT Press, 1996.

———, 'Arty Party', *London Review of Books* Vol. 25, No. 23, 4 December 2003, 21–2.

———, 'Post-Critical', *October* Vol. 139, 2012, 3–8.

———, 'The Medium Is the Market' [2008], in Natasha Degen (ed.), *Market*, Cambridge, MA: MIT Press and London: Whitechapel Gallery, 2013, 198–204.

Fraser, Andrea, 'From Critique of Institutions to an Institution of Critique', in John C. Welchman (ed.), *Institutional Critique and After*, Vol. 2, Zurich: JRP Ringier, 2006.

Freed, Hermine, 'Where Do We Come from? Where Are We? Where Are We Going?', in Ira Schneider and Beryl Korot (eds), *Video Art: An Anthology*, New York: Harcourt Brace Jovanovich, 1976.

Gallagher, Paul and Edward Helmore, 'Doyen of American Critics Turns His Back on 'Nasty, Stupid' World of Modern Art', *The Observer*, 28 October 2012.

Geczy, Adam, 'Djamu Gallery: Some Thoughts on Exhibiting Aboriginal Art', *Postwest*, No. 14, 1999, 12–16.

———, *Fashion and Orientalism*, London: Bloomsbury, 2013.

Geczy, Adam and Alan Cruickshank, 'Appropriation: No Longer Appropriate', *Contemporary Art+Culture Broadsheet*, Vol. 43, No. 1, 2013, 11–13.

Geczy, Adam and Vicki Karaminas (eds), *Fashion and Art*, London and New York: Berg, 2012.

———, *Queer Style*, London: Bloomsbury, 2013.

Green, Christopher, *Cubism and Its Enemies*, New Haven and London: Yale University Press, 1987.

Greer, Germaine, 'Note to Robert Hughes: Bob, Dear, Damien Hirst Is Just One of Many Artists You Don't Get'. London: *The Guardian*, 22 September 2008.

Griffin, Tim, 'Compression', *October* Vol. 135, 2011, 3–8.

Grosenick, Uta and Burkhard Riemschneider (eds), *Art at the Turn of the Millennium*, Cologne: Taschen, 1999.

Groys, Boris, *Art Power*, Cambridge, MA: MIT Press, 2008a.

———, 'A Genealogy of Participatory Art', in Robert Atkins et al. (ed.), *The Art of Participation, 1950 to Now*, exh. cat., London: Thames and Hudson, 2008b, 18–31.

Haig, Ian, 'Australian Video in the 1980s', unpublished paper presented at Video Void symposium, Contemporary Centre for Photography, Melbourne, November 2010.

Hanru, Hou, 'The Impossible Formulation of the Informe', *Third Text*, Vol. 10, No. 37, 1996, 91–3.

Hickey, Dave, 'After the Great Tsunami', in *The Invisible Dragon: Four Essays on Beauty*, Los Angeles: Art Issues Press, 1993, 53–68.

Hirst, Damien, *I Want to Spend the Rest of My Life Everywhere, with Everyone, One to One, Always Forever Now*, New York: Monacelli Press, 1997.

Holmes, Brian, 'DIY Geopolitics', in Stimson, Blake and Gregory Sholette, (eds), *Collectivism after Modernism: The Art of Social Imagination after 1945*, Minneapolis and London: University of Minnesota Press, 2007, 273–94.

Hopkins, David, *Art after Modern Art 1945–2000*, Oxford: Oxford University Press, 2000.

Horowitz, Noah, *The Art of the Deal. Contemporary Art in a Global Financial Market*, Princeton and Oxford: Princeton University Press, 2011, 228.

Hughes, Robert, *American Visions: The Epic History of Art in America*, London: Harvill Press, 1997.

Hugo, Joan, 'L'informe: Mode d'emploi', *Frieze*, 11 November 1996.

Inside Out: New Chinese Art, exh. cat., Berkeley and London: California University Press, 1998.

Jameson, Fredric, 'Postmodernism or the Cultural Logic of Late Capitalism', in Joseph Natoli and Linda Hutcheon (eds), *A Postmodern Reader*, Stony Brook: SUNY Press, 1993, 312–32.

——, *The Cultural Turn. Selected Writings 1983–1998*, London: Verso 1998, 1–20.

Jones, Stephen, 'Some Notes on the Early History of the Independent Video Scene in Australia', in Jill Scott and Sally Couacaud (eds), *The Australian Video Festival 1986*, exh. cat., Sydney: The Australian Video Festival, 1986, 88–94.

Kawamura, Yuniya, *The Japanese Revolution in Paris Fashion*, Oxford and New York: Berg, 2004, 95.

Khan, Rimi, *Reconstructing Community-based Arts: Cultural Value and the Neoliberal Citizen*, unpublished PhD thesis, University of Melbourne, 2011.

Koop, Stuart and Max Delany, *Screen Life: Videos from Australia*, exh. cat., Madrid: Reina Sofia Museum, 2002.

Krauss, Rosalind, *A Voyage to the North Sea: Art in the Age of the Post-medium Condition*, London: Thames and Hudson, 1999.

——, 'The Cultural Logic of the Late Capitalist Museum' [1990], in James Meyer (ed.), *Minimalism*, London: Phaidon, 2000.

——, *The Originality of the Avant-Garde and Other Modernist Myths*, Cambridge, MA: MIT Press, 1986.

Lefebre, Eric (ed.), *Aristes chinois à Paris*, exh. cat., Paris: Musée Cernuschi, 2011.

Lewis, Justin, *Art, Culture and Enterprise: The Politics of Art and the Cultural Industries*, London: Routledge, 1990.

Liu Da Hong: Paintings 1986–92, exh. cat., Hong Kong: Schoeni Fine Oriental Art, 1992.

Lyotard, Jean-Francois, 'After the Sublime: The State of Aesthetics', in David Carroll (ed.), *The States of Theory: History, Art and Critical Discourse*, Stanford: Stanford University Press, 1990.

Marshall, P. David, *The Celebrity Culture Reader*, New York and London: Routledge, 2006.

Martin, Adrian, 'Before and After Art & Text' & Something Close to Nothing: Appropriation in Australian Experimental Film and Video of the 1980s', in

Rex Butler (ed.), *What Is Appropriation?* 2nd edition 2000, Power Publication & IMA, 1996, 107–18, 273–92

Mattick, Paul, *Art in Its Time: Theories and Practices of Modern Aesthetics*, London and New York: Routledge, 2003.

McAuliffe, Chris, 'Developmental Play: Deskilling and Deferral in Contemporary Art', in *Avant-Gardism for Children*, exh. cat. Brisbane: University Art Museum, University of Queensland, 1999: 15–20.

McKenzie, Robyn, 'Kathy Temin: Infantile Terrible: Object Relations and the Problem Child', *Art + Text*, Vol. 45, 1993, 30.

Merewether, Charles and Tom Nicholson, 'The Practice of Action: An Exchange between Charles Merewether and Tom Nicholson', in *After Action for Another Library, Pier 2/3*, Biennale of Sydney, 2006.

Meyer, James (ed.), *Minimalism*, London: Phaidon, 2000.

Minglu, Gao, 'Towards a Transnational Modernity: An Overview of *Inside Out: New Chinese Art*', in Minglu Gao (ed.), *Inside Out: New Chinese Art*, exh. cat., Berkeley and London: California University Press, 1998.

Moore, Catriona, 'Museum Hygiene', *Photofile*, Vol. 41, March 1994, 8–14.

Morgan, Robert, *The End of the Art World*, New York: Allworth Press, 1998.

Morris, Robert, 'Anti-form', *Artforum*, Vol. 6, No. 4, 1968, 33–5.

Muir, Gregor, *Lucky Kunst: The Rise and Fall of Young British Art*, London: Aurum Press, 2009.

Murphy, Bernice, 'Towards a History of Australian Video', in Jill Scott and Sally Couacaud (eds), *The Australian Video Festival 1986*, exh. cat., Sydney: The Australian Video Festival, 1986.

Nealon, Jeffrey, *Post-postmodernism, or, the Cultural Logic of Just-in-Time Capitalism*, Stanford: Stanford University Press, 2012.

Negri, Antonio, *Art and Multitude*, trans. Ed Emery, Cambridge: Polity, 2011.

Carol, Lu and Sue-an, van der Zip, *New World Order: Contemporary Installation Art and Photography from China*, exh. cat., Rotterdam: Groninger Museum and Nai Publishers, 2008.

Nuttall, Jeff, *Art and the Degradation of Awareness*, London: Calder/Riverrun, 2001.

Obendorf, Hartmut, *Minimalism: Designing Simplicity*, London: Springer Verlag, 2009, 52.

Osborne, Peter, *Anywhere or Not at All: The Philosophy of Contemporary Art*, London and New York: Verso, 2013.

Perniola, Mario, 'Feeling the Difference', in James Swearingen and Joanne Cutting-Grey (eds), *Extreme Beauty: Aesthetics, Politics, Death*, New York and London: Continuum, 2002, 4–14.

Perry, Gill, 'Dream Houses: Installations and the Home', in Gill Perry and Paul Wood (eds), *Themes in Contemporary Art*, New Haven and London: Yale University Press in association with The Open University, 2004, 231–76.

Plant, Sadie, *The Most Radical Gesture. The Situationist International in a Postmodern Age*, London: Routledge, 1992.

Potts, Alex, *The Sculptural Imagination*, New Haven and London: Yale University Press, 2000.

Poynor, Rick, *Obey the Giant: Life in the Image World*, London: August; Basel: Birkhauser, 2001.

Pratt, Mary Louise, 'Arts of the Contact Zone' (Originally Published in 1991), Excerpted in David Bartholomae and Anthony Petroksky (eds), *Ways of Reading*, 3rd edition, London: St Martin's, 1996, 442–62.

Rancière, Jacques, 'The Emancipated Spectator', *Artforum*, March 2007, 271–80.
———, *Dissensus: On Politics and Aesthetics*, trans. Steven Corcoran, New York and London: Continuum, 2010.
Rankin-Reid, Jane, 'Shirthead', *Art/Text*, Vol. 46, 1993, 78.
Reckitt, Helena, 'Forgotten Relations: Feminist Artists and Relational Aesthetics', in Angela Dimitrakaki and Lara Perry (eds), *Politics in a Glass Case: Feminism, Exhibition Cultures and Curatorial Transgressions*, Liverpool: Liverpool University Press, 2013, 131–56.
Rhodes, Colin, *Outsider Art*, London: Thames and Hudson, 2000.
Robertson, Jean and Craig McDaniel, *Themes in Contemporary Art*, New York and Oxford: Open University Press, 2012.
Rose, June, *Modigliani: The Pure Bohemian*, London: Constable, 1990.
Round Table: The Present Conditions of Art Criticism, *October*, Spring 2002, No. 100, 200–28.
Rush, Michael, *New Media in late 20th-Century Art*, London: Thames and Hudson, 1999.
Said, Edward, *The World, The Text and the Critic*, London: Faber, 1983.
Serra, Richard 'Donald Judd' [1994], in James Meyer (ed.), *Minimalism*. London: Phaidon, 2000, 289.
Simmel, Georg, 'Die Mode', in *Philosophische Kultur. Über das Abenteuere, dis Geschlechter und die Krise der Moderne*, Berlin: Klaus Wagenbach Verlag, 1923.
Smith, Terry, *What Is Contemporary Art?*, Chicago and London: Chicago University Press, 2009.
Spivak, Gayatri Chakravorty, 'Culture', in *A Critique of Postcolonial Reason: Toward a History of the Vanishing Present*, Cambridge, MA: Harvard University Press, 1999.
———, *Nationalism and Imagination*, London and Calcutta: Seagull Books, 2010.
Stallabrass, Julian, *High Art Lite*, London and New York: Verso, 1999.
Stiles, Kristine, 'I/eye/oculus', in Gill Perry and Paul Wood (eds), *Themes in Contemporary Art*, New Haven and London: Yale University Press with The Open University, 2004, 183–229.
Stimson, Blake and Gregory Sholette (eds), *Collectivism after Modernism: The Art of Social Imagination after 1945*, Minneapolis and London: University of Minnesota Press, 2007.
Sullivan, Eve, 'Hany Armanious', *Agenda*, Vol. 36, May 1994, 27.
Thompson, Don, *The $12 Million Stuffed Shark: The Curious Economics of Contemporary Art*, New York: Palgrave McMillan, 2008.
'Theory of the Dérive', *Situationist International* # 2 Paris, 1958.
Titmarsh, Mark, *SynCity* exh. catalogue, Sydney: d/Lux/MediaArts, 2006.
Tofts, Darren, *Interzone: Media Arts in Australia*, Melbourne: Craftsman House, 2005.
———, 'Australian Video in the 1990s', unpublished
 paper presented at Video Void symposium, Contemporary Centre for Photography, Melbourne, November 2010.
van den Berg, Karen and Ursula Pasero, 'Large Scale Fabrication and the Currency of Attention' [2012], in Natasha Degen (ed.), *The Market*, Cambridge, MA: MIT Press and London: Whitechapel Gallery, 2013, 126–31.
Vine, Richard, *New China New Art*, Munich and New York: Prestel Verlag, 2008.
Virilio, Paul, *Art and Fear*, London and New York: Continuum, 2003.
Waugh, Alexander, *The House of Wittgenstein: A Family at War*, New York: Anchor Books, 2008.

Williams, Peter, 'When Less Is More, More or Less: Subtraction and Addition in (Post) Modernist Poetics', in James Swearingen and Joanne Cutting-Grey (eds), *Extreme Beauty: Aesthetics, Politics, Death*, New York and London: Continuum, 2002, 40–52.

Wilson, Elizabeth, *Bohemians: The Glamorous Outcasts*, London, I.B. Tauris, 2002.

Žižek, Slavoj, *For They Know Not What They Do: Enjoyment as a Political Factor*, London and New York: Verso, 1991.

———, *Welcome to the Desert of the Real*, London: Verso, 2002.

———, *In Defense of Lost Causes*, London and New York: Verso, 2008.

———, *Living in the End Times*, London and New York: Verso, 2010.

———, 'Hegel and Shitting', in Slavoj Žižek, Clayron Crockett and Creston Davis (eds), *Hegel and the Infinite: Religion, Politics, and Dialectic*, New York: Columbia University Press, 2011.

———, 'To Begin from the Beginning', in Yong-june Park (ed.), *Demanding the Impossible*, Cambridge: Polity, 2013.

Zurbrugg, Nicholas, 'Jameson's Complaint: Video Art and the Intertextual Time-Wall', *Screen*, Vol. 32, Spring 1991, 16–34.

Films

Ashby, Hal, *Being There*, Lorimar Film Entertainment, 1979.

Schnabel, Julian, *Basquiat*, Miramax Films, 1996.

Internet sources

Art Thoughtz, Hennessy Youngblood, 'Relational Aesthetics', https://www.youtube.com/watch?v=7yea4qSJMx4

Biennale of Sydney, 2010 website: http://www.biennaleofsydney.com.au/, last accessed 25 October 2013.

Claire Bishop, Introduction to 'Rethinking Spectacle', and Mark Godfrey. Forum at Tate Modern, 31 March 2007, available at http://channel.tate.org.uk/media/38061678001#media:/media/38061678001/24869330001&context:/channel/most-popular

Arthur C. Danto, 'Marcel Duchamp and the End of Taste: A Defence of Contemporary Art', *Tout-fait: The Marcel Duchamp Studies Online Journal*, Vol. 1, No. 3, December 2000. http://www.toutfait.com/issues/issue_3/News/Danto/danto.html

Hany Armanious, 'Artist's Statement' in 'The Hot Seat: The Artist and His Critic', ABC RN Arts Today, 10 November 2000, available at http://www.abc.net.au/rn/arts/atoday/stories/, last accessed March 2004.

http://www.nytimes.com/1987/04/09/arts/sunflowers-buyer-japanese-insurer.html

http://www.msnbc.msn.com/id/17482641/#.TwzQMM2BL9o

Interview published on Temporary Services website: http://www.temporaryservices.org/concrete_wochenklausur.pdf, http://www.wochenklausur.at/

Liu, 'Inside Out: New Chinese Art', *Freize 44*, January-February 1999, available at http://www.frieze.com/issue/review/inside_out_new_chinese_art/

'Louvre to Build Branch in Abu Dhabi', Associated Press 3 June 2007, available at http://www.msnbc.com

Nina Möntmann, *(Under)Privileged Spaces: On Martha Rosler's "If You Lived Here…"*, e-flux journal, 2009.

Oxford Dictionaries Online: http://www.oxforddictionaries.com/definition/english/exotic, last accessed 7 January 2015.

PVI artist statement: http://www.pvicollective.com/, last accessed 25 October 2013.

Wim Pijbes in conversation, in R.J Preece, `Damien Hirst's diamond skull at the Rijksmuseum: *Behind the scenes* (2008)': http://www.artdesigncafe.com/damien-hirst-rijksmuseum-diamond-skull-2008, last accessed 7 January 2015.

INDEX

Note: Locators in *italics* refer to figures and locators followed by 'n' refer to notes.